Augmented Reality

1. Download the free *re*Generation³ app from the App Store or Google Play on your iOs or Android device

2. Open the app

3. Look for page with this symbol

4. Scan the page to access additional content

More information:
www.elysee.ch/regeneration3

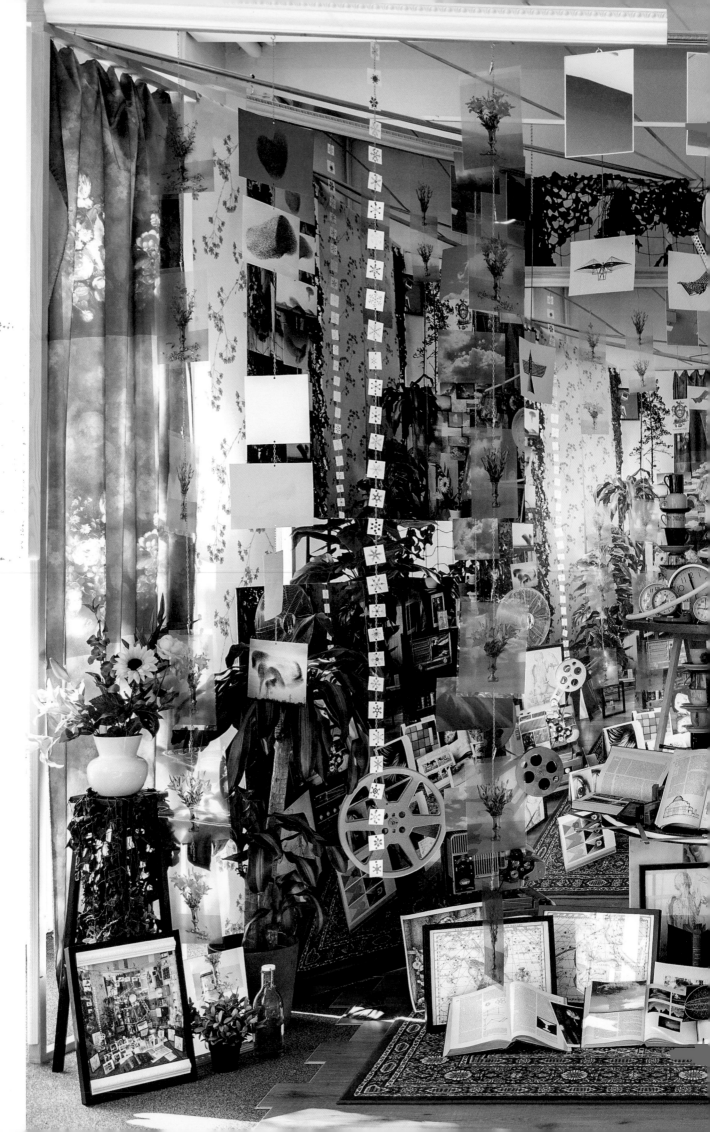

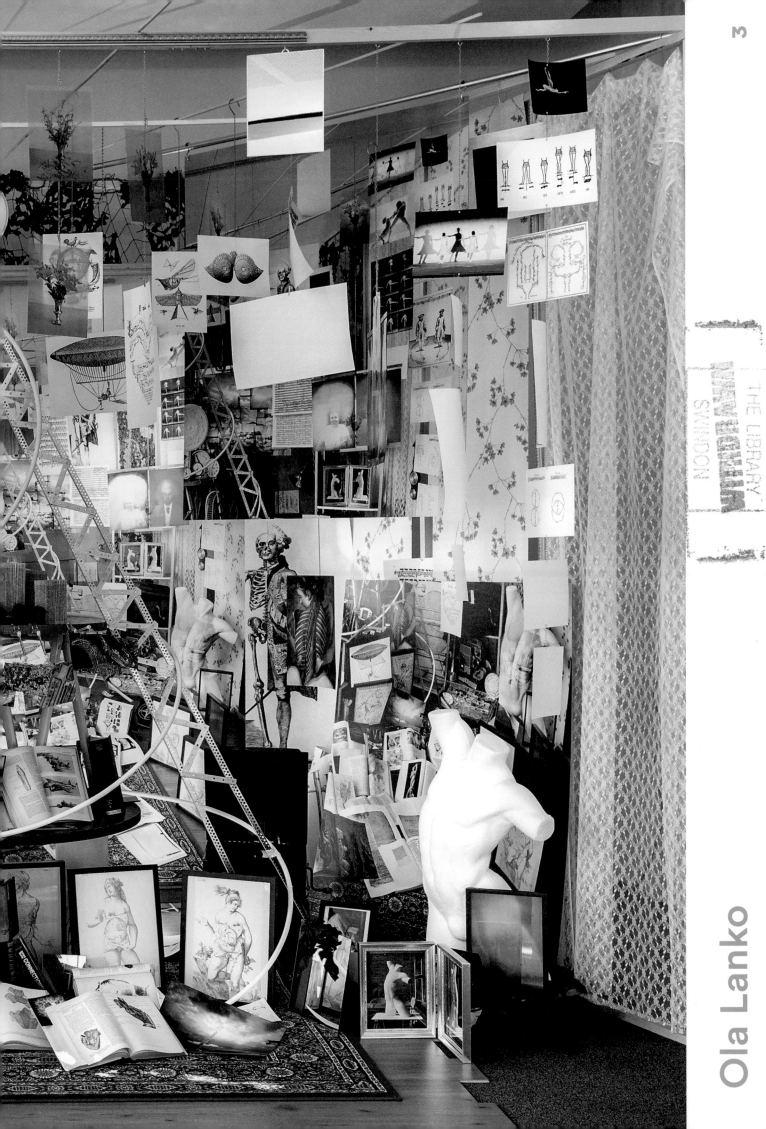

Ola Lanko

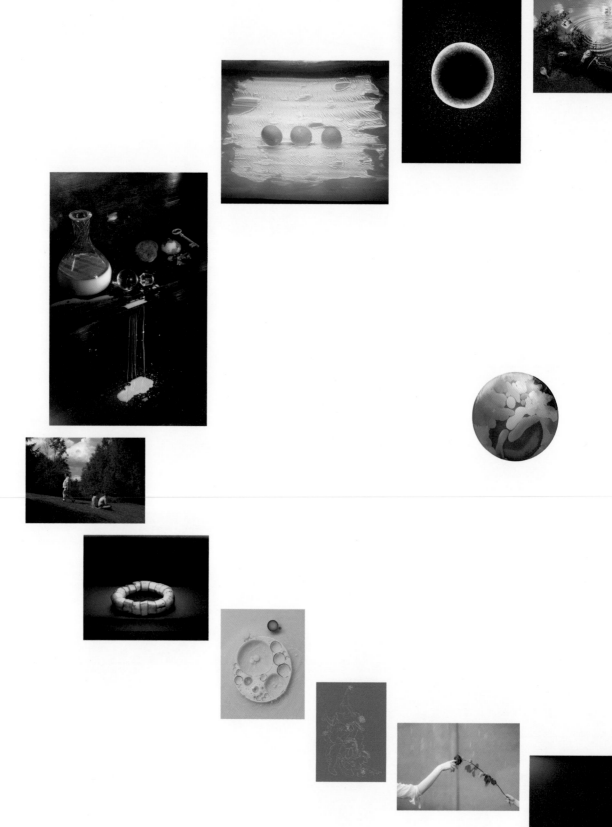

Lavish Fields

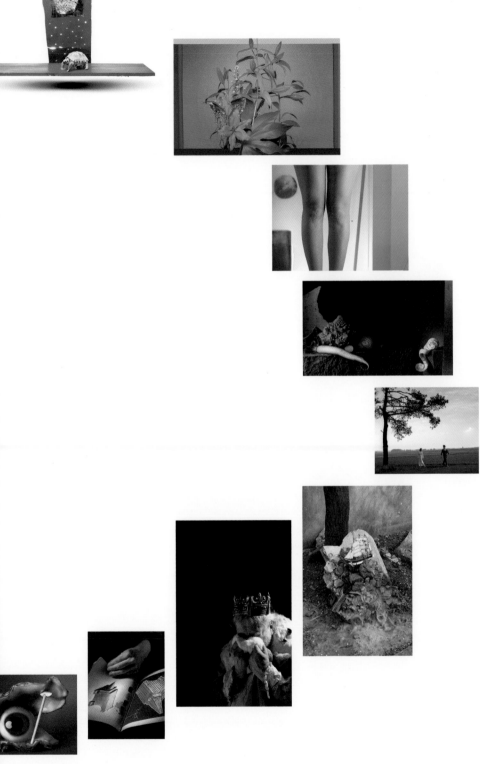

Robert Mainka

Dust Catcher

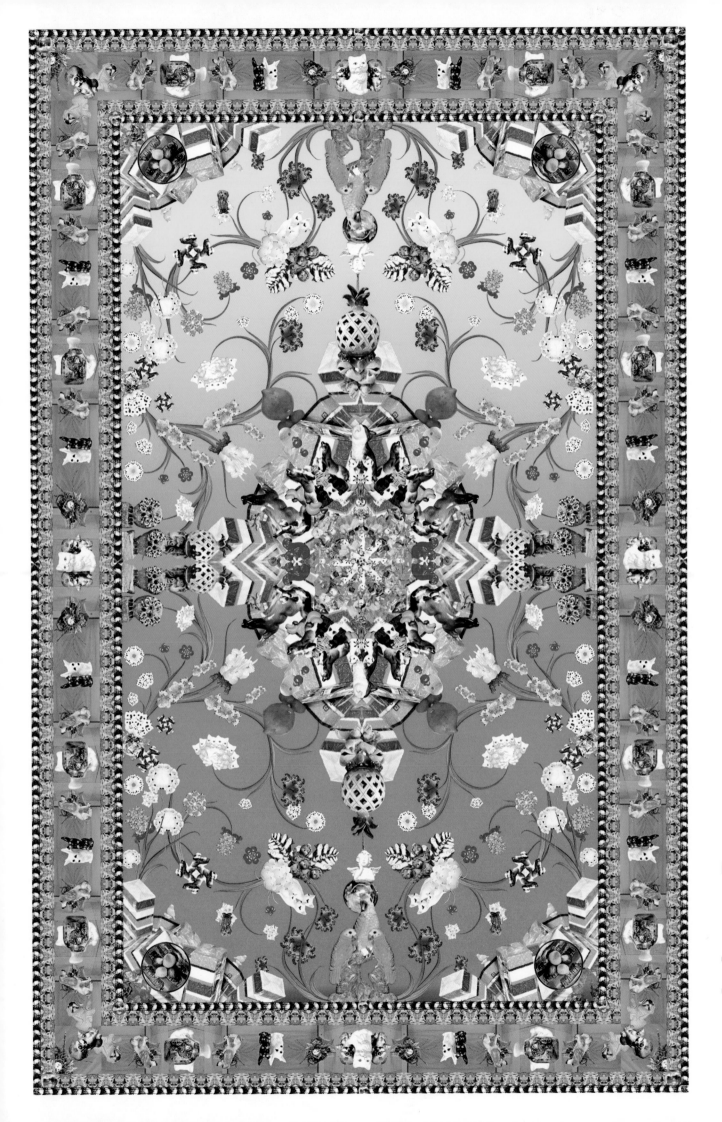

Magdalena Baranya

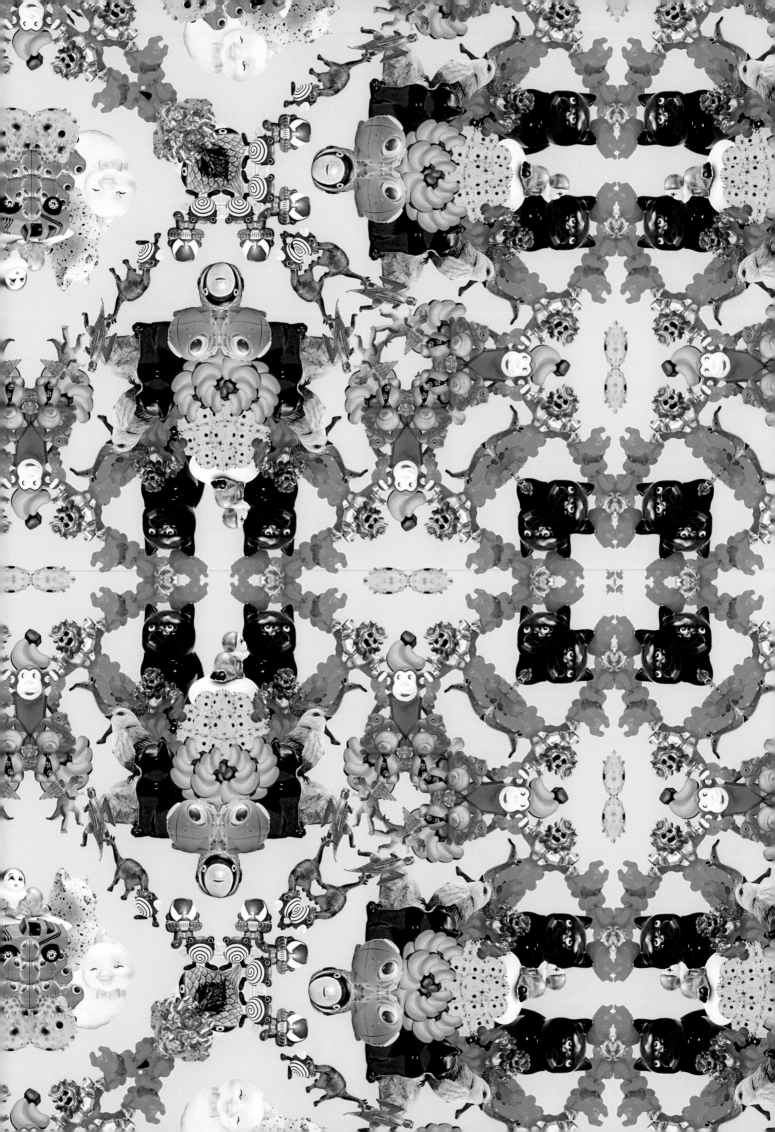

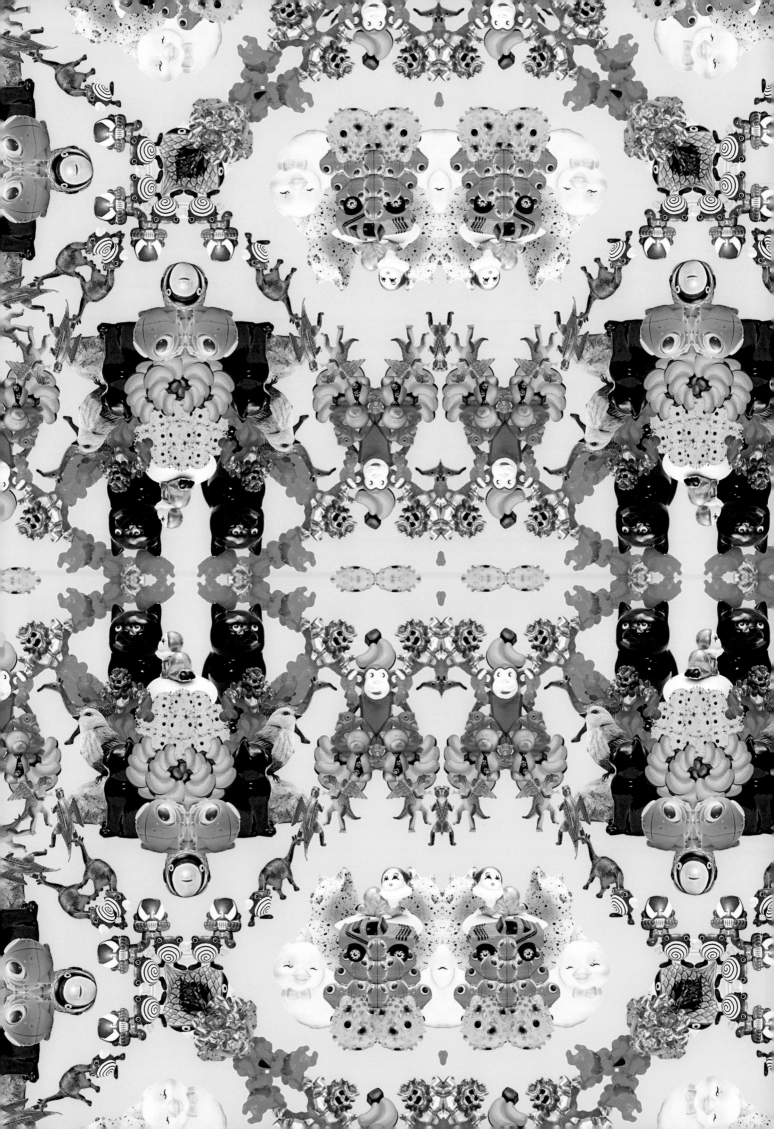

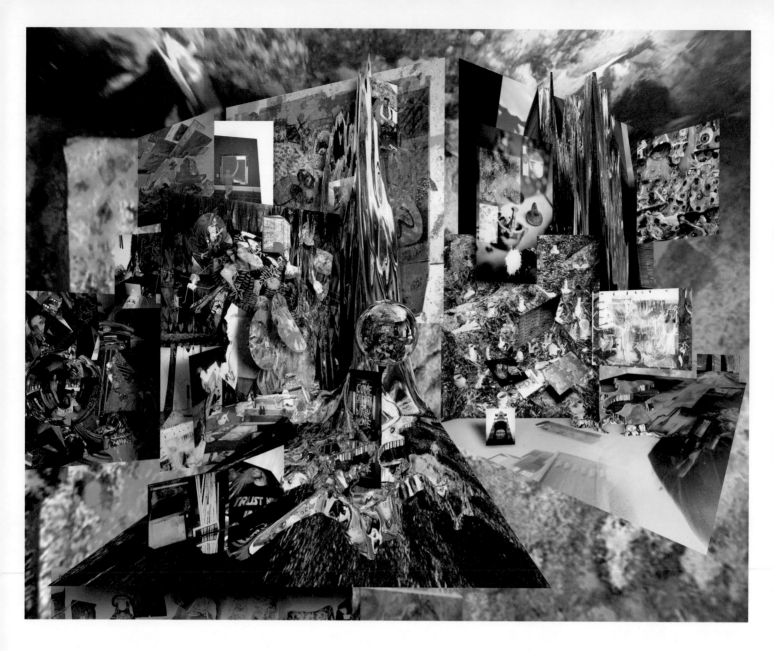

Liaisons: 1

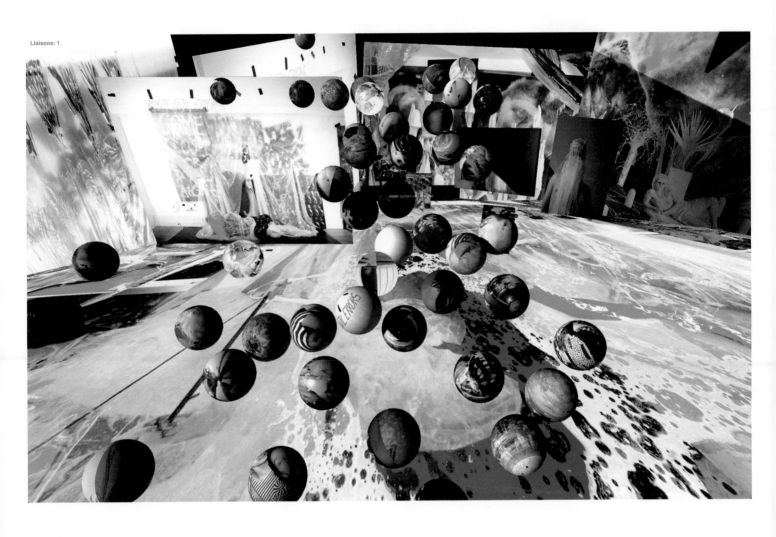

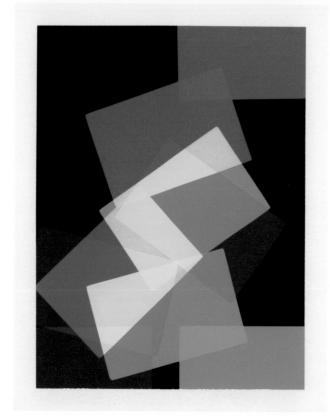

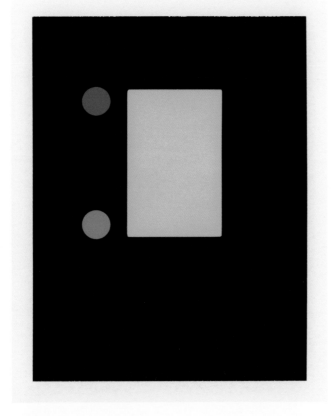

The Conquest of Materials

Benjamin Swanson

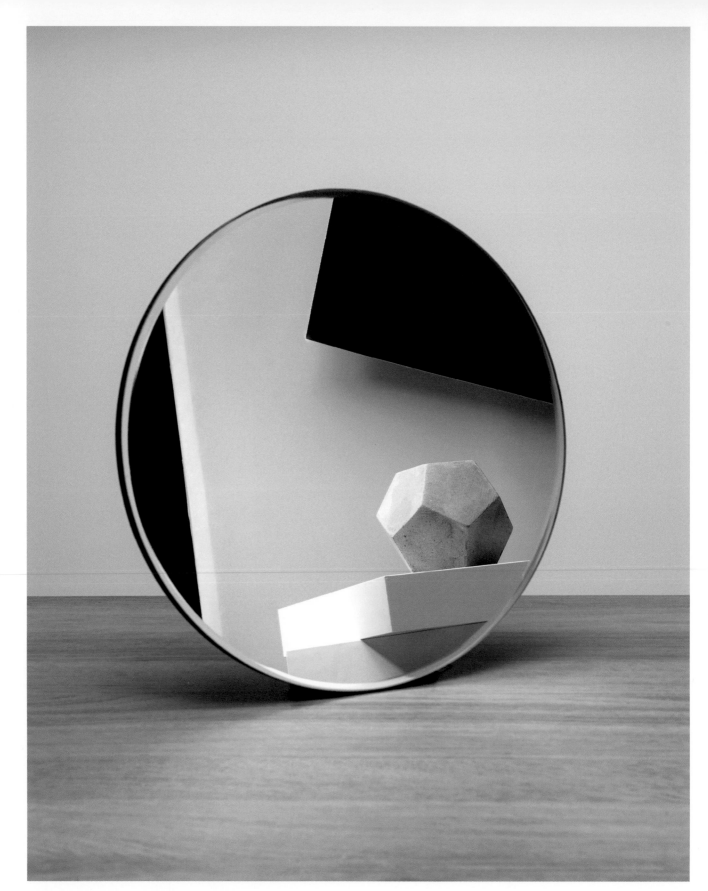

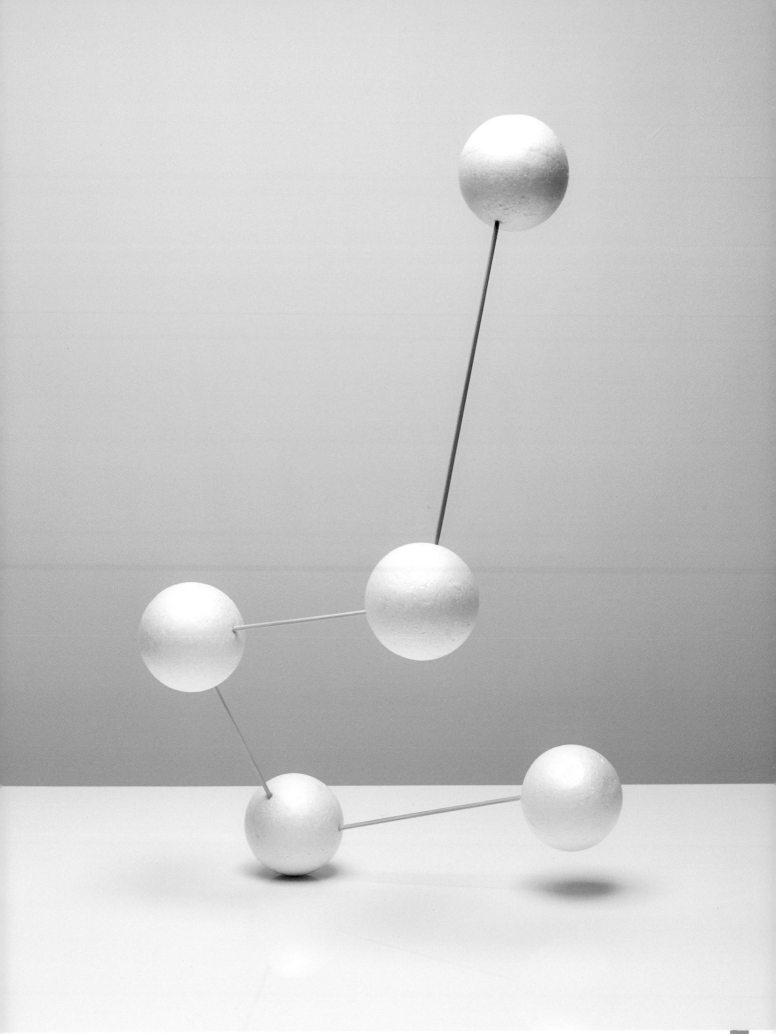

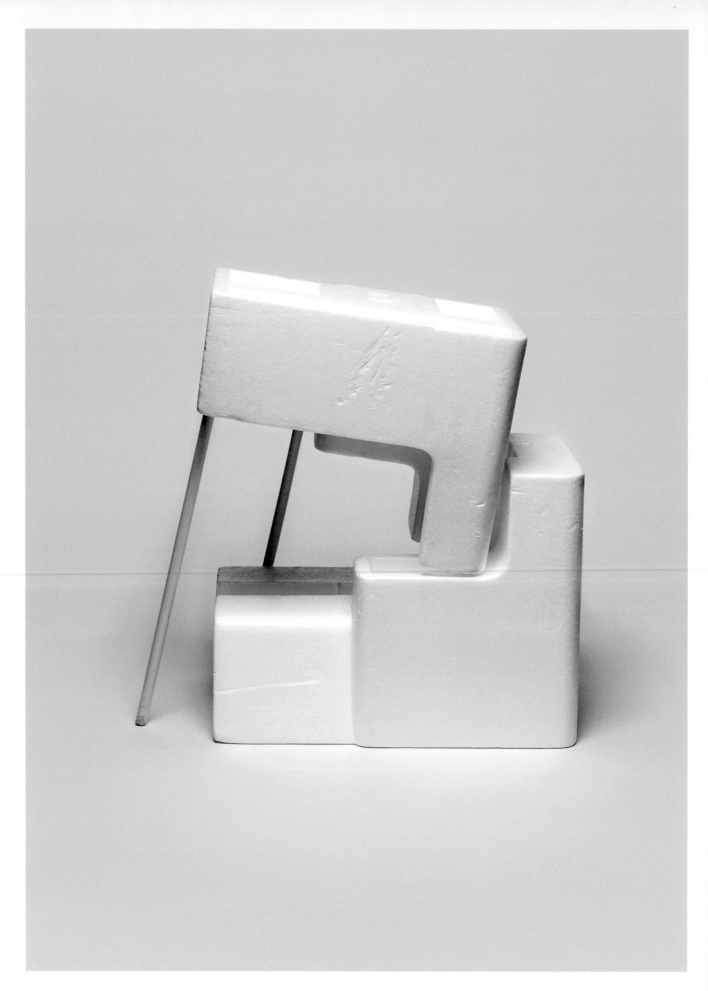

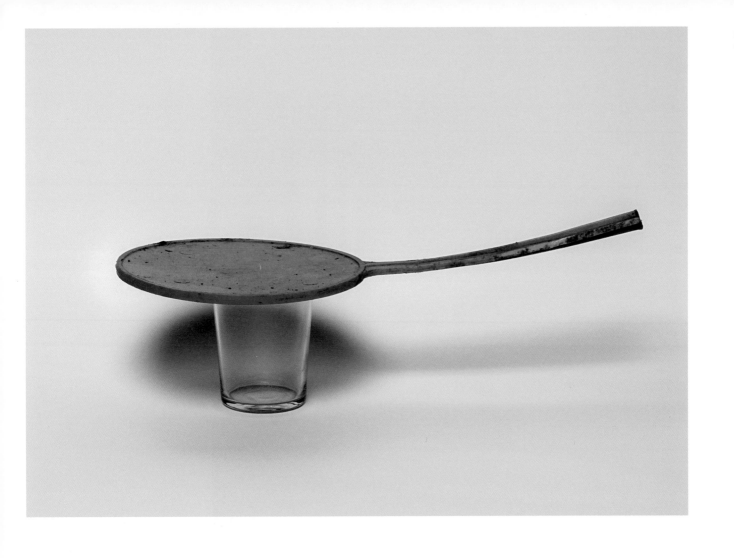

Delphine Burtin

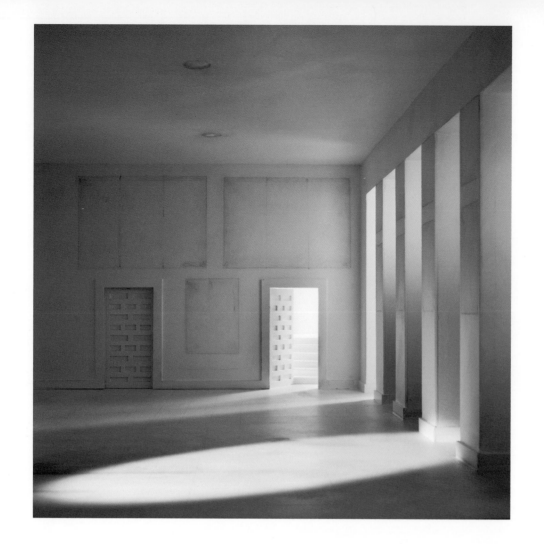

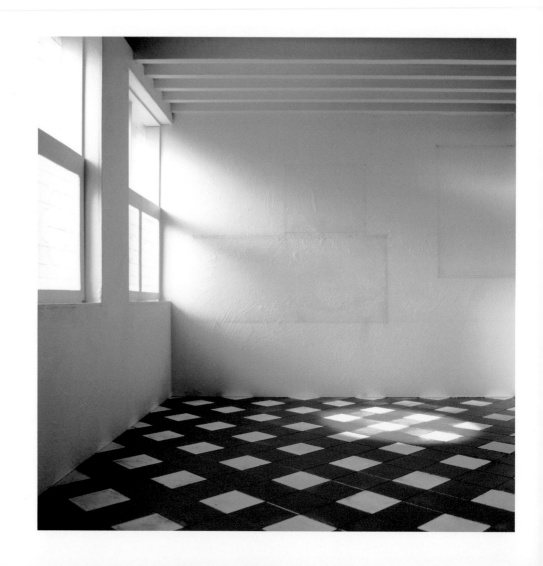

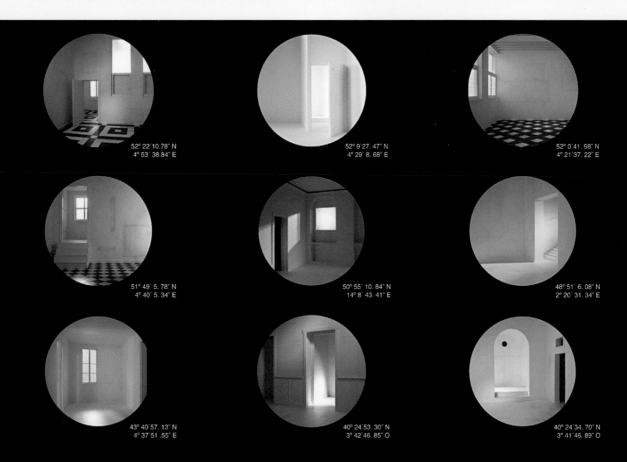

52° 22´10.78" N
4° 53´38.84" E

52° 9´27. 47" N
4° 29´8. 68" E

52° 0´41. 98" N
4° 21´37. 22" E

51° 49´5. 78" N
4° 40´5. 34" E

50° 55´10. 84" N
14° 8´43. 41" E

48° 51´6. 08" N
2° 20´31. 34" E

43° 40´57. 13" N
4° 37´51 .55" E

40° 24´53. 30" N
3° 42´46. 85" O

40° 24´34. 70" N
3° 41´46. 89" O

11.00

Emilio Pemjean

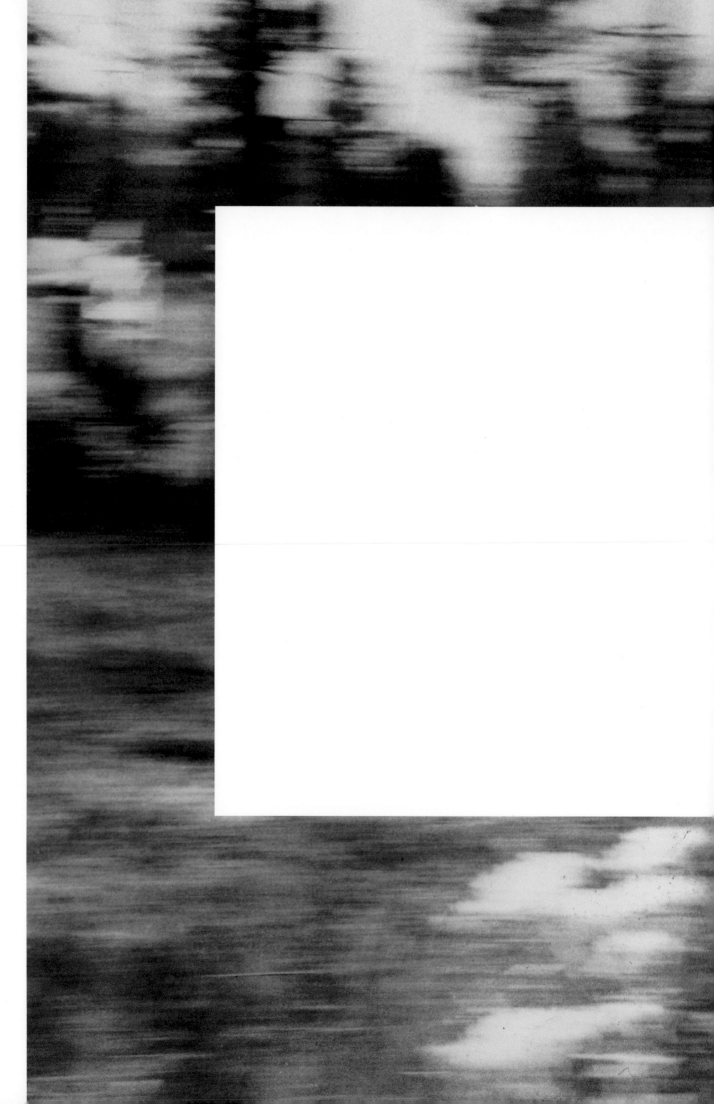

Etudes de vitesse

Simon Rimaz 23

F

FREUD'S STUDY. Arriving at Freud's study, which has been preserved in his former Hampstead home in London, one is not sure whether one has entered a psychoanalyst's office, or a Victorian opium den. The oriental décor, antiquities, and Egyptian steles suggest something more than just a casual inquiry into working processes of human psyche. Freud's study is anything but the sterile environment of a scientist. This place gleams with a decadent glamour and the walls could tell one too many stories of Freud's patients' most private and scandalous thoughts. In this dream like space, which seems to be so far from everyday reality, one is immediately drawn to lie down on the infamous couch veiled in Persian tapestries, and confess the darkest of secrets.

However the piece of furniture that is somewhat more captivating than the couch itself, is Freud's slightly grotesque leather armchair. Its design is an uncannily close match with some of the primitive idols resting on Freud's desk. Apparently the chair was specially designed by the architect Felix Augenfeld in order to allow Freud to read in his favorite and rather peculiar position - one of his legs slung over the arm of the chair, the book held high and his head unsupported. Thus this object of my curiosity is perhaps merely a utilitarian piece of furniture, designed in order to provide comfort during its owner's reading. On the other hand, it is possible that as such this chair, being a kind of an imprint of Freud's unique body posture, becomes almost a surrogate for Freud himself. With its bizarre, human-like form, this chair haunts the study with Freud's eternal presence.

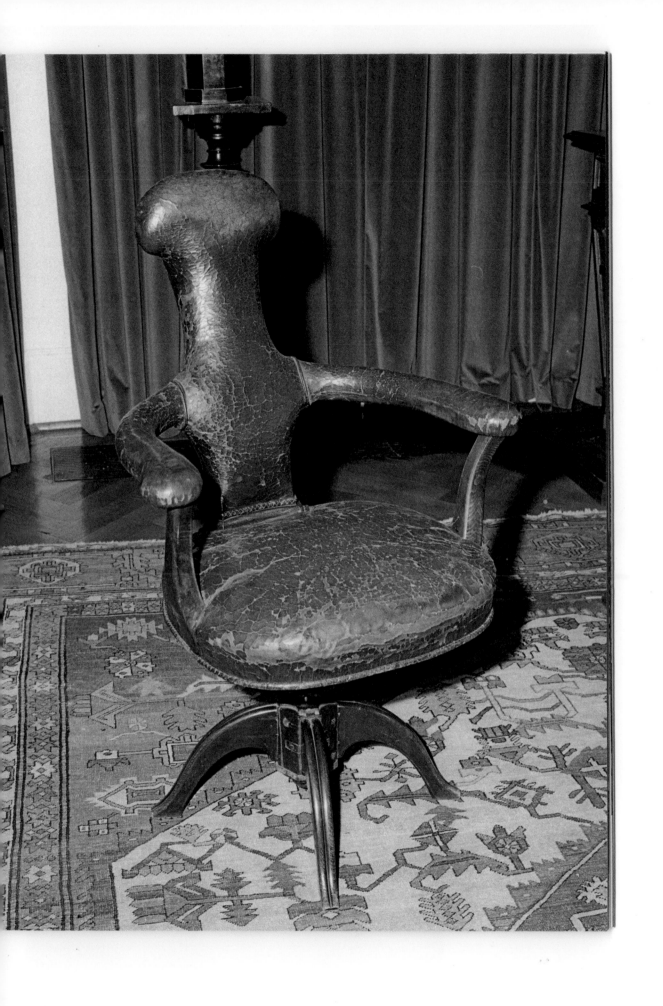

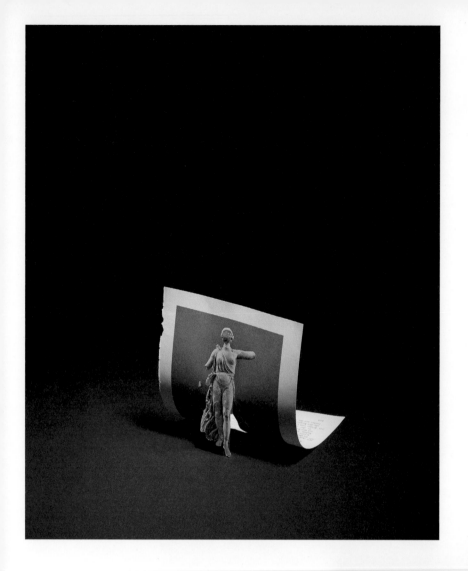

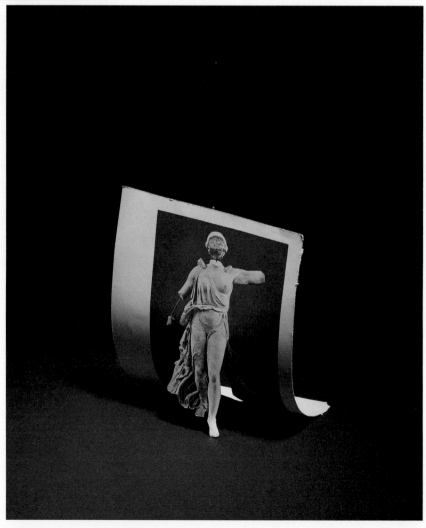

Nike

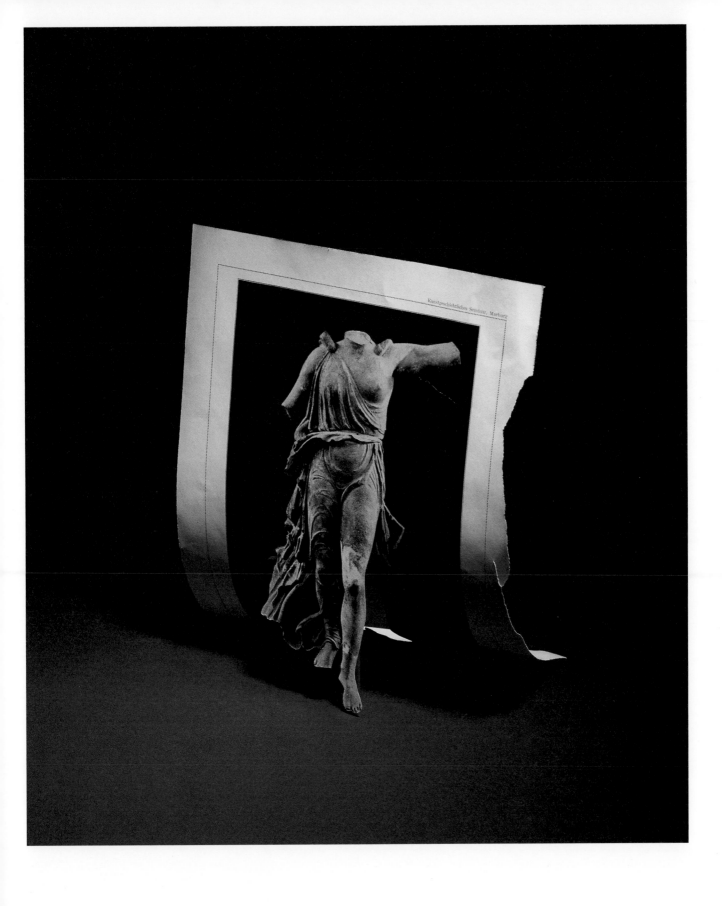

Kunstgeschichtliches Seminar, Marburg

Michael Etzensperger

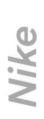

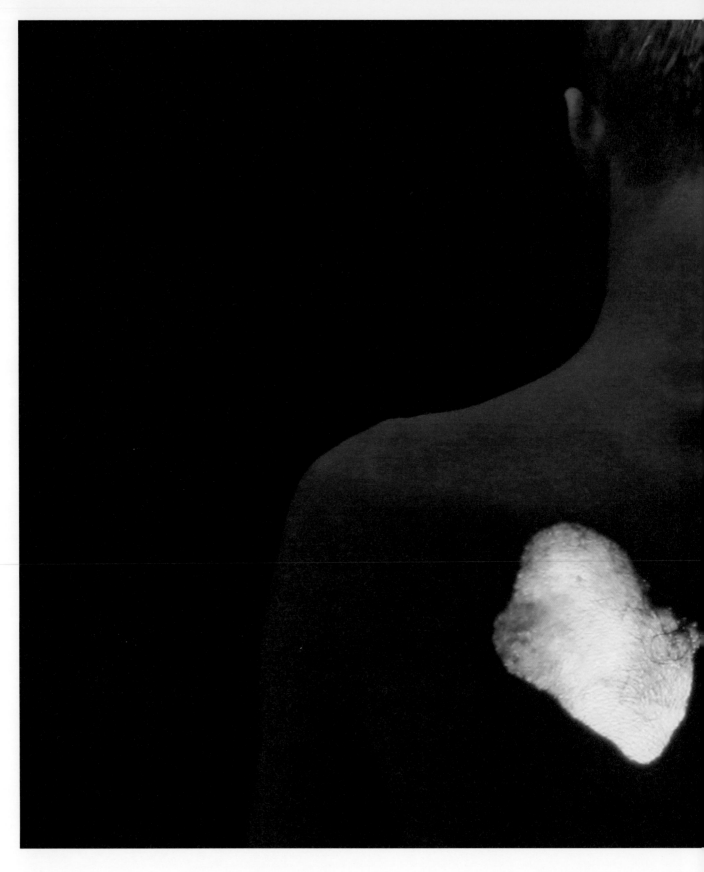

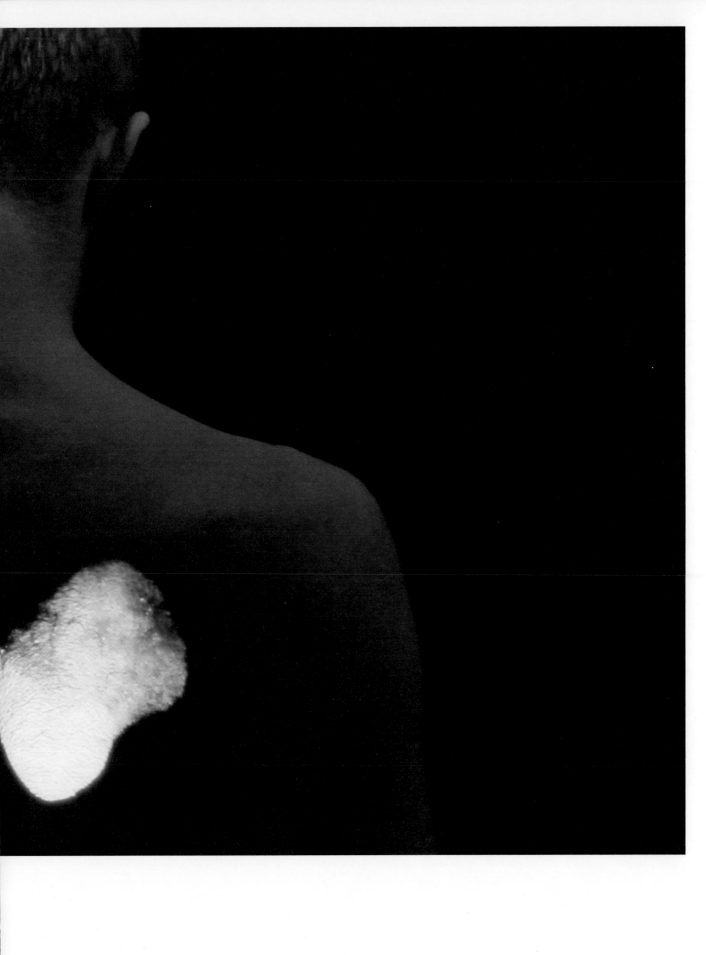

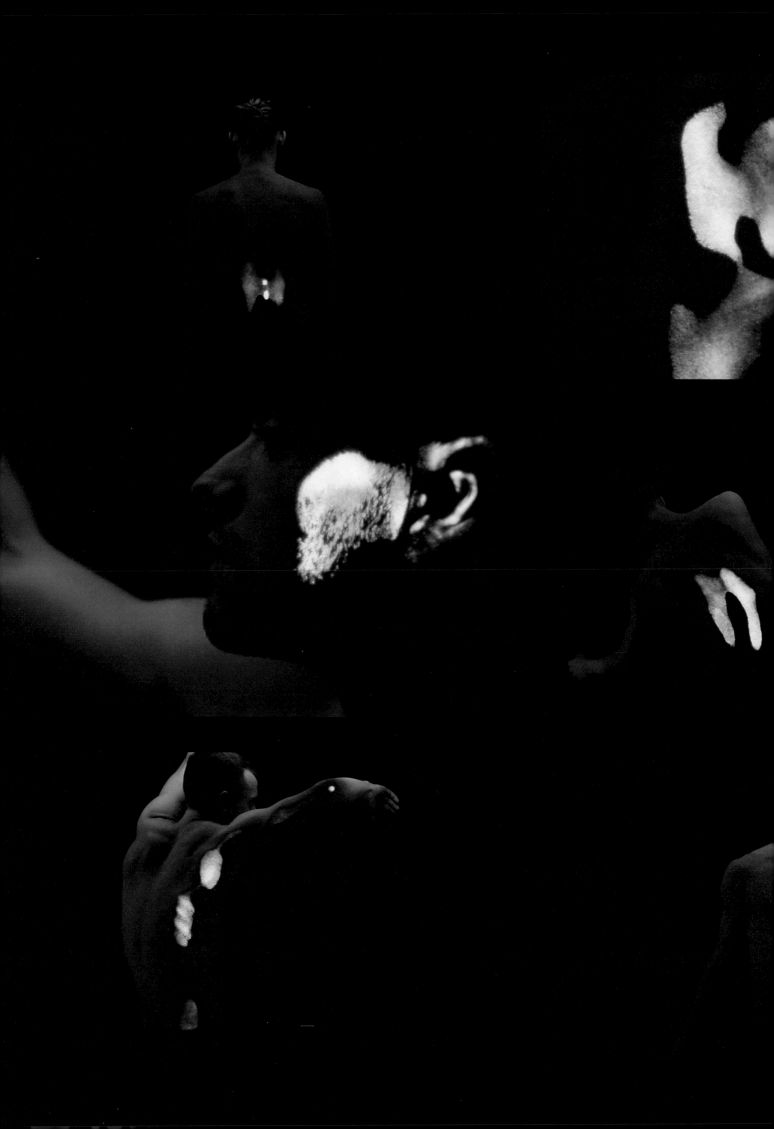

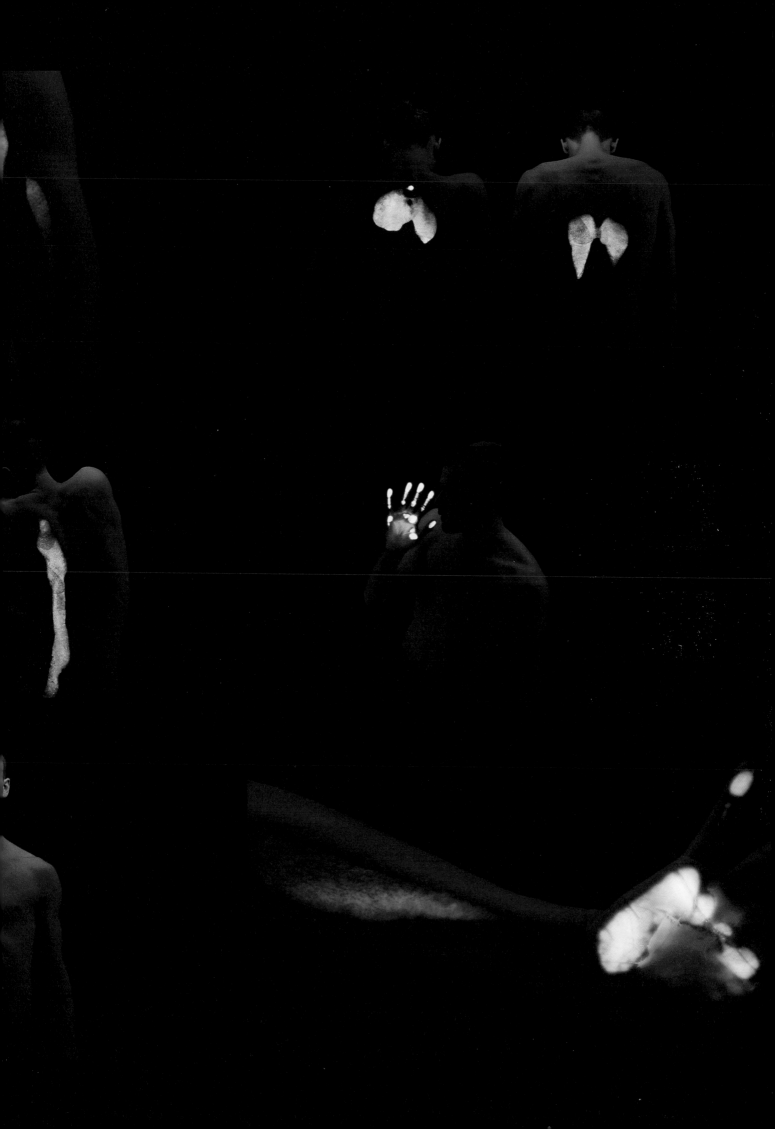

Jansen
Feature Type: Crater, craters, a circular depression.
Named for: Zacharias Janssens Dutch opticians (1580s–1630).
Location: 13.50°N 28.70°E
Size: 23.0 km / 14.3 mi

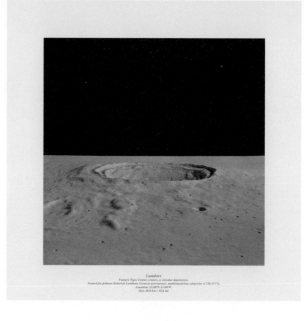

Lambert
Feature Type: Crater, craters, a circular depression.
Named for: Johann Heinrich Lambert German astronomer, mathematician, physicist (1728–1777).
Location: 25.80°N 21.00°W
Size: 30.0 km / 18.6 mi

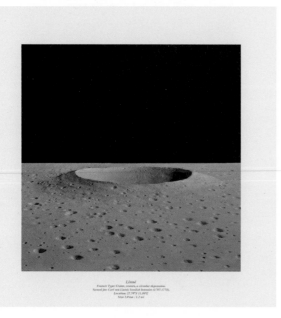

Linné
Feature Type: Crater, craters, a circular depression.
Named for: Carl von Linné Swedish botanist (1707–1778).
Location: 27.70°N 11.80°E
Size: 2.0 km / 1.2 mi

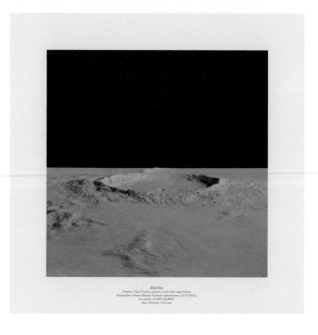

Marius
Feature Type: Crater, craters, a circular depression.
Named for: Simon Mayer German astronomer (1573–1624).
Location: 11.80°N 50.80°W
Size: 41.0 km / 25.5 mi

Lunar Crater

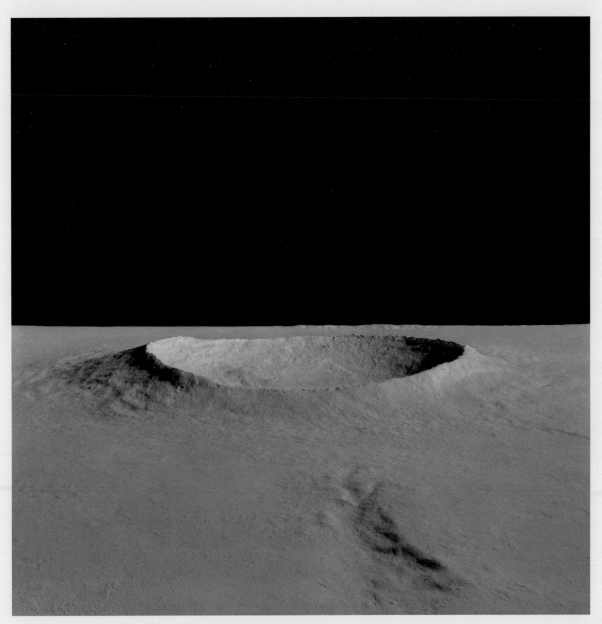

Al-Bakri
Feature Type: Crater, craters, a circular depression.
Named for: Ibn Muhammad Al-Bakri; Spanish-Arab geographer (1010-1094).
Location: 14.30°N 20.20°E
Size: 12.0 km / 7.5 mi

Li Zhi

Peak

Jae Hoon Lee

l'étendue de mes connaissances ⊕

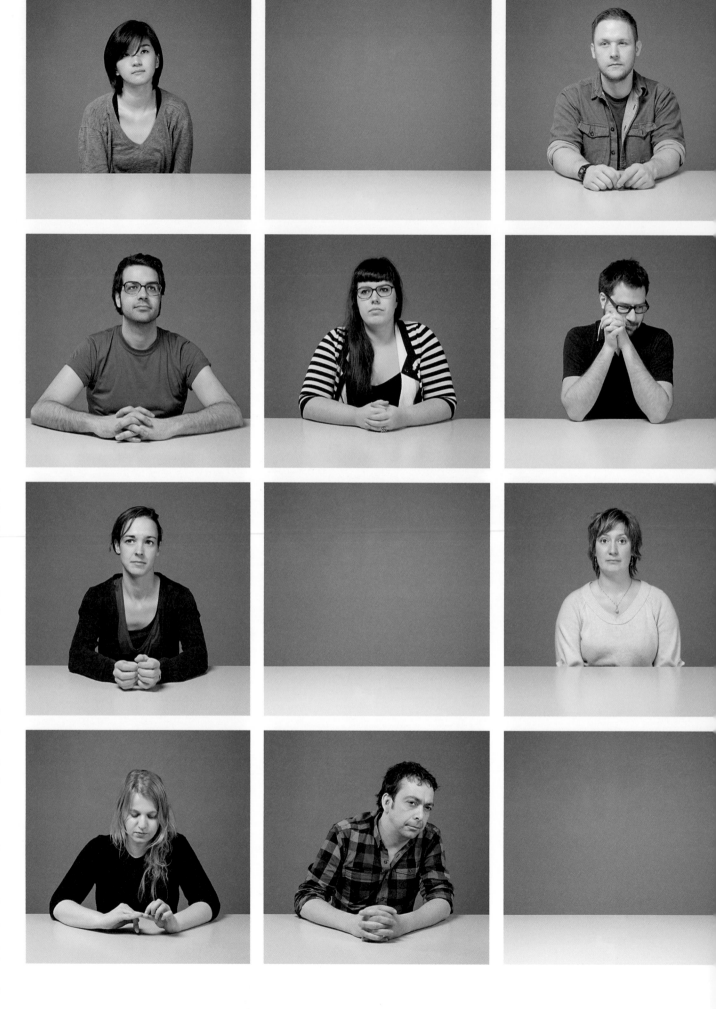

Jacinthe Robillard

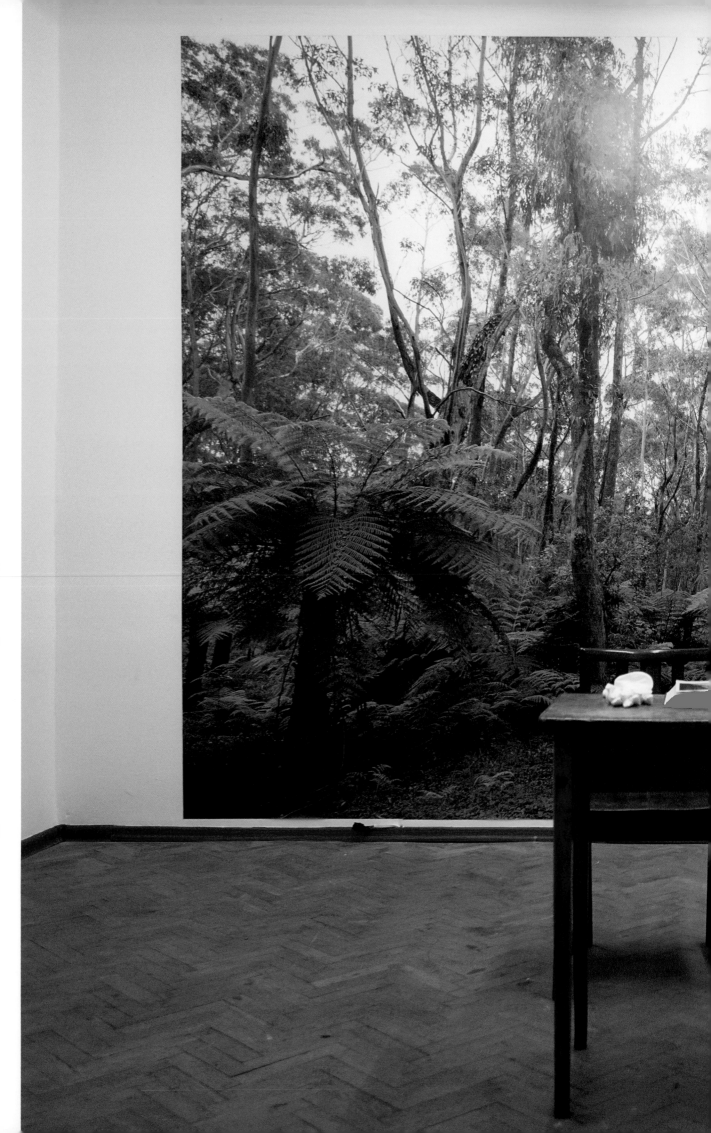

There's nothing there, anyway

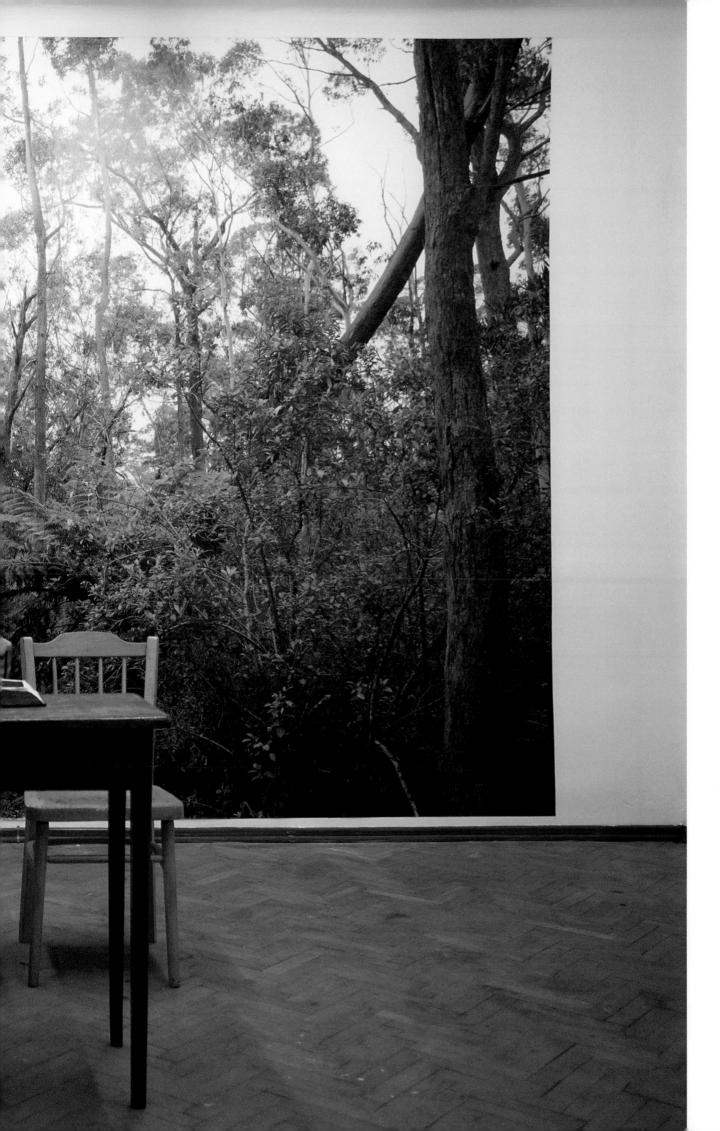

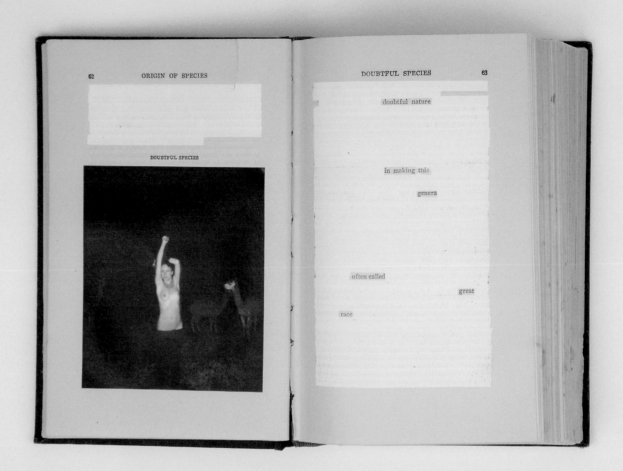

There's nothing there, anyway

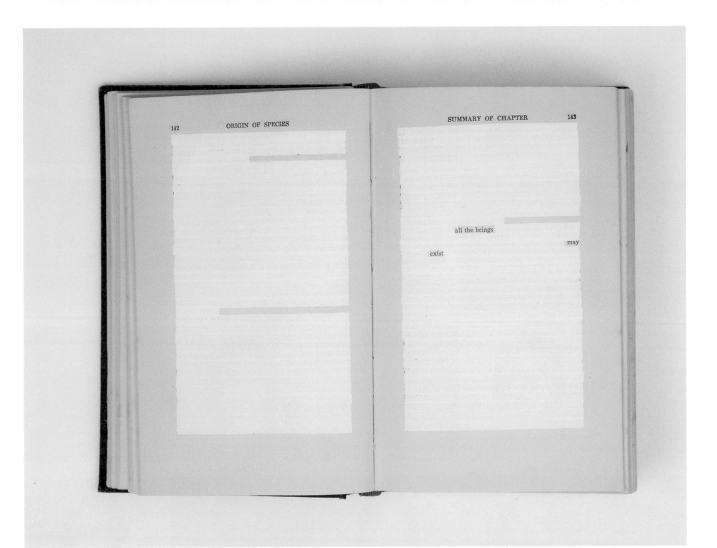

all the beings

exist may

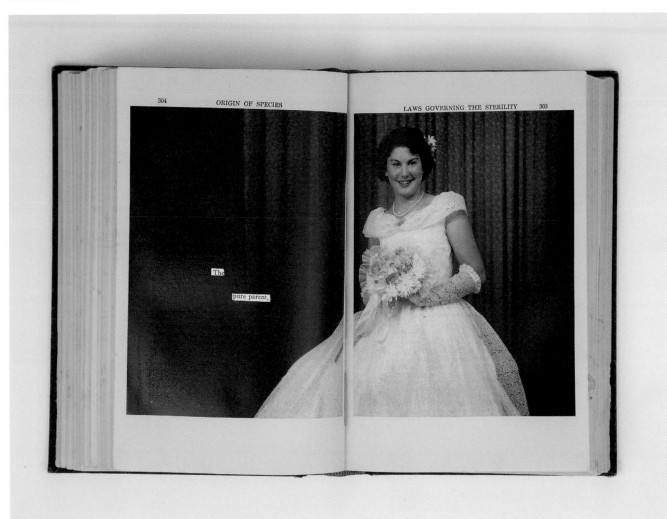

The

pure parent,

Marek Kucharski & Diana Lelonek

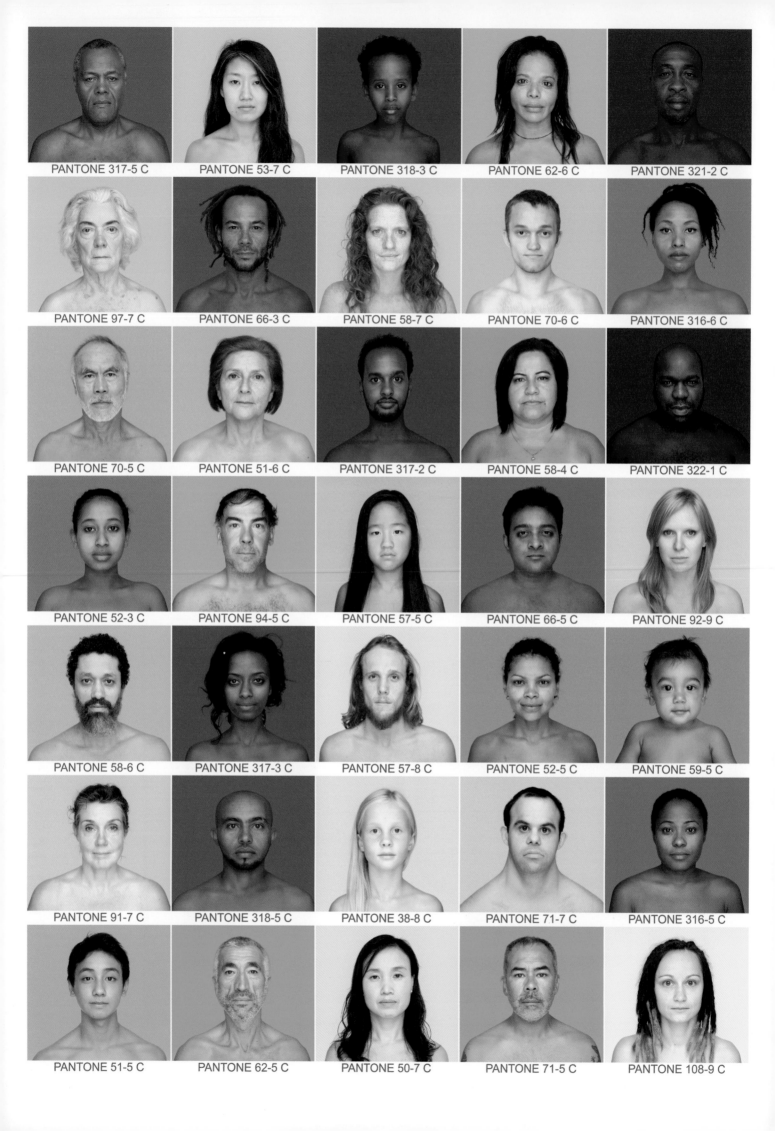

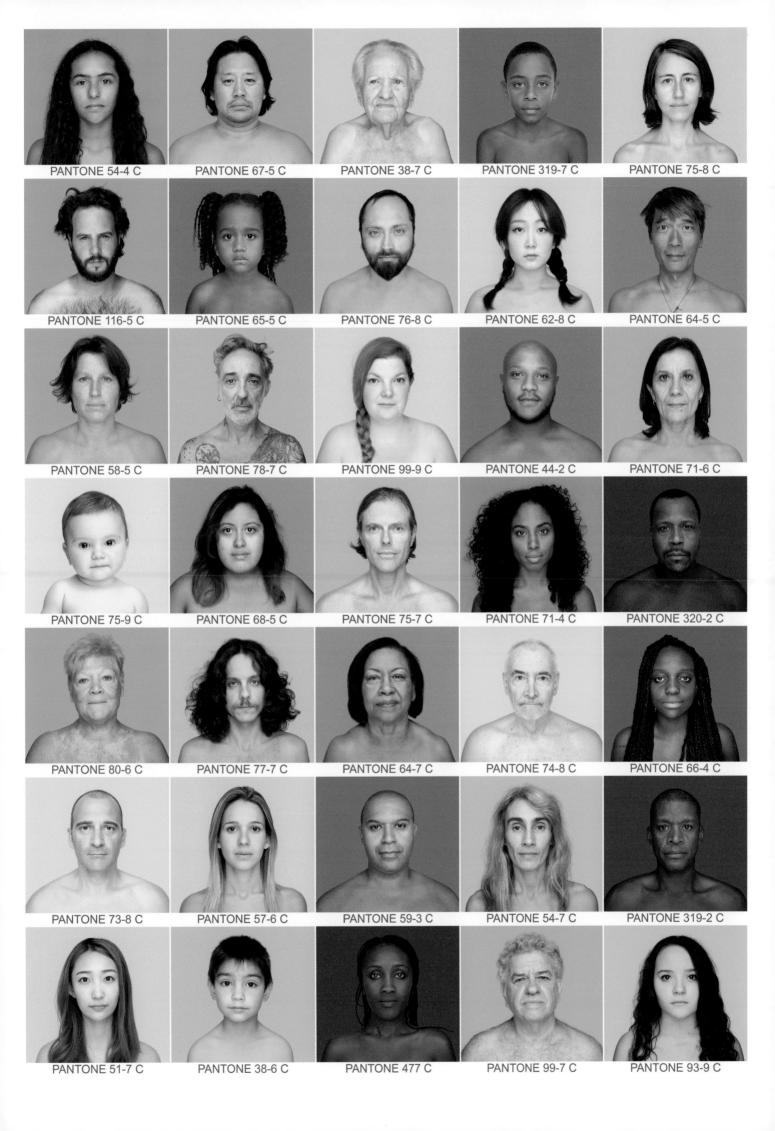

PANTONE 54-4 C PANTONE 67-5 C PANTONE 38-7 C PANTONE 319-7 C PANTONE 75-8 C

PANTONE 116-5 C PANTONE 65-5 C PANTONE 76-8 C PANTONE 62-8 C PANTONE 64-5 C

PANTONE 58-5 C PANTONE 78-7 C PANTONE 99-9 C PANTONE 44-2 C PANTONE 71-6 C

PANTONE 75-9 C PANTONE 68-5 C PANTONE 75-7 C PANTONE 71-4 C PANTONE 320-2 C

PANTONE 80-6 C PANTONE 77-7 C PANTONE 64-7 C PANTONE 74-8 C PANTONE 66-4 C

PANTONE 73-8 C PANTONE 57-6 C PANTONE 59-3 C PANTONE 54-7 C PANTONE 319-2 C

PANTONE 51-7 C PANTONE 38-6 C PANTONE 477 C PANTONE 99-7 C PANTONE 93-9 C

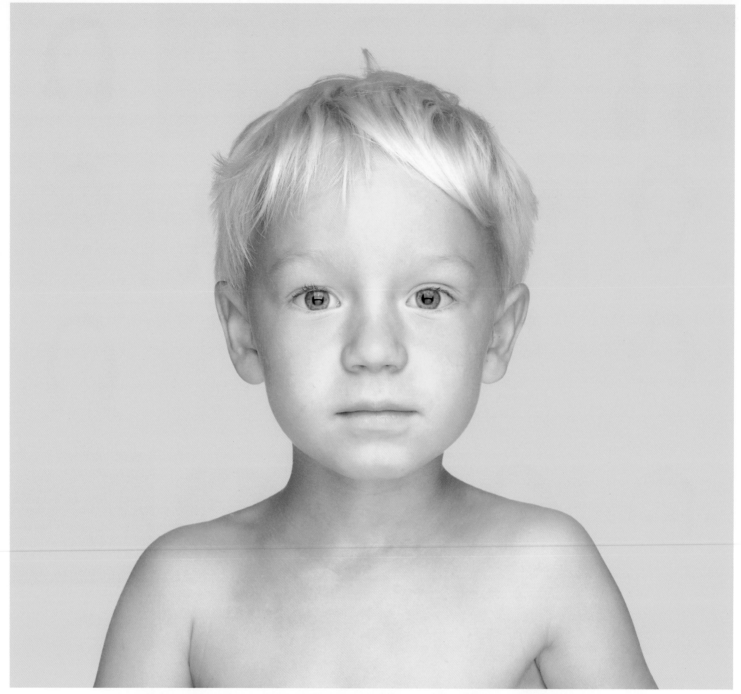

PANTONE 57-7 C

PANTONE 54-9 C

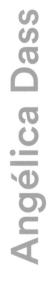

Text
10.11

tesam evanukampartham
aham ajnana-jam tamah
nasayamy atma-bhavastho
jnana-dipena bhasvata

Out of compassion for them, I, dwelling in
their hearts, destroy with the shining lamp
of knowledge the darkness born of
ignorance.

Excerpt from Prabhupada's Purport

But even if a devotee does not take advantage of their literatures or of his spiritual master, if he is sincere in his devotional service he is helped by *Krsna* Himself within his heart. The only qualification is that one carry out devotional service in full Krsna consciousness. For them this answer is given by the Supreme Lord: those who are engaged in pure devotional service, even though they be without sufficient education and even without sufficient knowledge of the Vedic principles, are still helped by the Supreme God, as stated in this verse.

Due to the contamination of material association, through many, many millions of births, one's heart is always covered with the dust of materialism, but when one engages in devotional service and constantly chants *Hare Krsna,* the dust quickly clears, and one is elevated to the platform of pure knowledge.

Misinterpretation

The hypnotic maha-mantra *Hare Krsna, Hare Rama* is prescribed the best way to attain enlightenment.

Facing Page: HARE KRSNA HARE RAMA

Mohit Bhatia

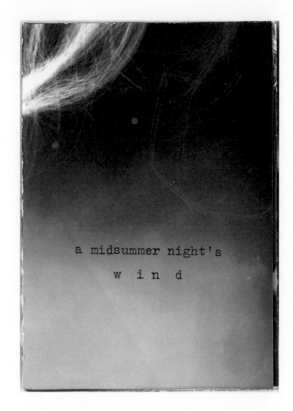

a midsummer night's

w in d

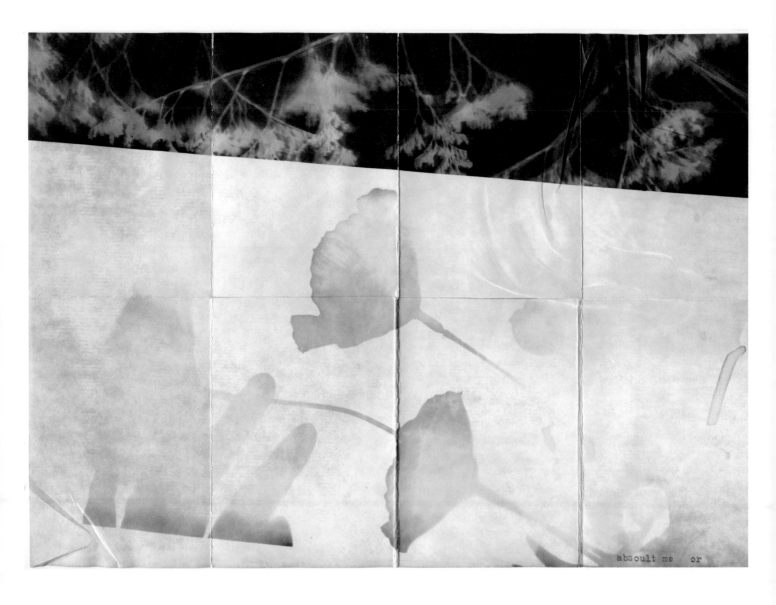

absoult me or

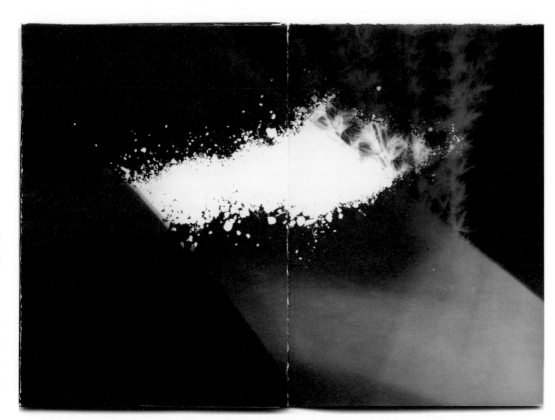

Jung A Kim

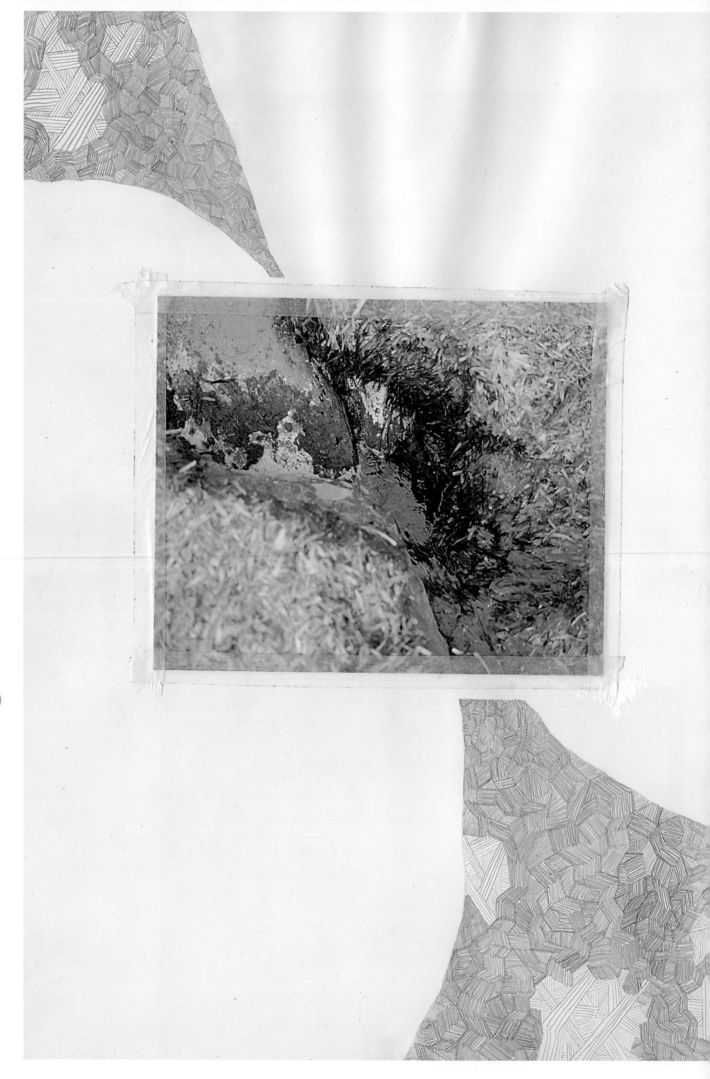

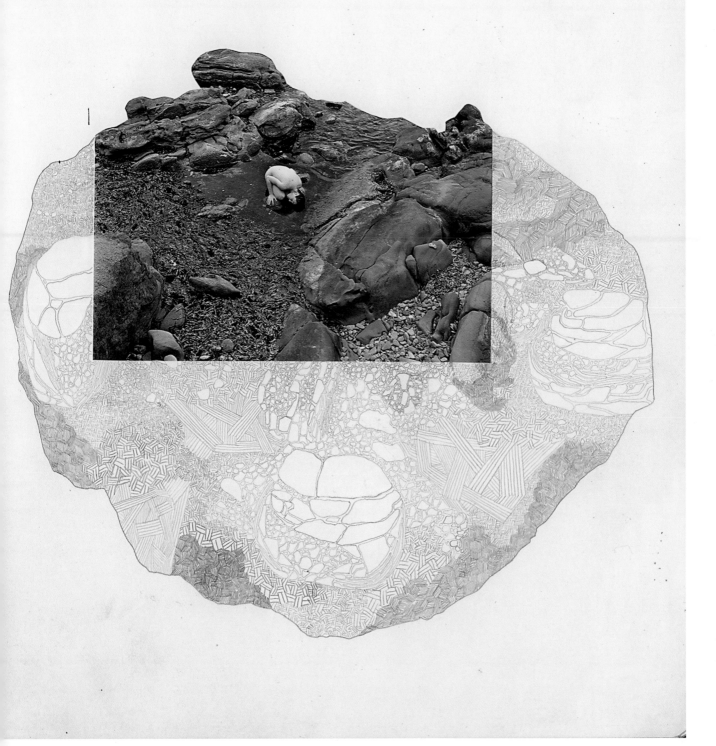

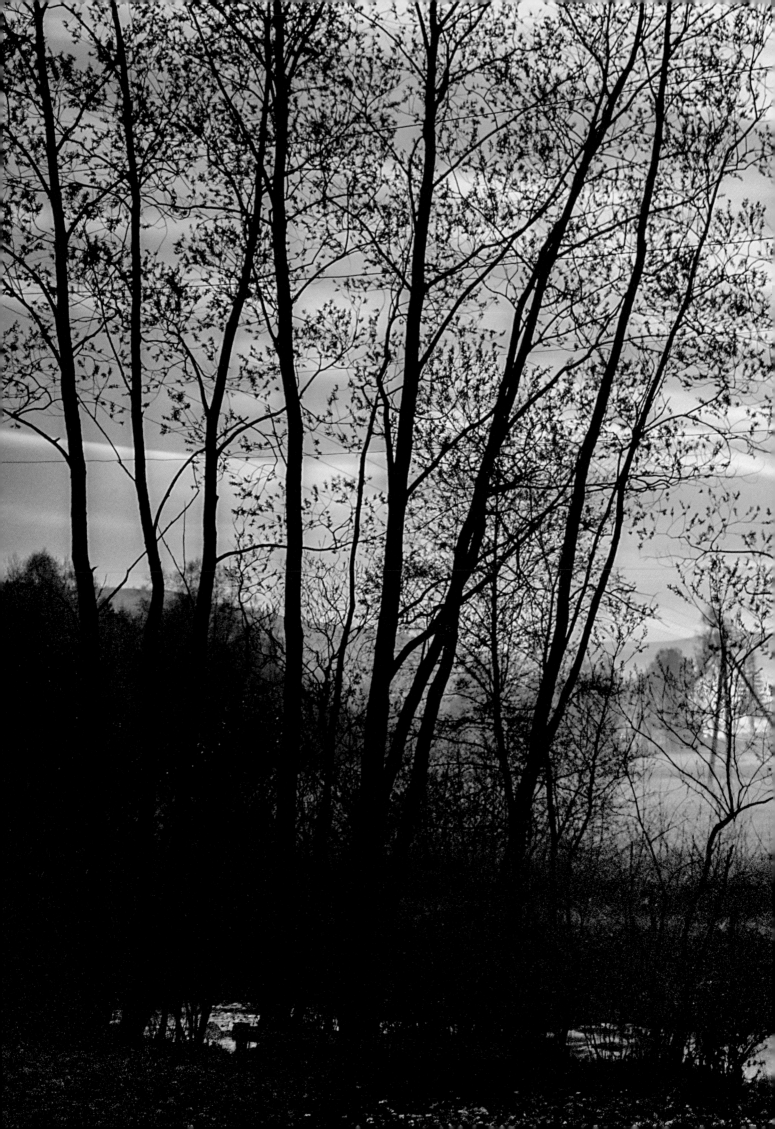

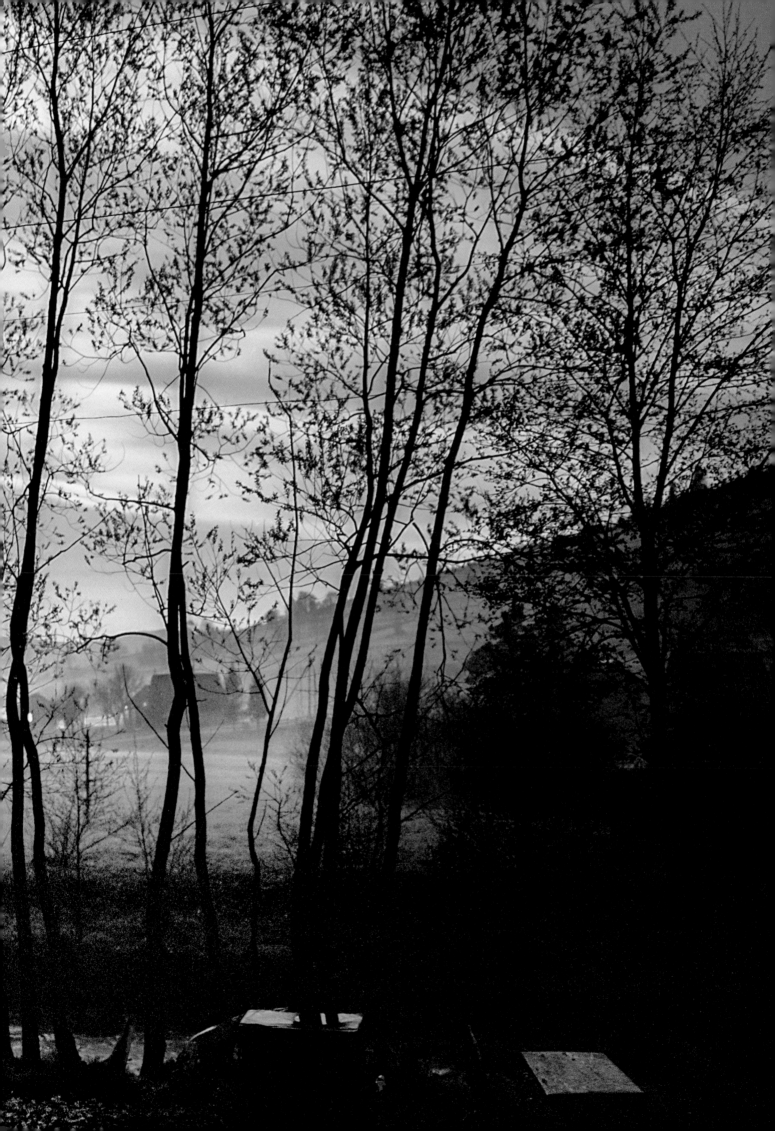

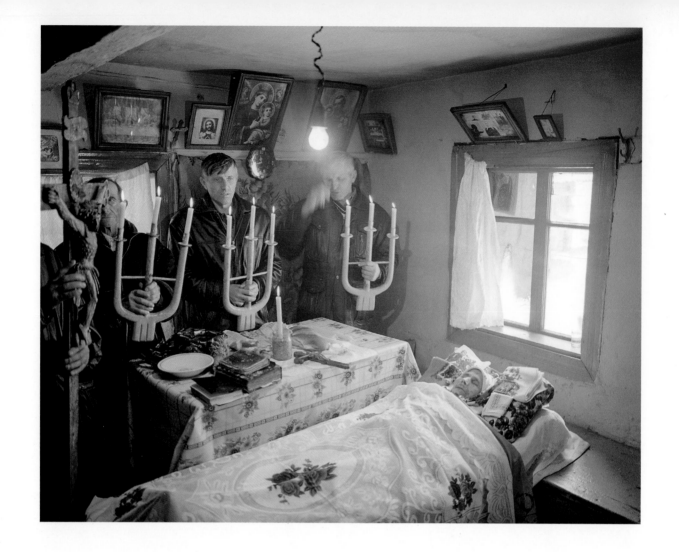

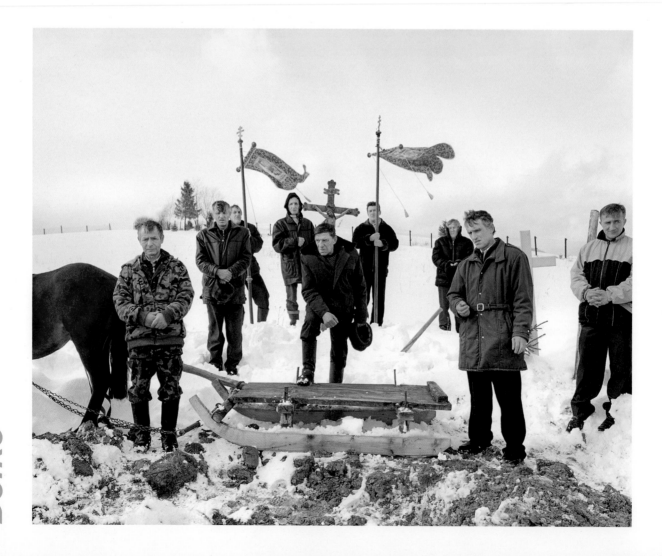

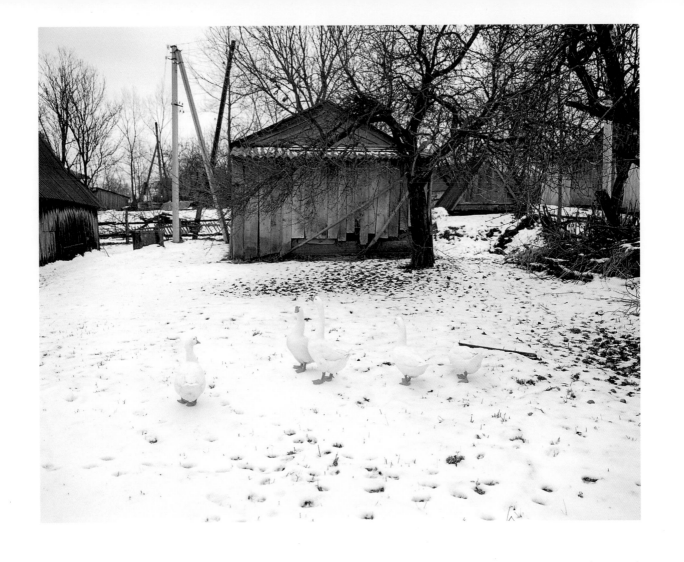

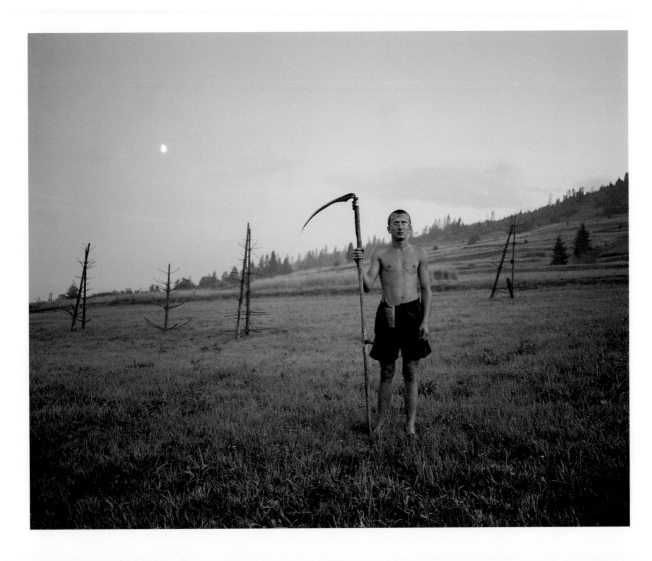

Jan Brykczyński

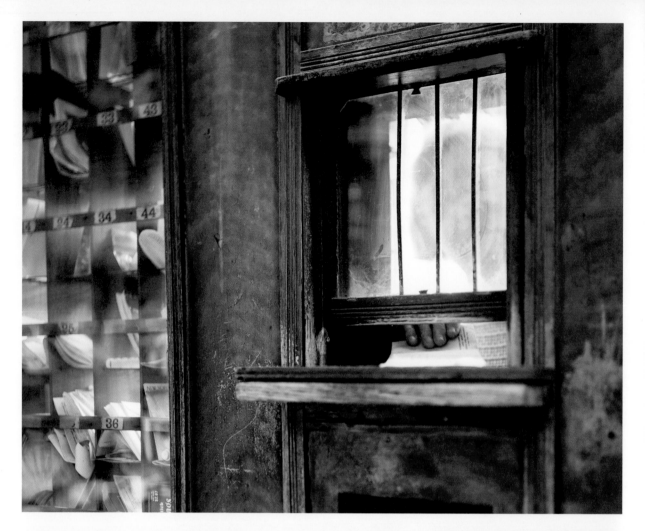

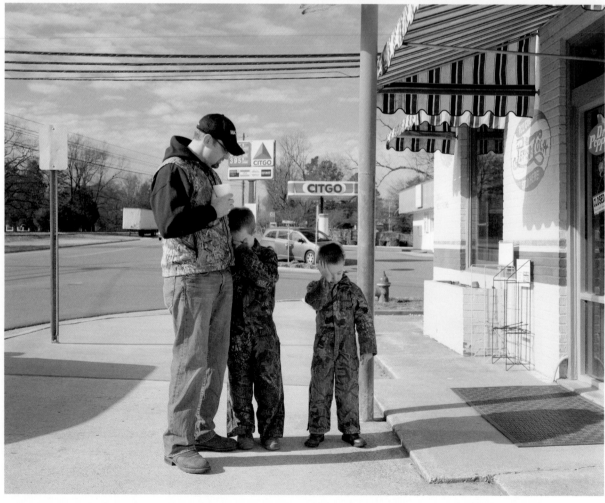

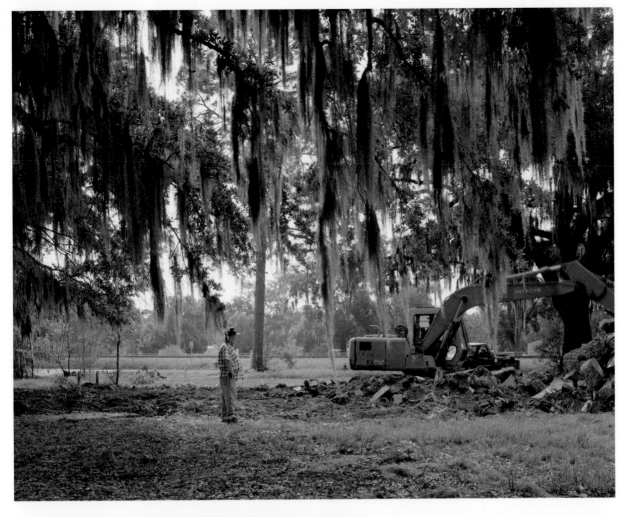

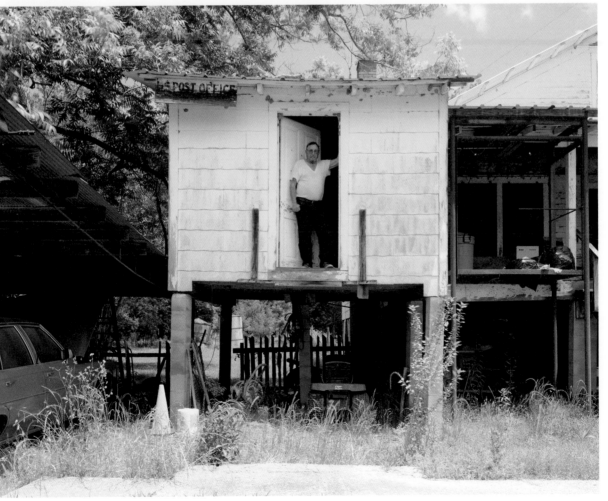

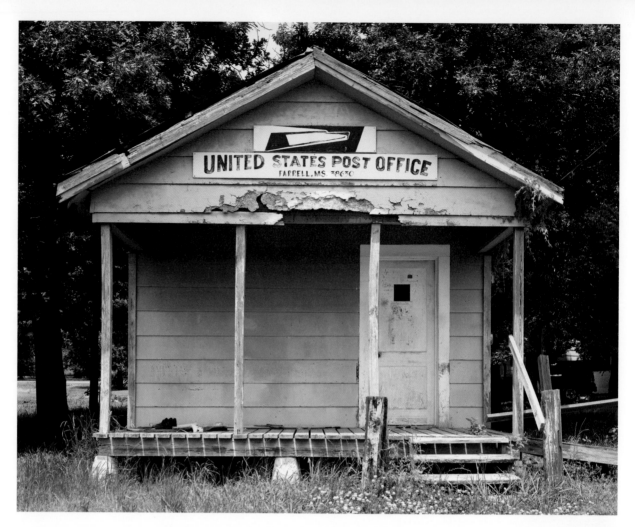

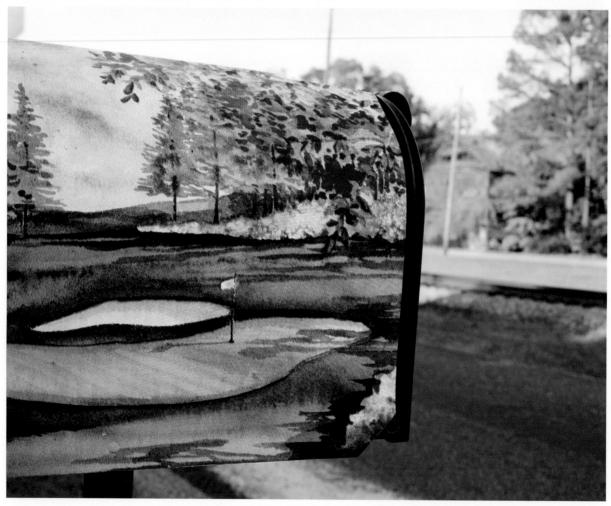

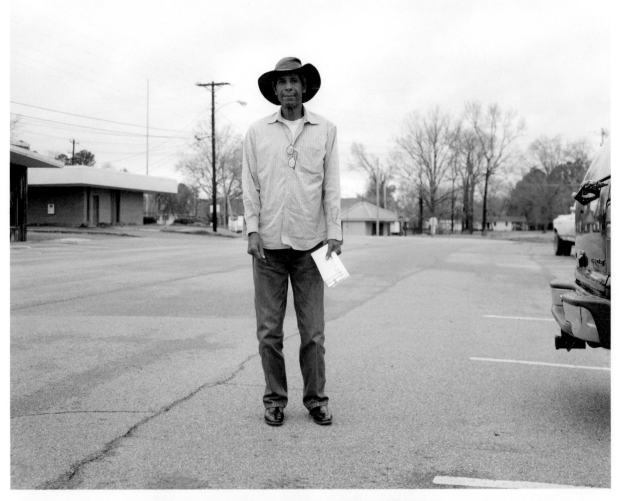

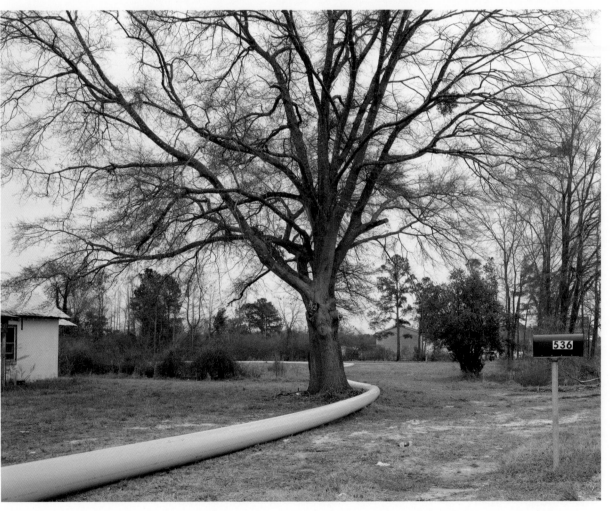

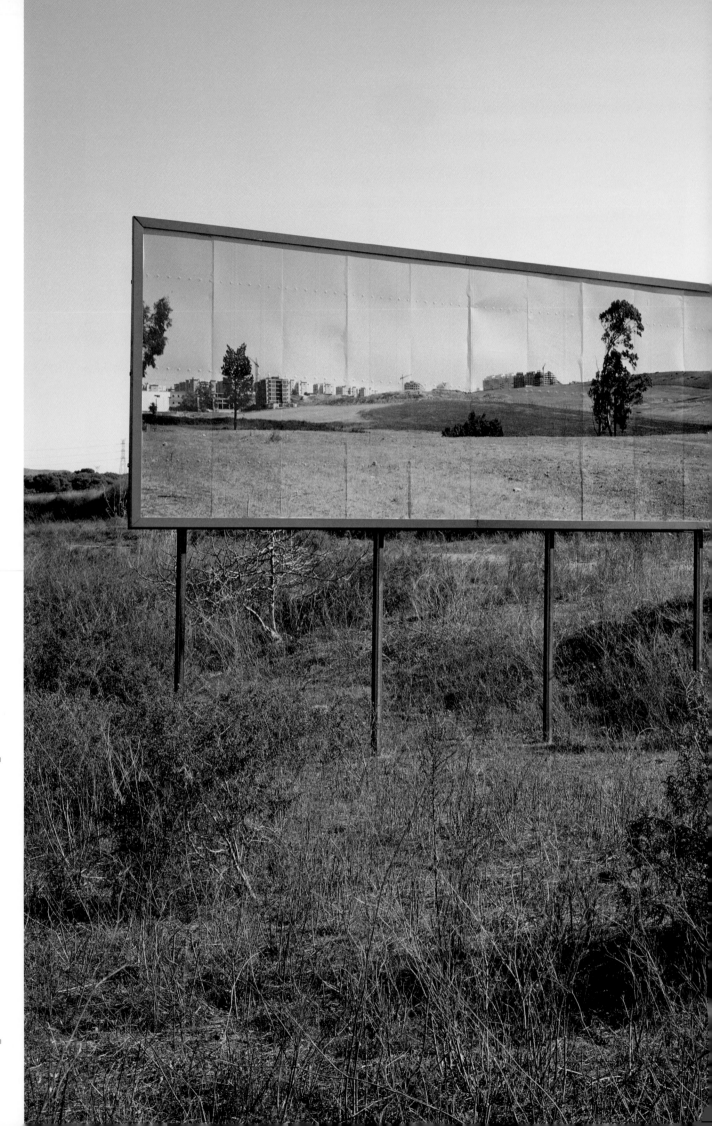

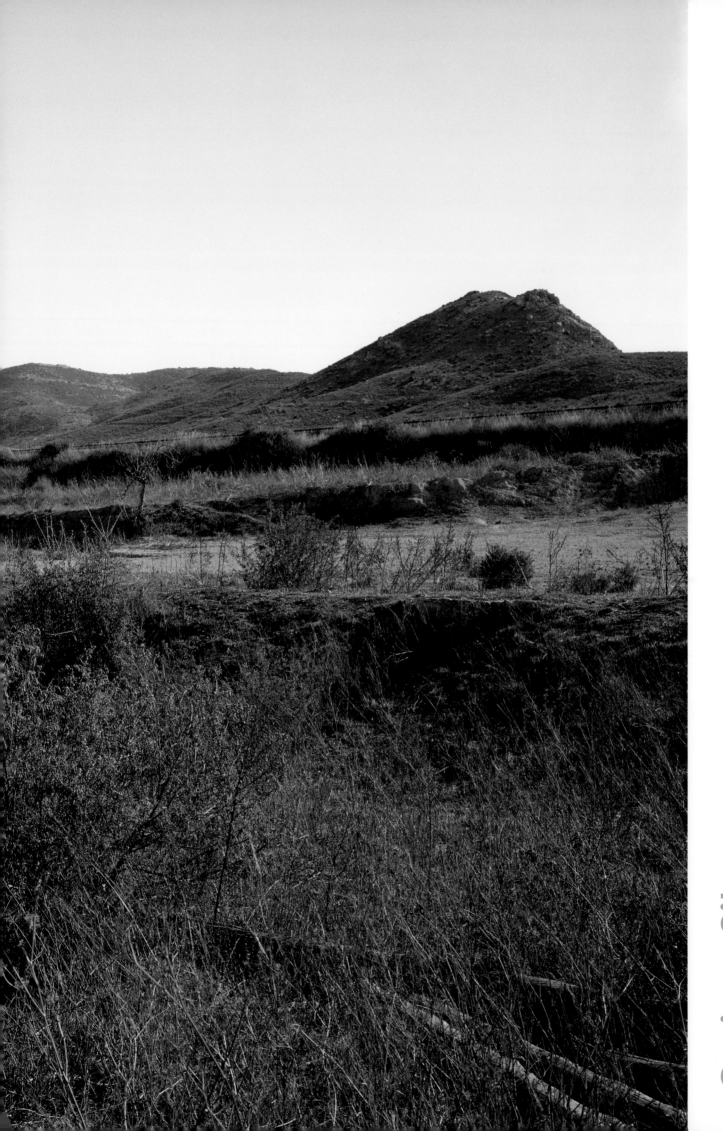

Corinne Silva

No contact.
No reaction.

ZURICH FINANCIAL
Mythenquai 2 8022 Zürich
Swiss Market Index 4.33% Financials no 2
Mercredi 18 avril 2012 10:45-11:20

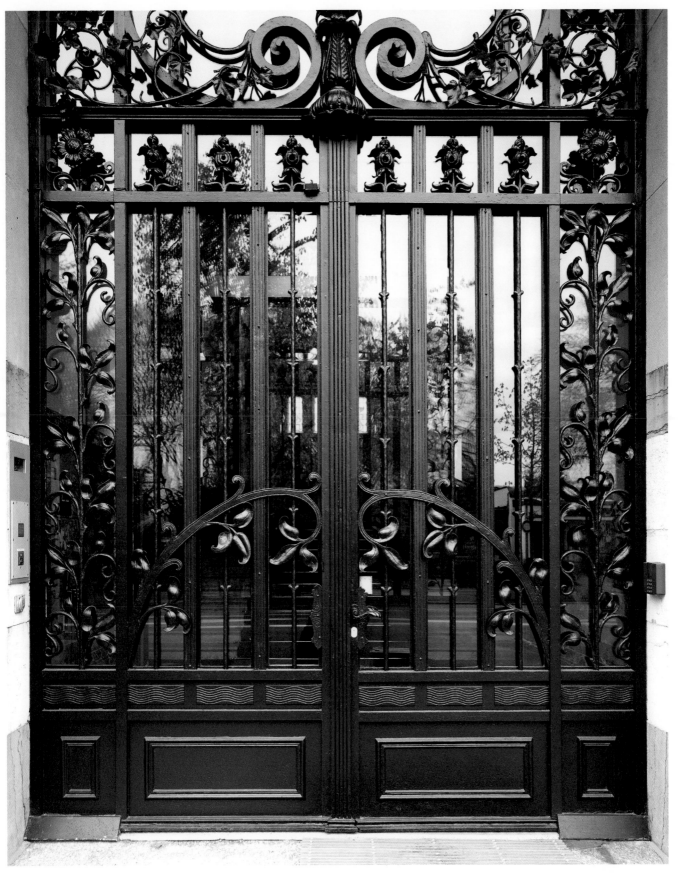

Giacomo Bianchetti

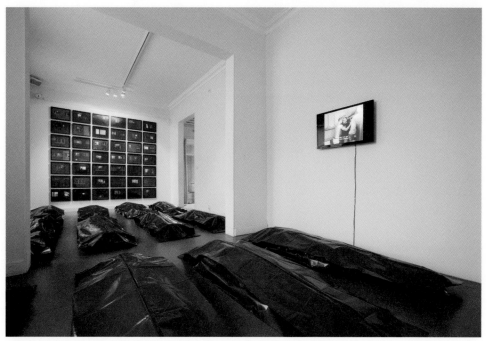
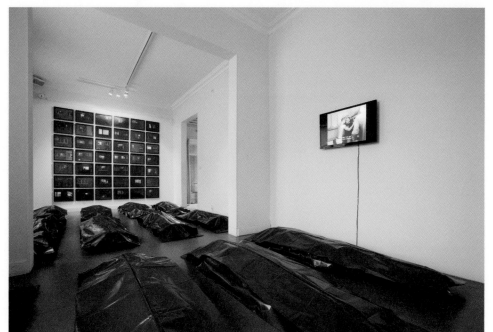

Karel Koplimets

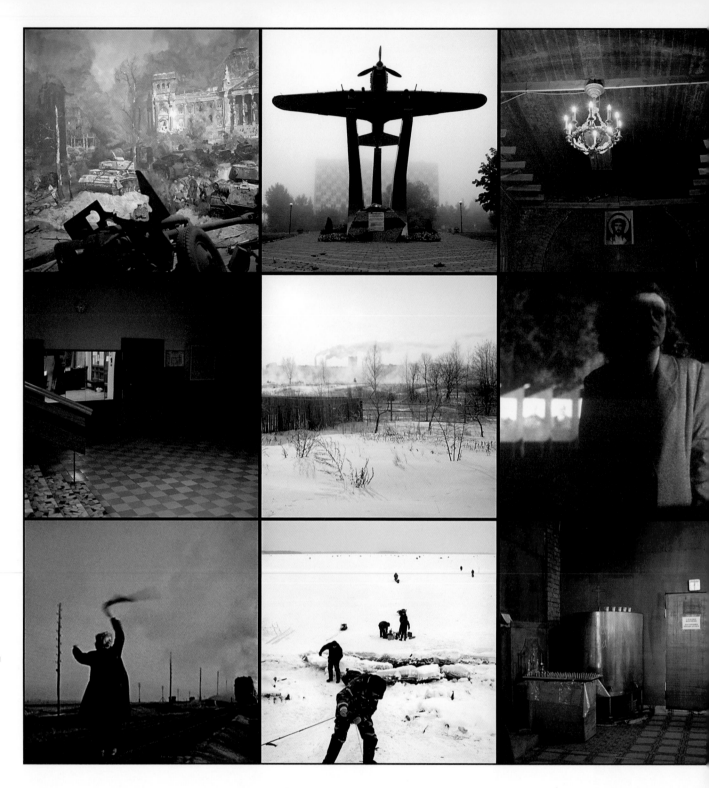

Ulrike Schmitz

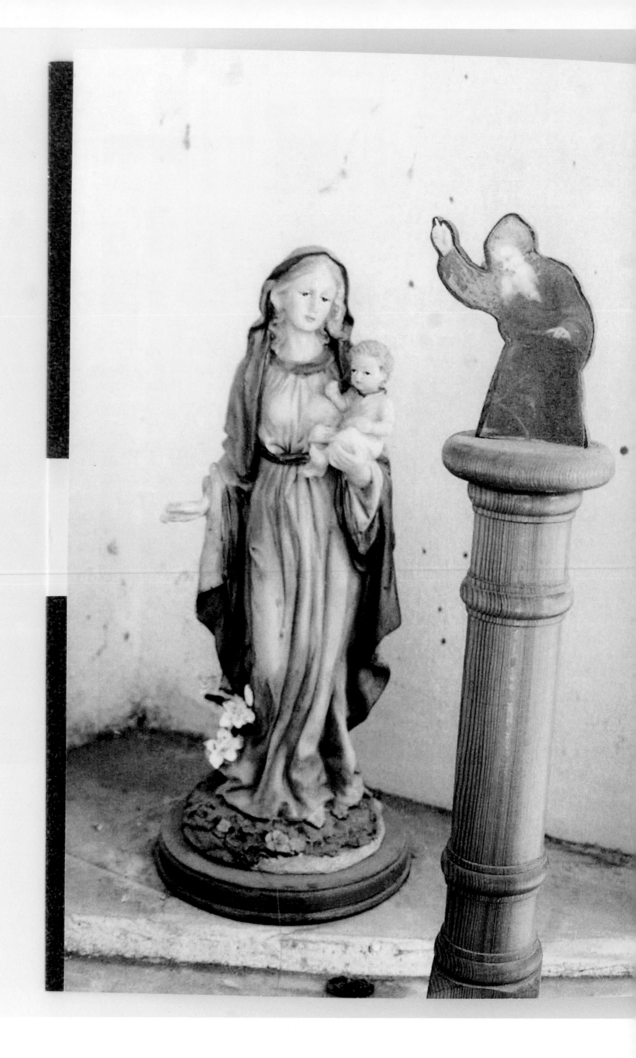

Hussam, trentenaire charismatique, fait partie des figures locales. Il gère, avec sa femme, le magasin qui ravitaille le camp et dirige un chantier pour la construction d'une dizaine de petites maisons en terre à la lisère du baraquement. Très apprécié, Hussam est en permanence entouré. Or, il tient à nous parler seul, ce qu'il a à raconter est difficile.

Nous partons nous promener pour être plus isolés. Le soleil se couche sur les champs de blé. Hussam, devant ce spectacle, précise qu'il est un homme de la campagne et que les gens de la campagne ont forcément une belle âme. Dans sa région, la campagne de Qoussair, la nature est belle et abondante, les gens vivent en harmonie. Ismaélites, Sunnites, Alaouites, on ne se demande pas sa religion.

Cette veste qu'Hussam porte aujourd'hui, c'est un souvenir important. Beau même, dit-il.

Chez lui, les hivers sont rudes. Au début de la révolution, pour affronter le froid lors des manifestations pacifiques, tous les hommes du village d'Hussam ont passé une commande groupée - plus simple et moins onéreux - pour acheter le même blouson. Ensemble, ils se sont organisés pour les trajets et sont tous allés manifester à Qoussaïr.

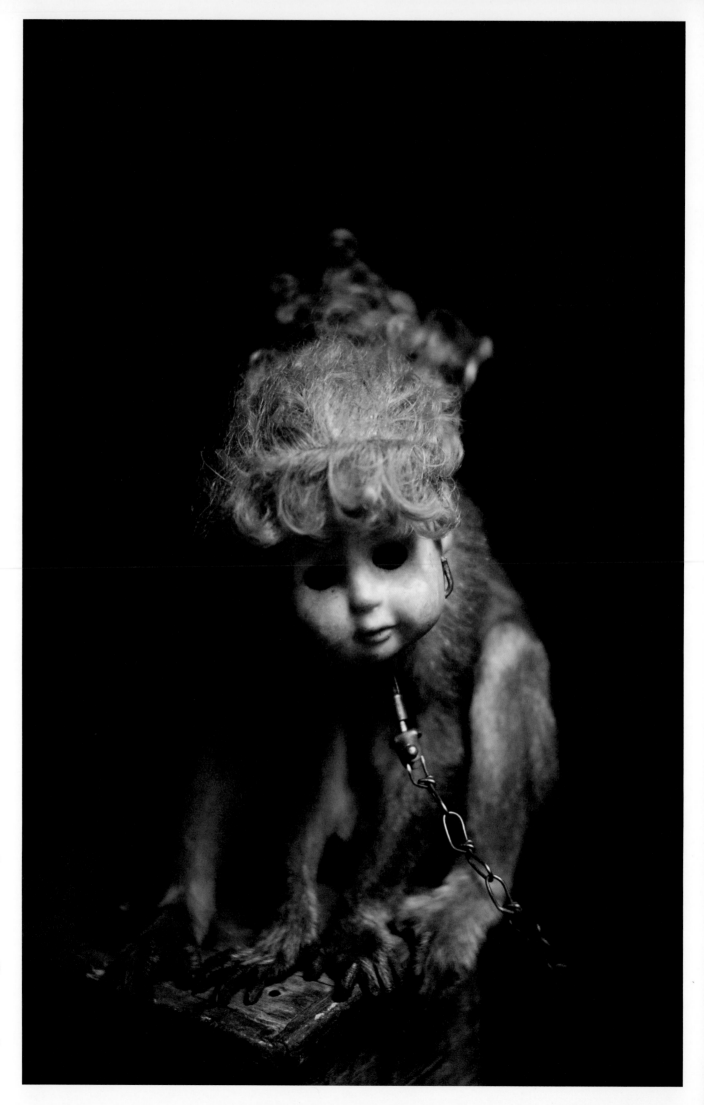

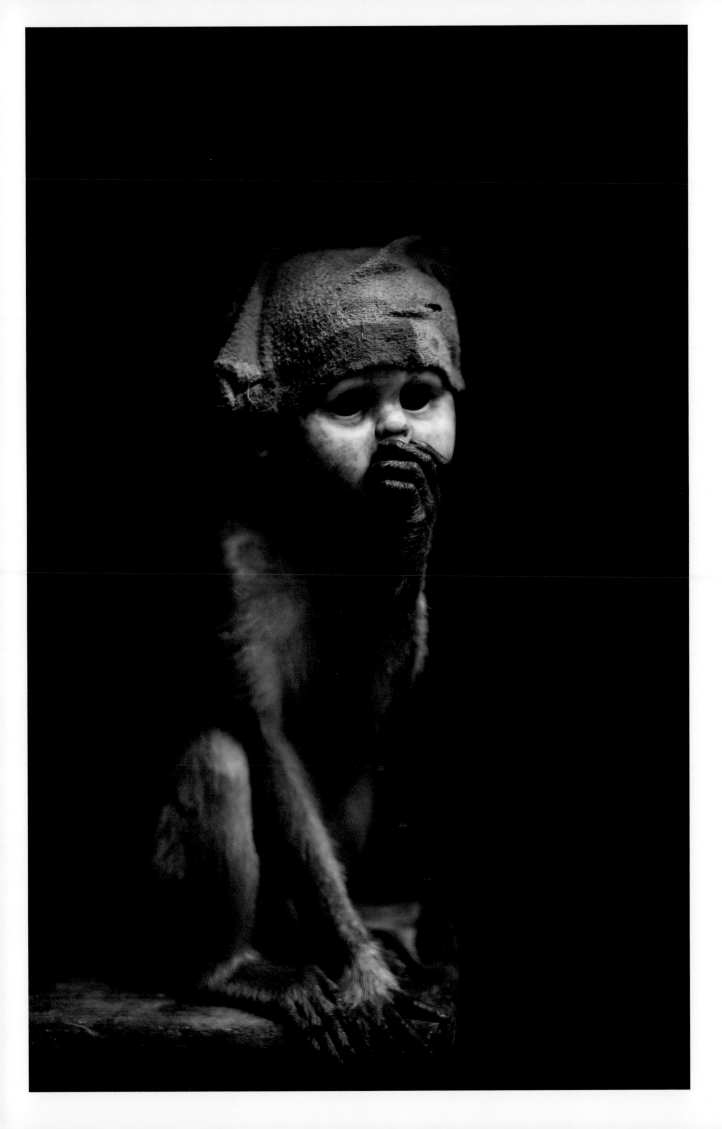

Artur Gutowski

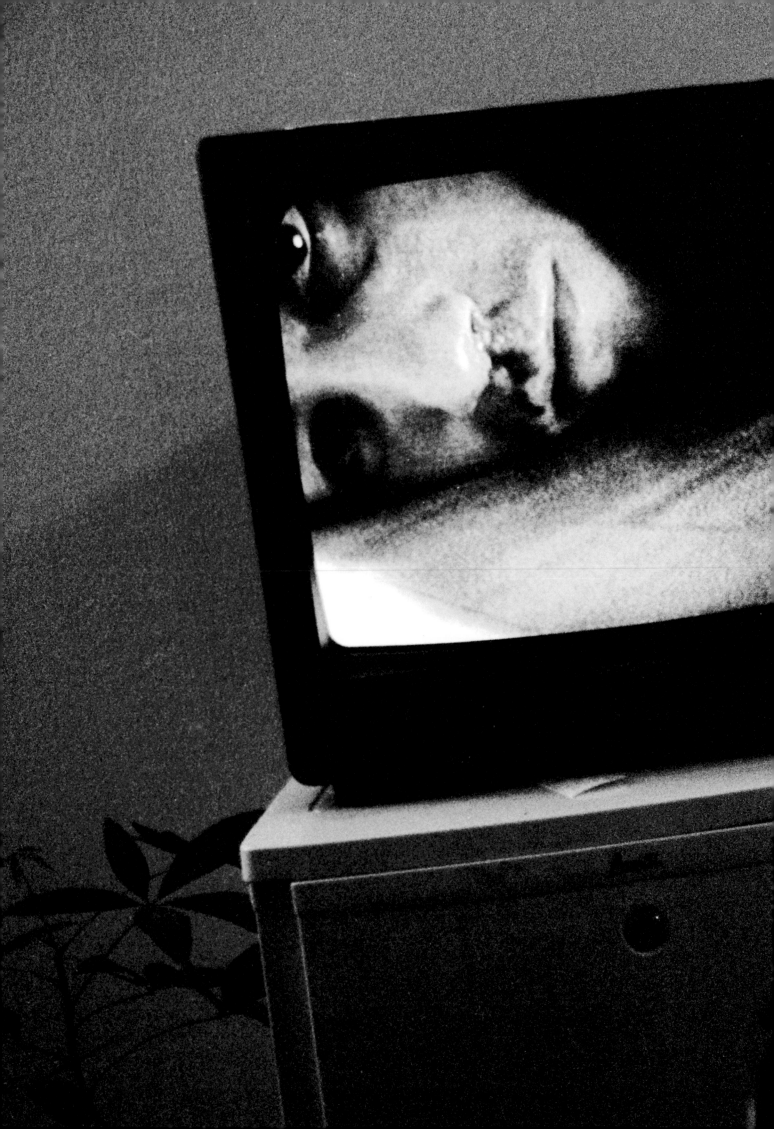

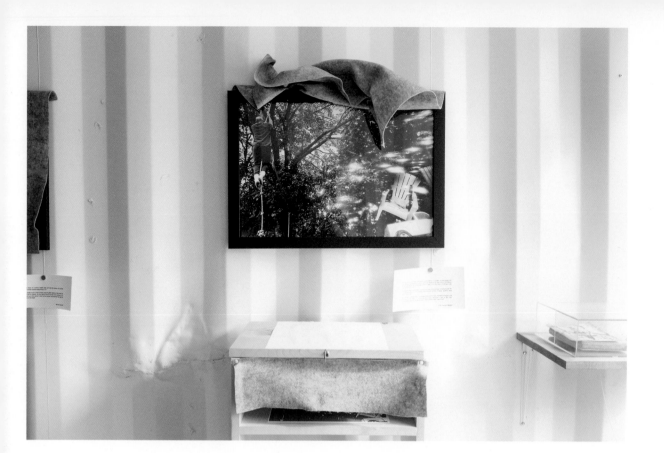

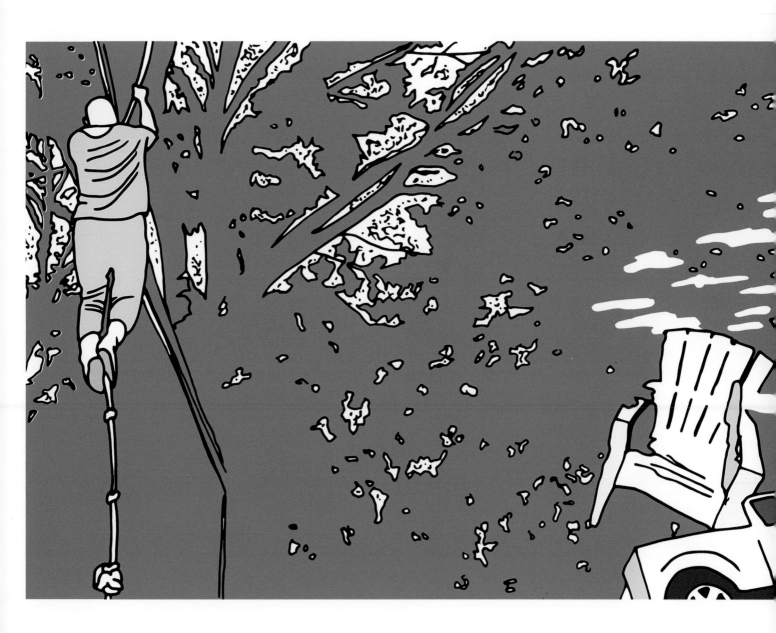

Name: Anthony

Age: 44

Location: Kilmarnock

Age of abuse: 8 years old

Abused by: Marist Brother and House Master

 at Catholic boarding school

"On one occasion he put his hand over my face while he touched me saying to me 'I saved your life, you could have died, you should be grateful'. He kissed me and used his tongue in my ear and I remember the strong smell of coffee on his breath. He would stay for a short period while he abused me and then move on to another bed."

Name: Patrick

Age: 53

Location: Wolverhampton

Age of abuse: 6 - 13 years old

Abused by: Staff at children's home, Catholic priest

"They showed me what to do, they gave me the pleasure of it and that's what hurts me so much because it sexualized me

and it shouldn't have done."

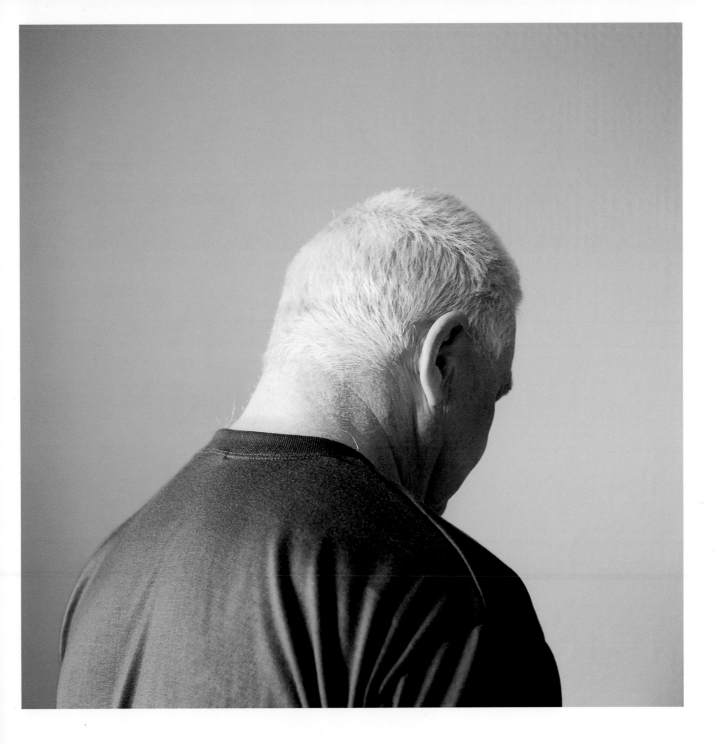

Name:	Mark
Age:	64
Location:	Fife
Age of abuse:	8 - 13 years old
Abused by:	Mother

"My mother adored my father and when he left her she couldn't handle it. I was my father's spitting image and I guess she wanted to replace him. I was eight when she started having sex with me."

Nadine

@NadineBonheur Paris

Baronne influente. Social Media Manag
http://blogs.psychologies.com/chicologies

15,340
Tweets

630
Following

2,443
Followers

91
Listed

 @humourdedroite L'Humour de Droite
Hey, did you see the photo of us ? followingme.fr
Dec 14

 @humourdedroite L'Humour de Droite
Take a look at those white socks ! It's true that they look a little centrist #FAIL
Dec 14

 @soymalau Baptiste Fluzin
I was expecting some comments but those about my sweater really upset me. Tweeters are a tough bunch.
Dec 14

 @soymalau Baptiste Fluzin
And, to think, it's my favorite sweater.
Dec 14

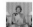 **@NadineBonheur** Nadine
@soymalau I had some about my shoes... Good luck, the worst is yet to come and the sweater is just fine.
Dec 14

 @woumpah Gautier
@NadineBonheur, @MiloozMil @jozue, @martynapawlak didn't want to eat the egg after the photo. I was a little disappointed.
Dec 14

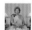 **@NadineBonheur** Nadine
@woupah, Did you bother to heat it up before asking her if she wanted it ? cc @MiloozMil @jozue @martynapawlak
Dec 14

 @woumpah Gautier
@NadineBonheur, No, and it had been in the fridge for a good hour. I feel so guilty. @MiloozMil @jozue @martynapawlak.
Dec 14

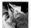 **@jesuisunblog** Renato
Thanks to this series of photos, I got to make some digital inroads with @NadineBonheur. Long live artistico-digital initiatives.
Dec 14

 @NadineBonheur Nadine
@jesuisunblog Kiss.
Dec 14

 @jok Thomas B
Quite a big male following, after the followingme.fr project, so I'm asking myself some questions about the future of my sexuality.
Dec 14

 @Purdey2000 Jessica Daubertes
There are five skulls on our photo. TOO DARK.
Mar 14

 @mr_monsieur Monsieur Monsieur
@purdey2000 5? I SEE NINE SKULLS AND A DEATH'S HEAD.
Mar 14

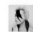 **@Purdey2000** Jessica Daubertes
@mr_monsieur shit
Mar 14

 @mr_monsieur Monsieur Monsieur
It looks like my feet are dirty.
Mar 14

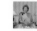 **@NadineBonheur** Nadine
@mr_monsieur @purdey2000 : Your place is nice, congratulations. XXXs.
Mar 14

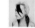 **@Purdey2000** Jessica Daubertes
@NadineBonheur Thanks ! But it sure doesn't look as clean as your place.
Mar 14

 @soymalau Baptiste Fluzin
I like the frames at @lapin_blanc followingme.fr
Mar 14

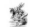 **@lapin_blanc** Lapin Blanc
@soymalau BA-SIC
Mar 14

 @mr_monsieur Monsieur Monsieur
@brloubrlou you have a very nice snake, cute.
Mar 14

 @brloubrlou Le pigeon mexicain
@mr_monsieur I return the compliment for your pretty tattoos my sweet.
Mar 14

 @brloubrlou Le pigeon mexicain
It doesn't look like it on the photo but I had washed my mattress cover the day before.
Mar 14

 @f f_f f Florent
@Cyroultwit CONGRATS FOR THE MESS IN YOUR OFFICE. REALLY, CONGRATULATIONS.
Mar 14

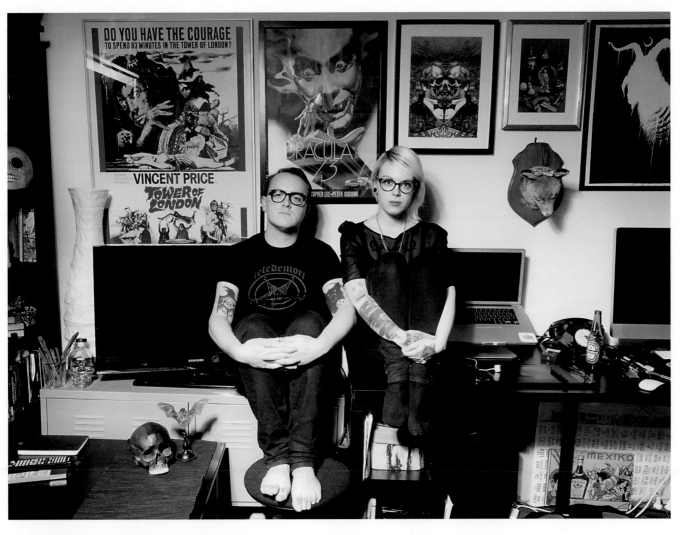

Jessica Daubertes
@purdey2000 Paris

Parfois.
http://www.fortifem.fr

9,378	**424**	**1,083**	**37**
Tweets	Following	Followers	Listed

Monsieur Monsieur
@mr_monsieur Paris, Norvège

Too Kvlt to Fuck.
http://www.fortifem.fr

18,732	**667**	**2,595**	**98**
Tweets	Following	Followers	Listed

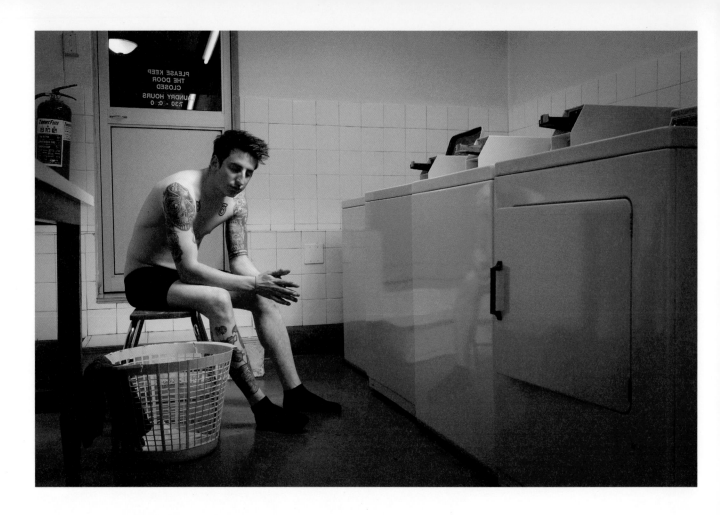

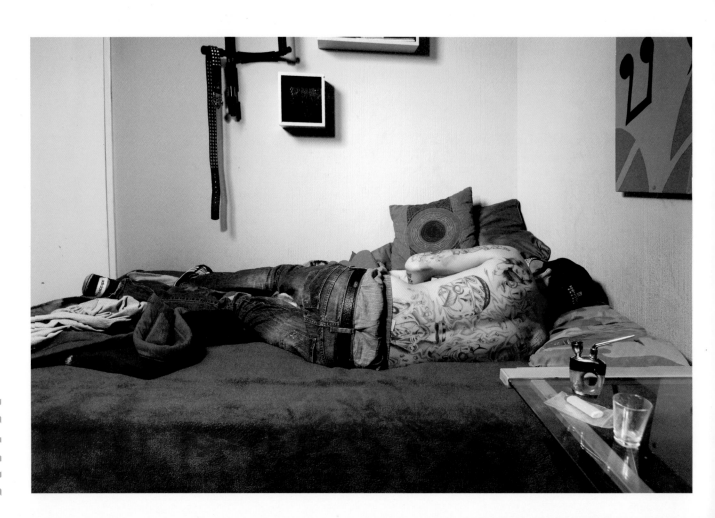

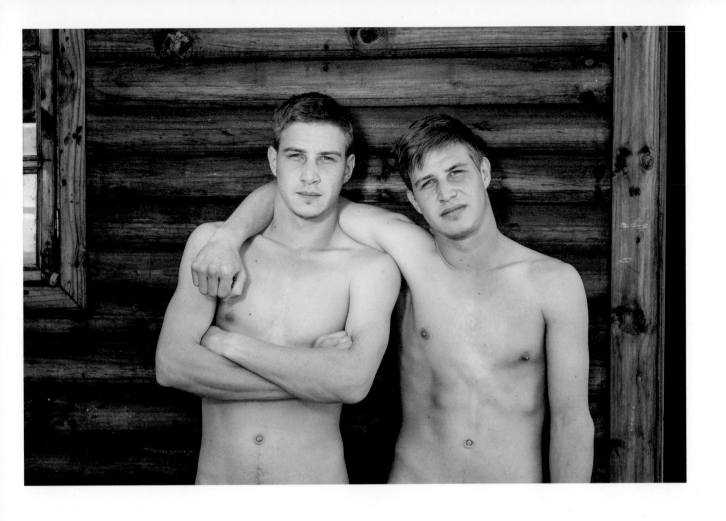

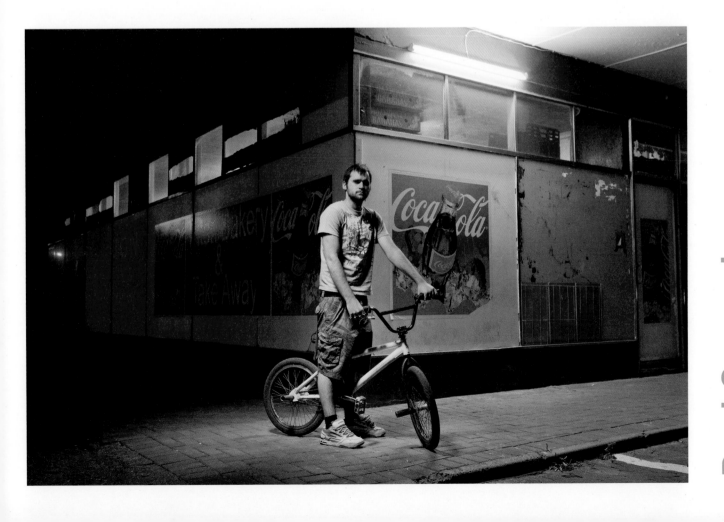

Paul Samuels

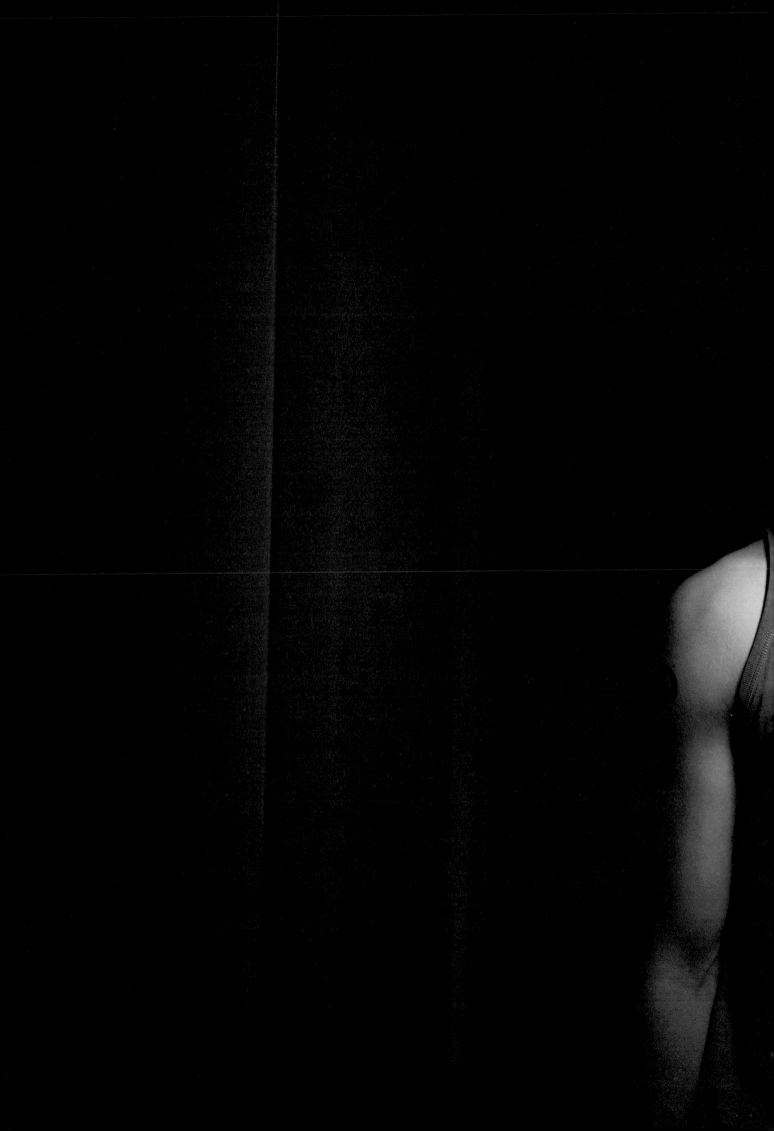

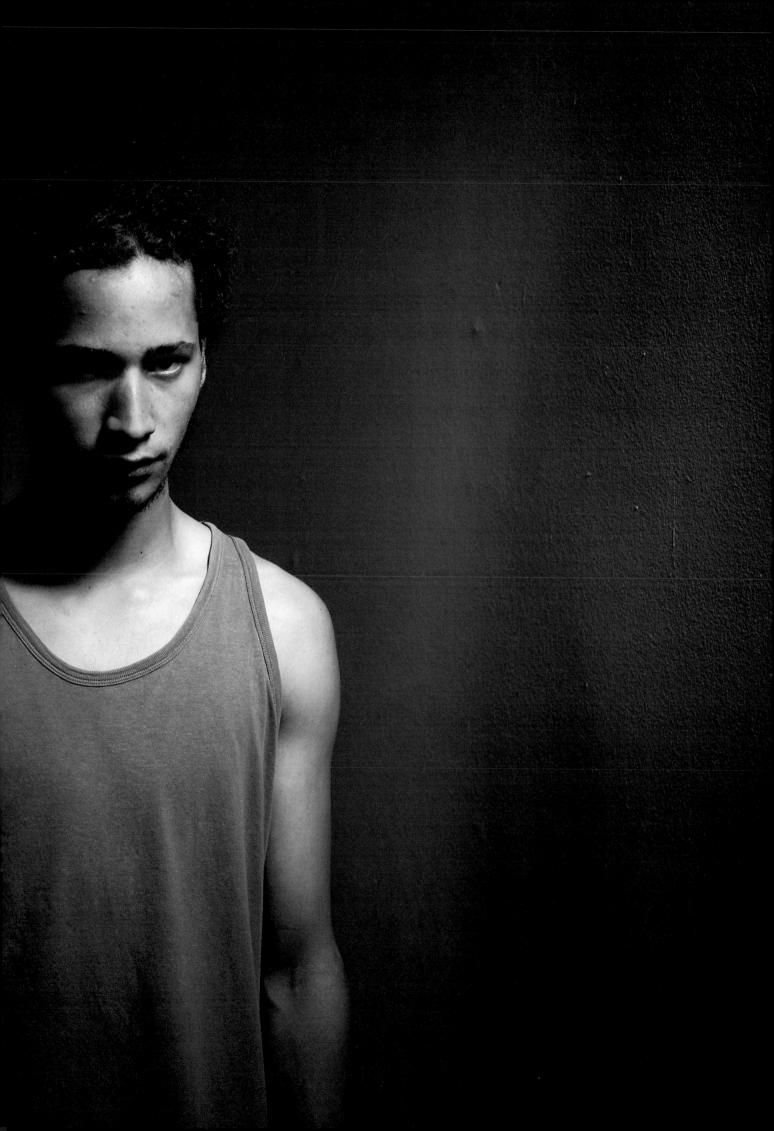

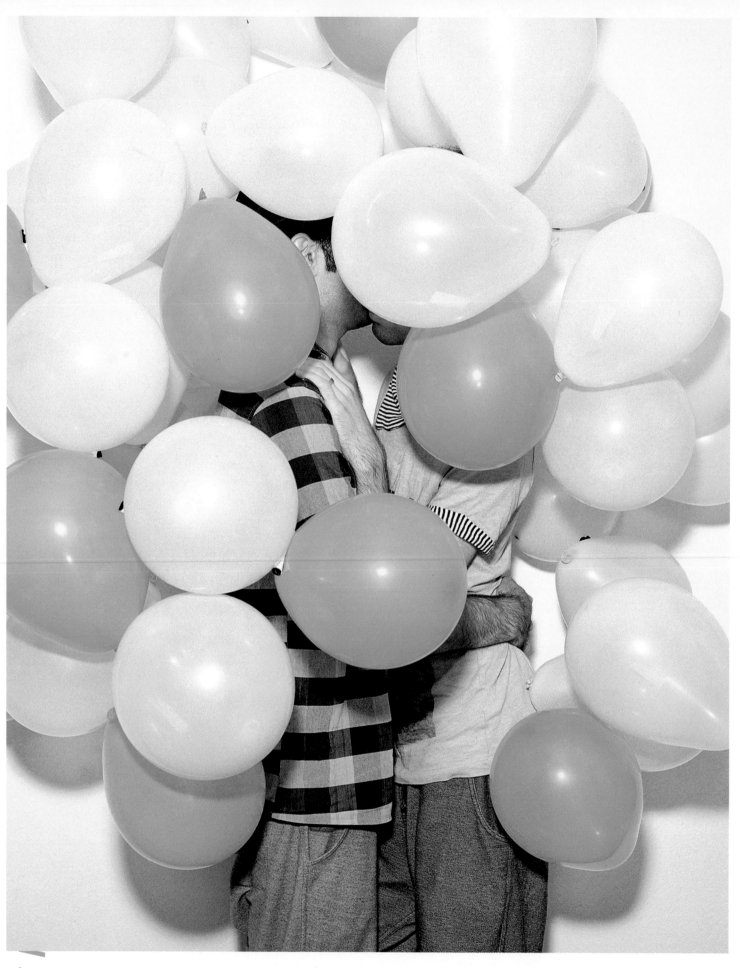

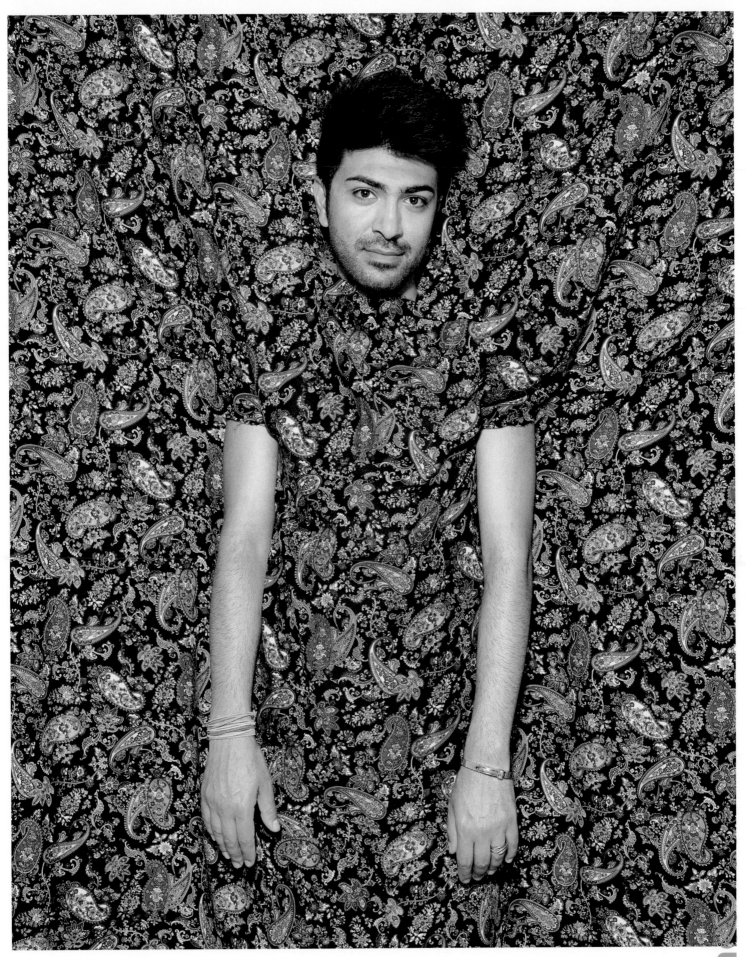

Il n'y a pas d'homosexuels en Iran

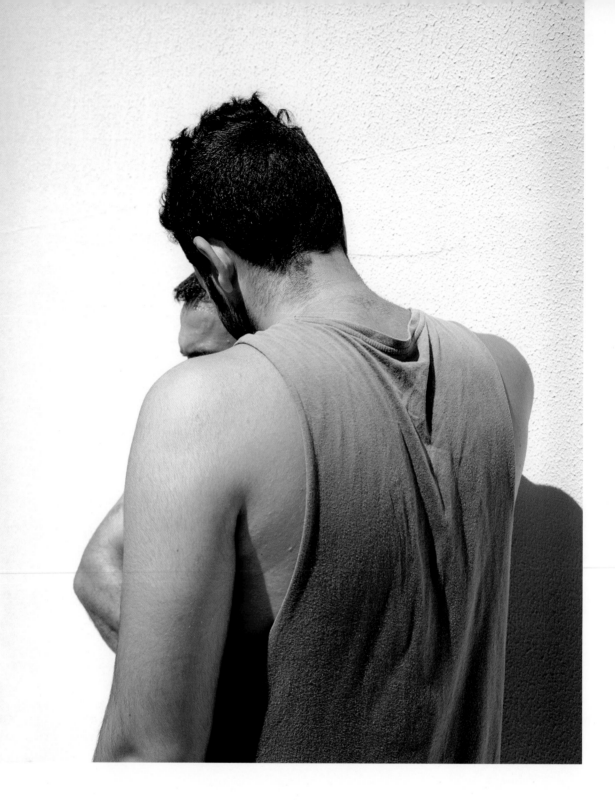

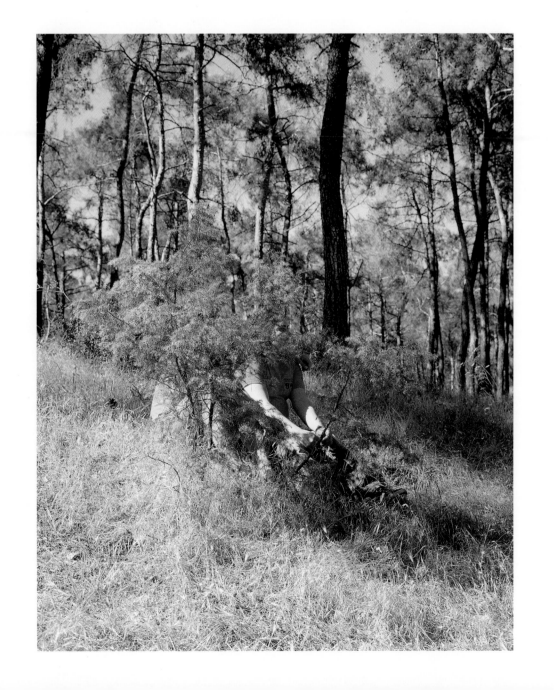

Laurence Rasti

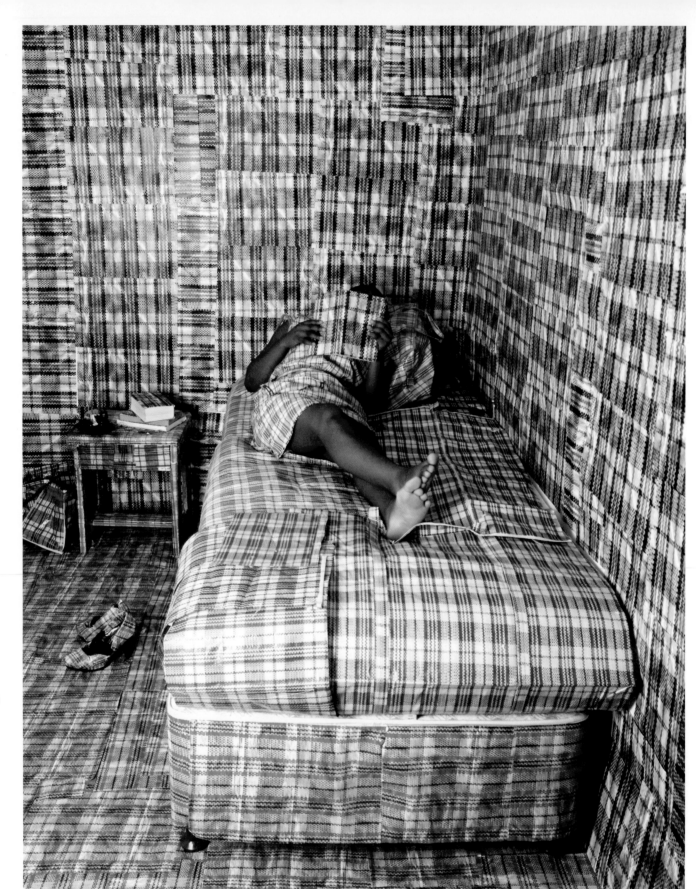

Umaskhenkethe likhaya lam

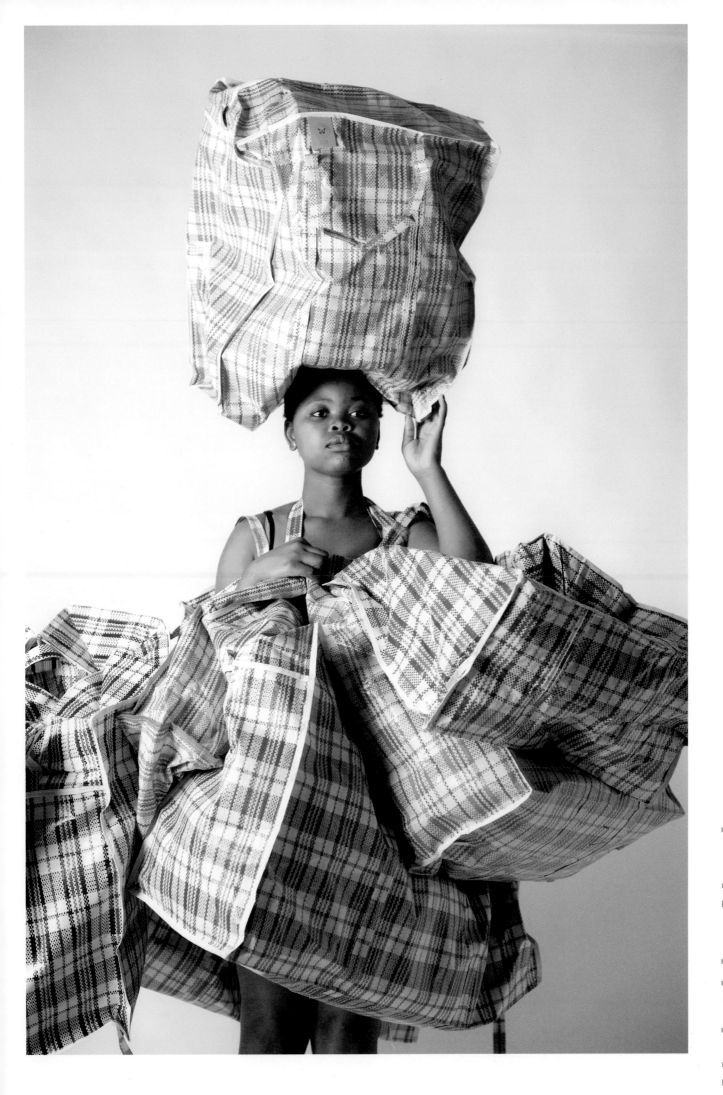

Nobukho Nqaba

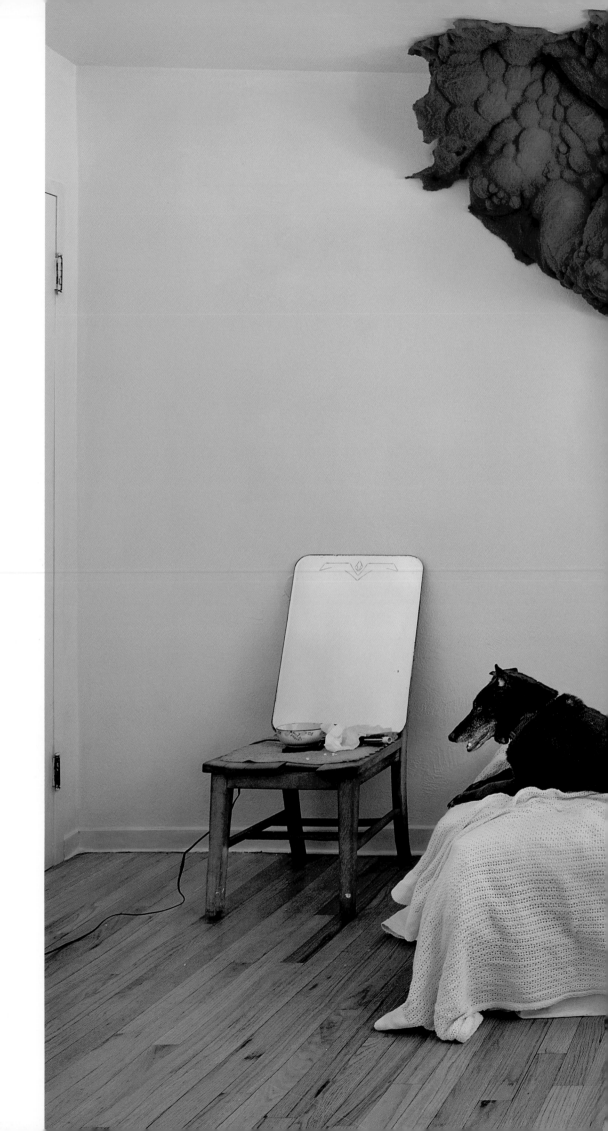

Testament

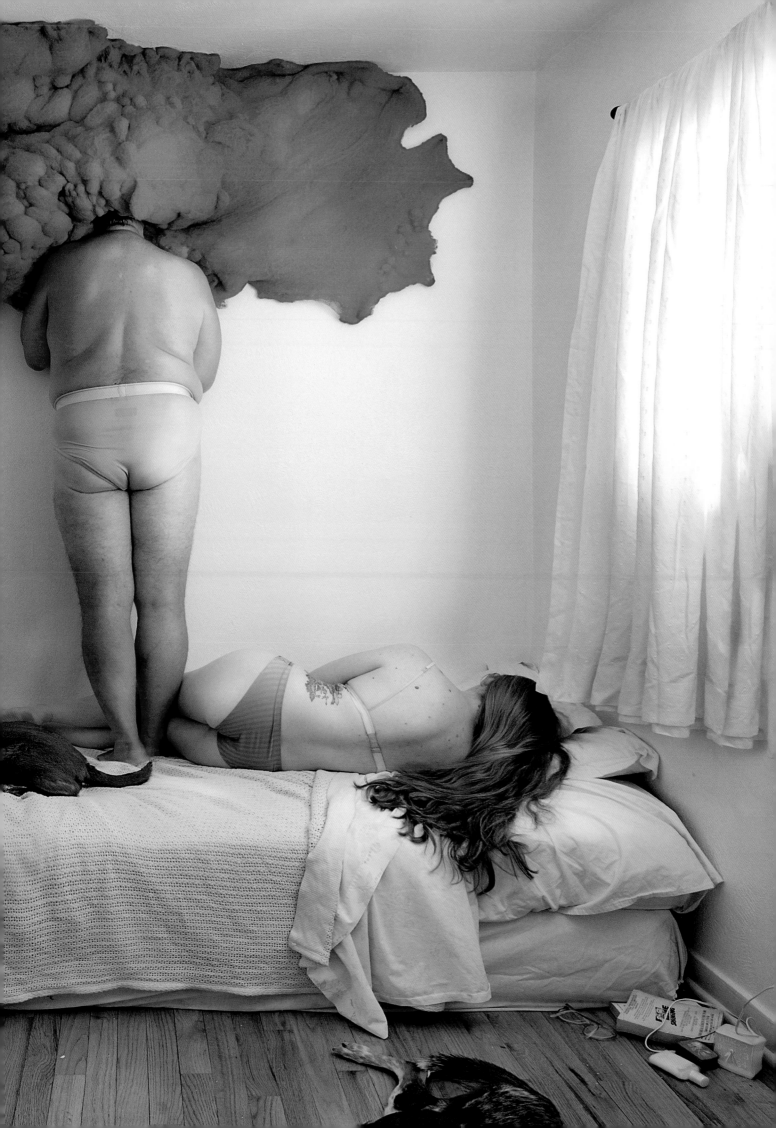

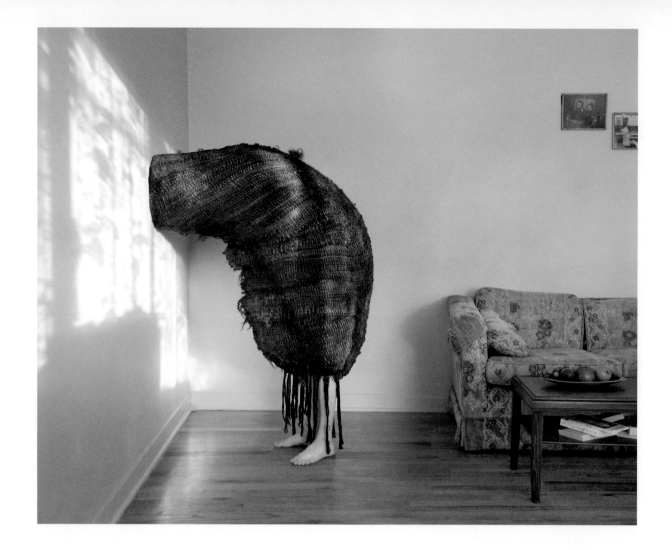

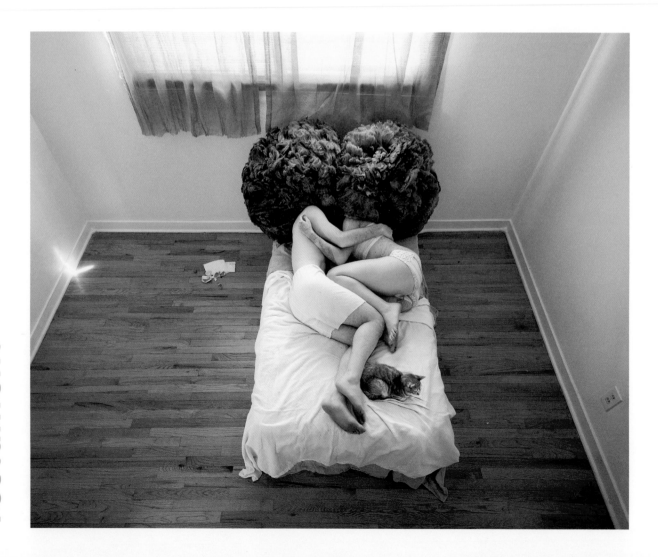

Testament

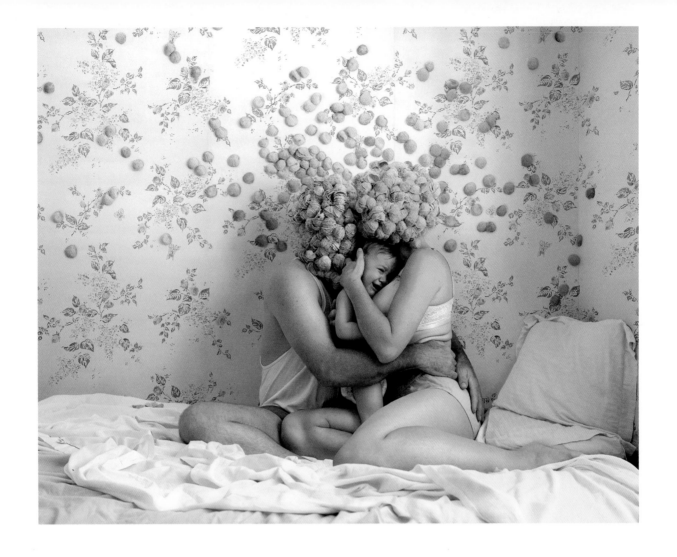

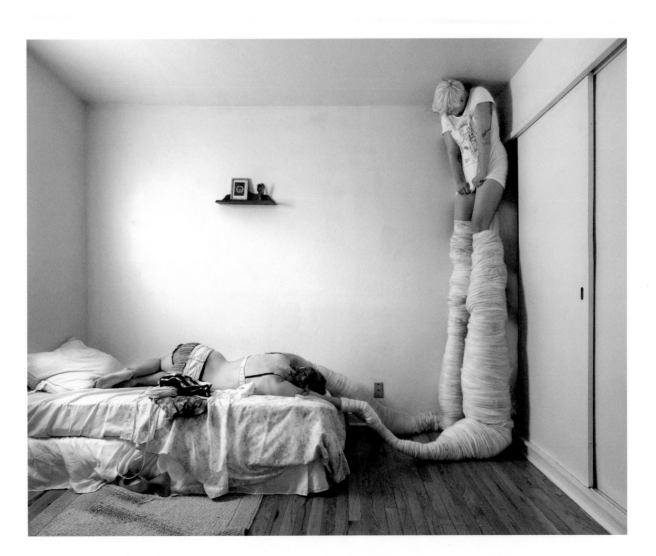

Jennifer B. Thoreson

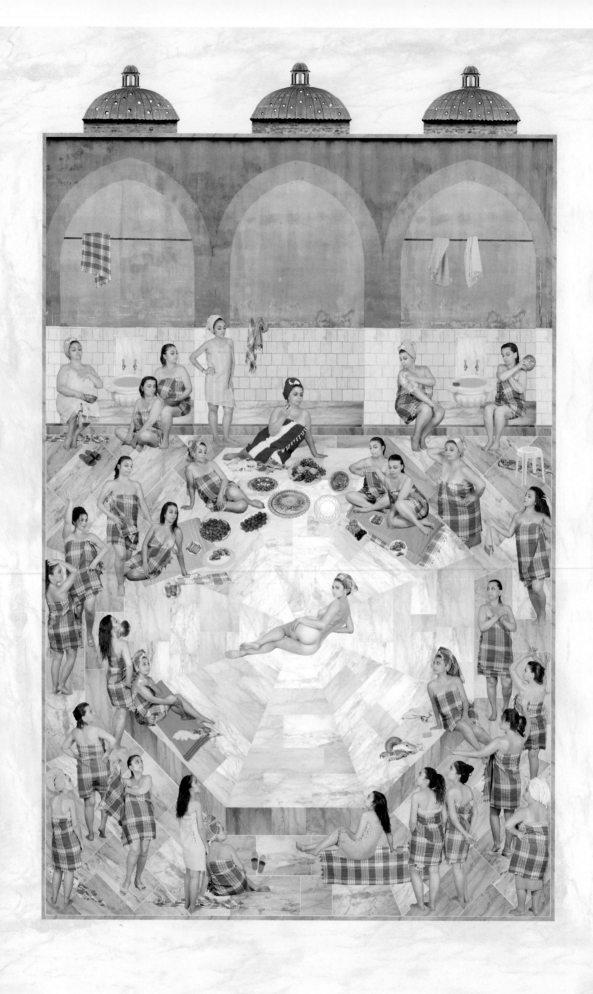

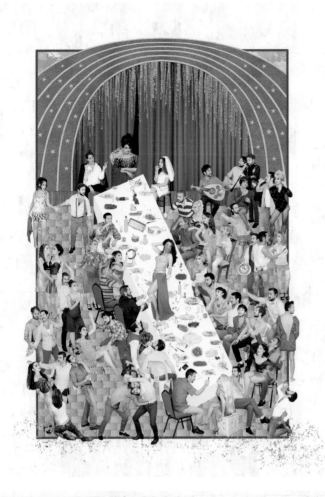

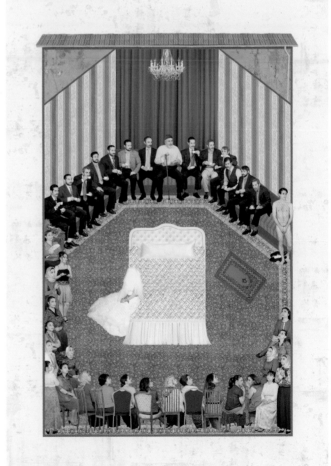

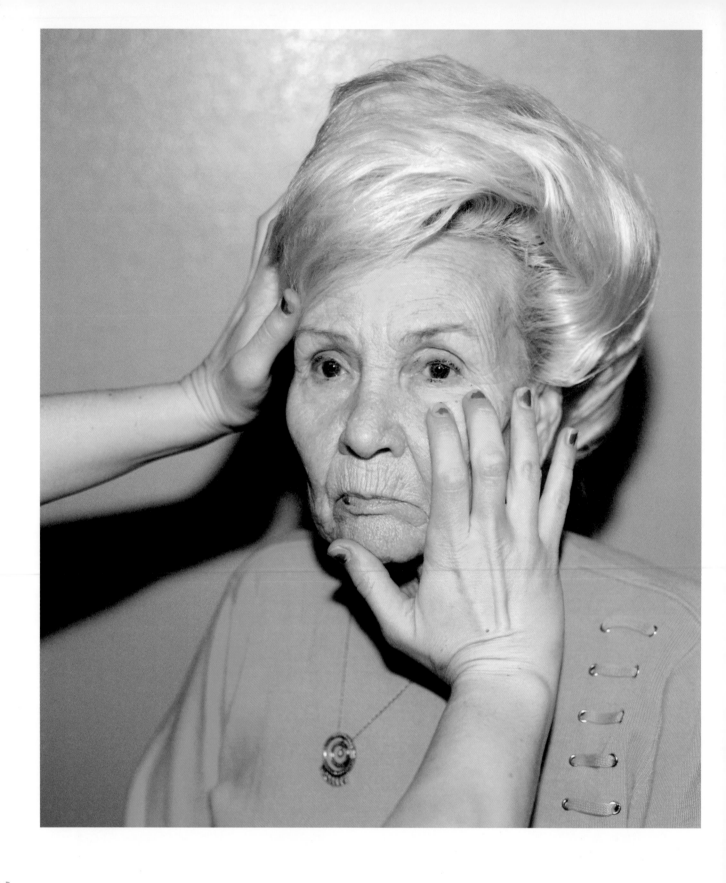

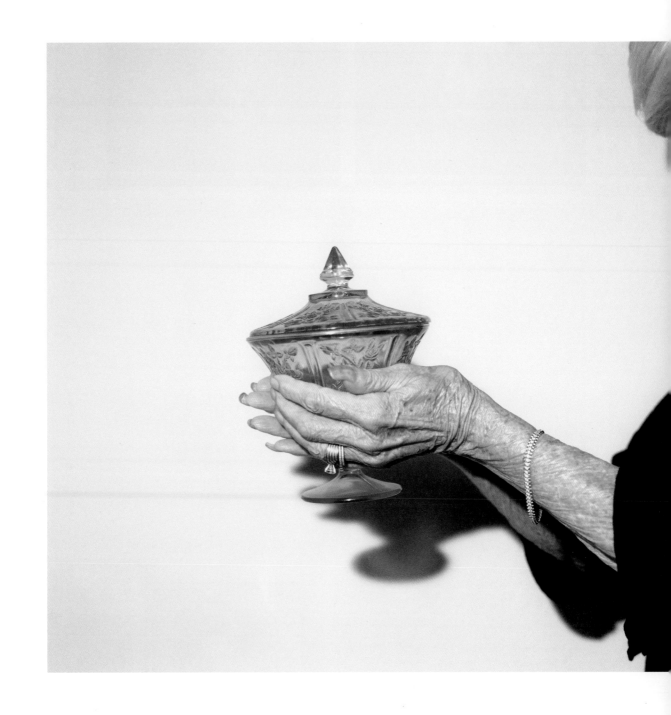

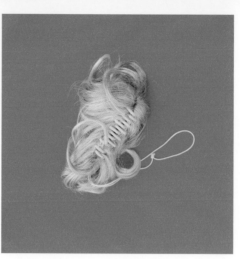

Shiny Ghost

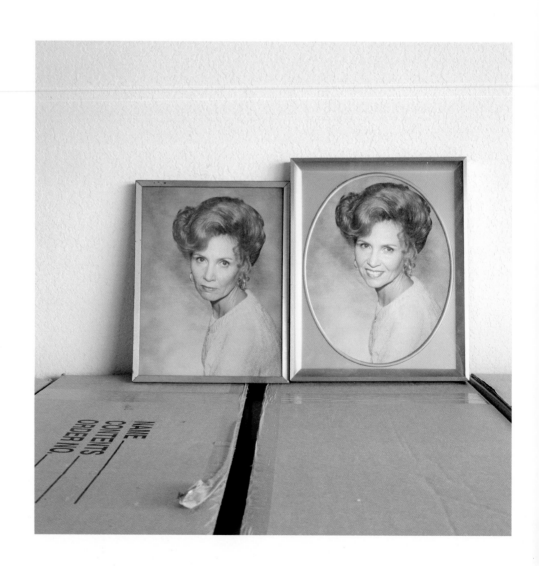

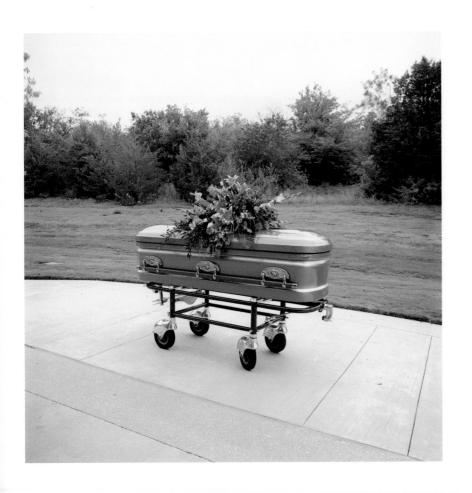

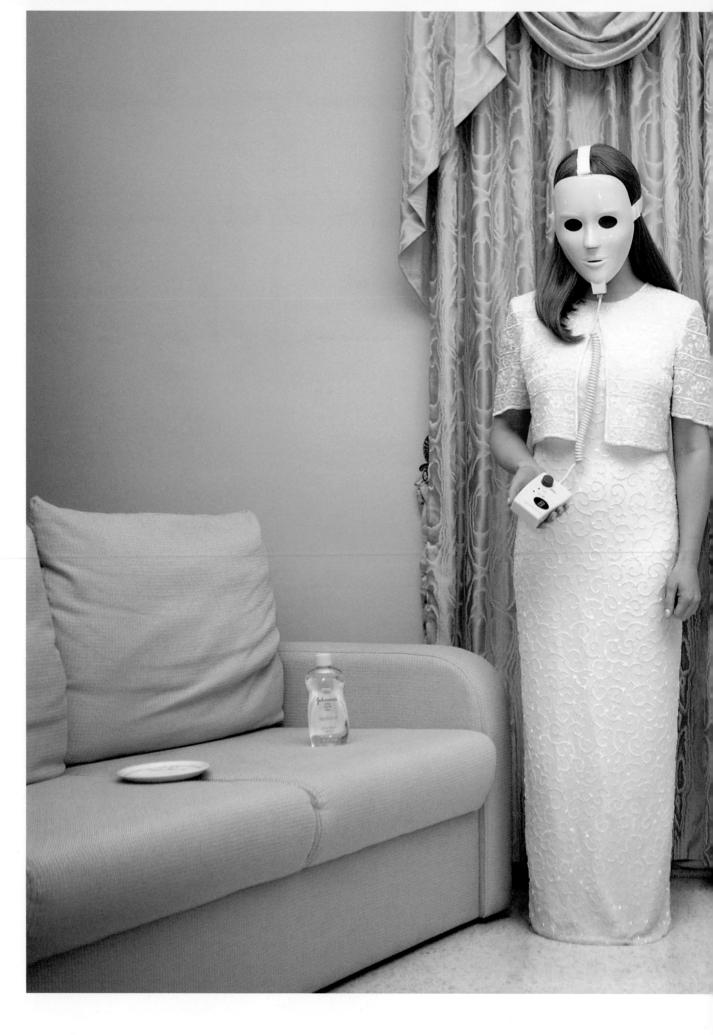

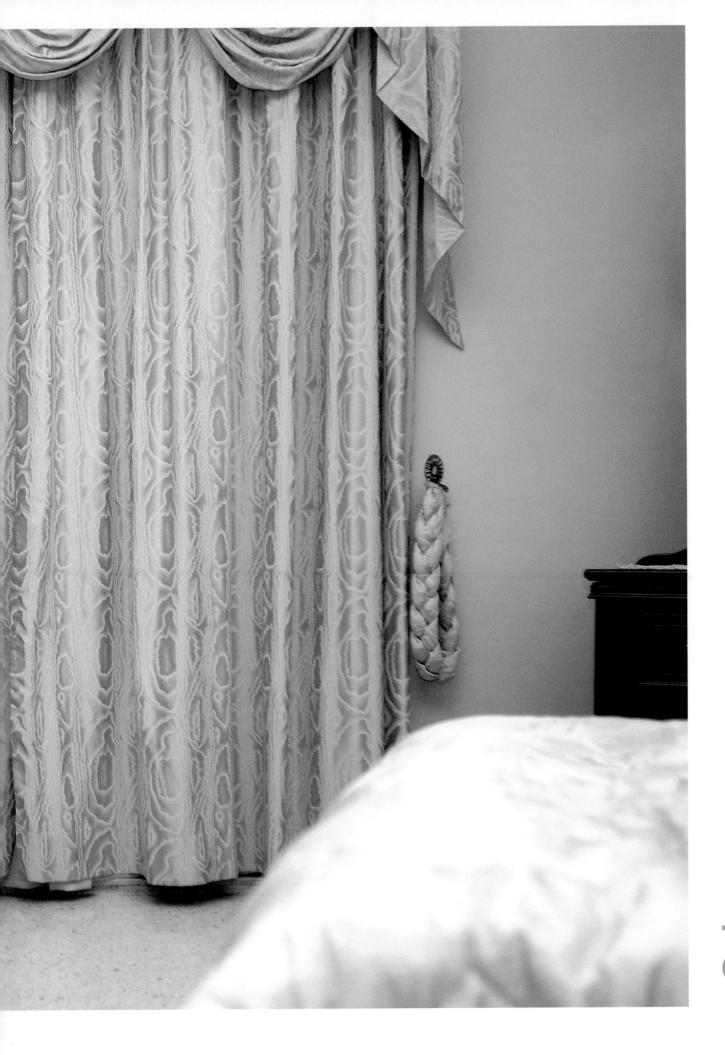

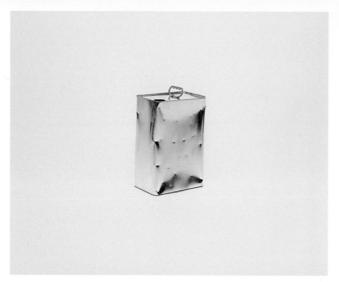

Empty space

Dinosaur skin

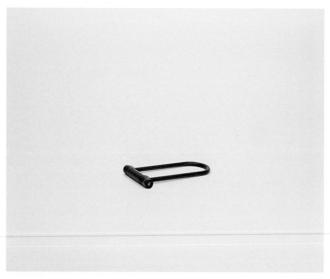

Shotgun

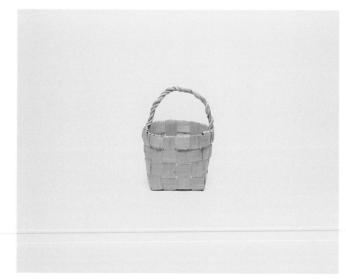

Chair

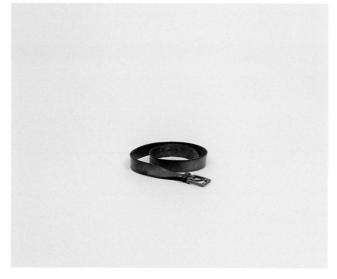

Champagne

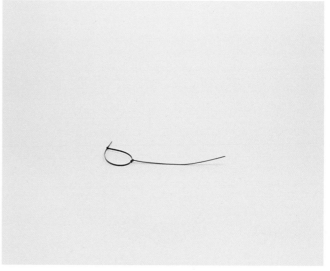

Wind

Foley Objects

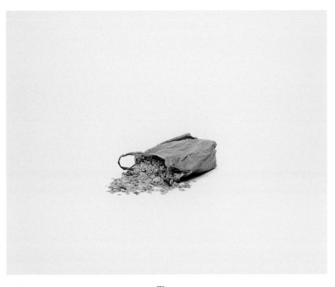

Waves

Bed

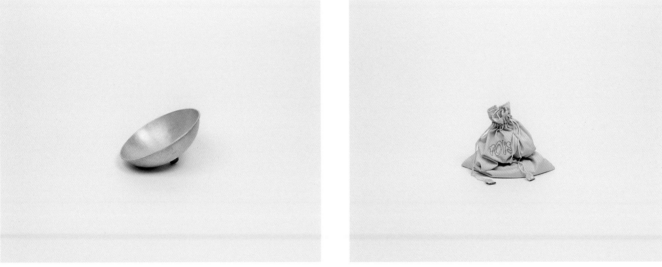

Church bell

Snow

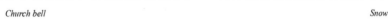

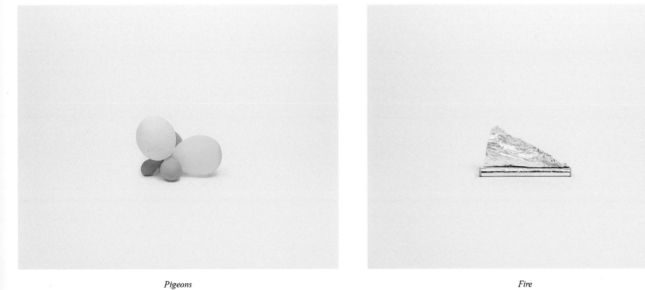

Pigeons

Fire

Foley Objects

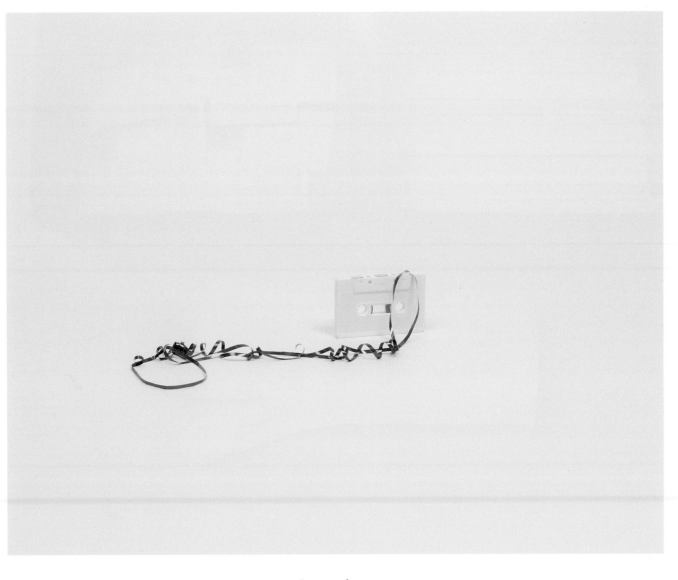

Leaves of grass

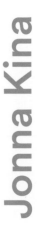

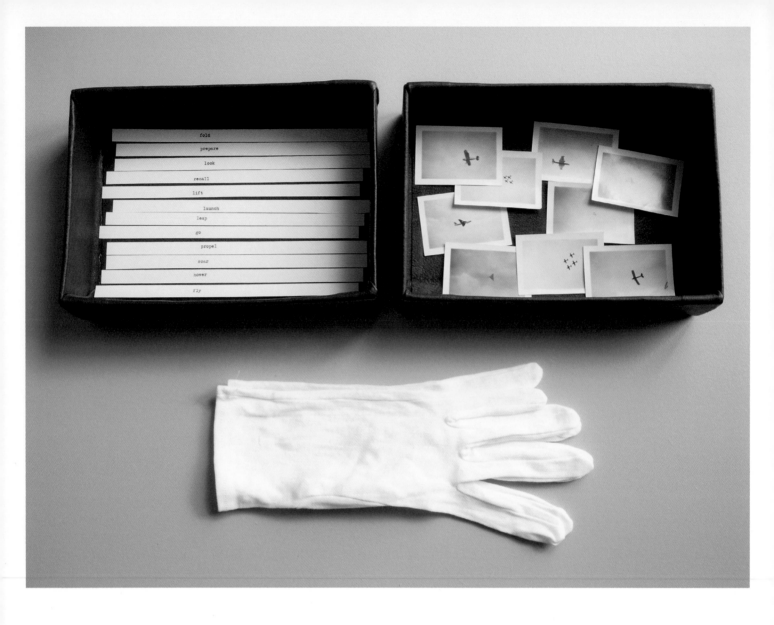

fold
prepare
look
recall
lift
launch
leap
go
propel
soar
hover
fly

Dream Collection

look

recall

lift

launch

leap

go

propel

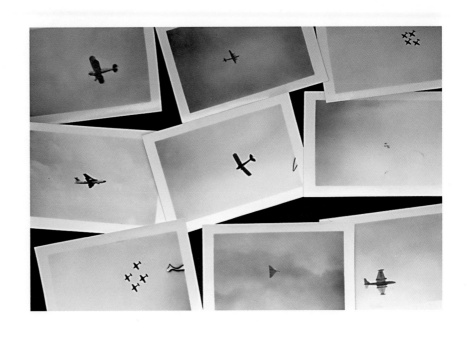

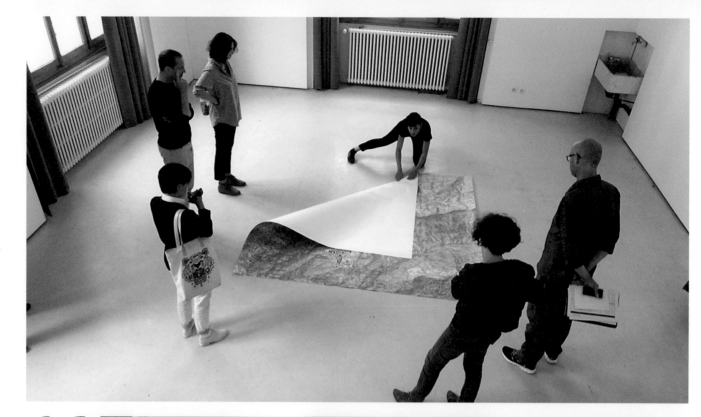

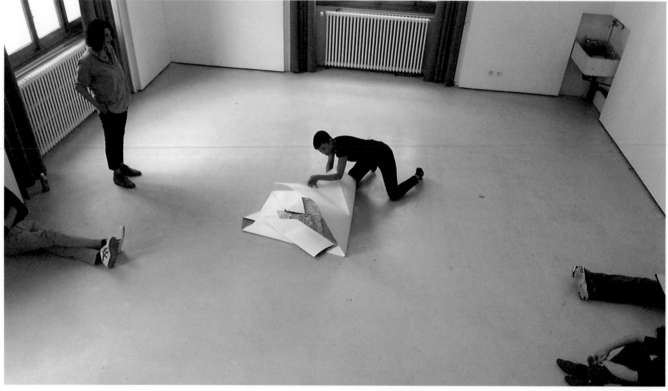

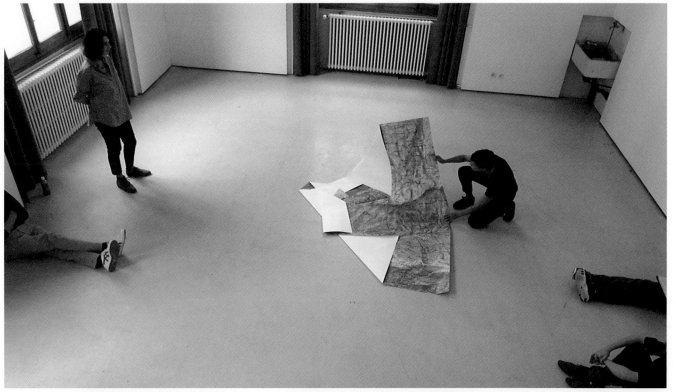

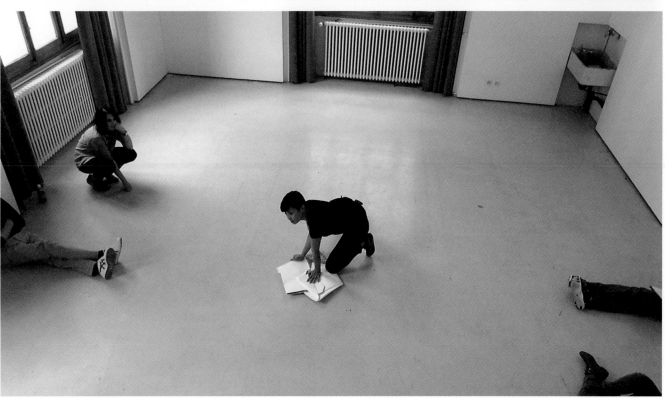

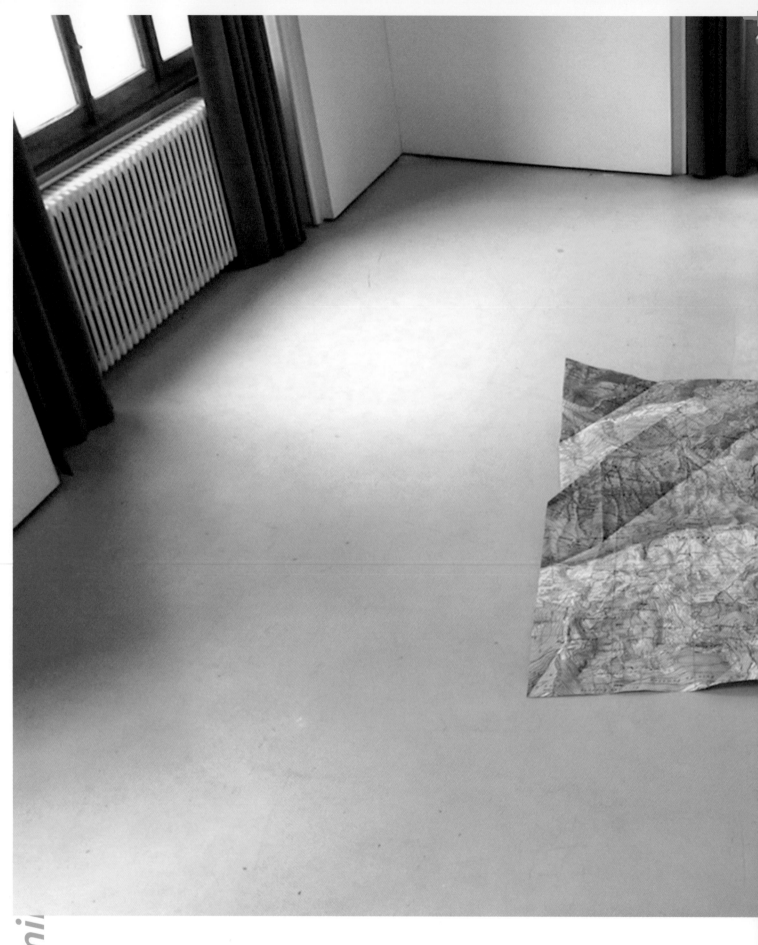

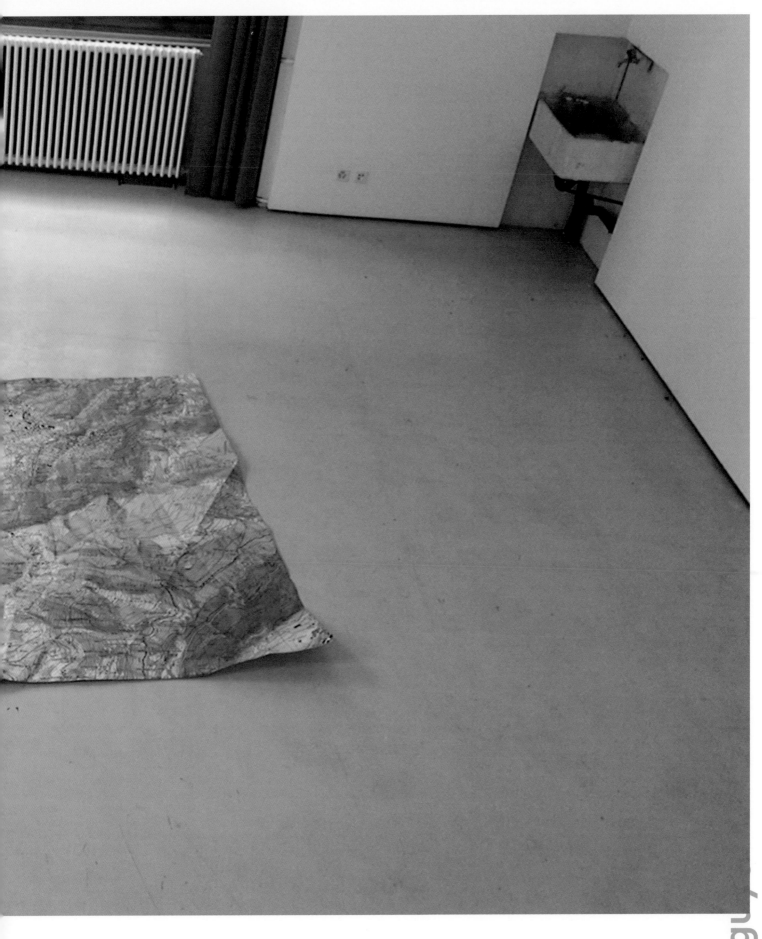

20 de noviembre de 1975

20 novembre 1975

Céline Liu

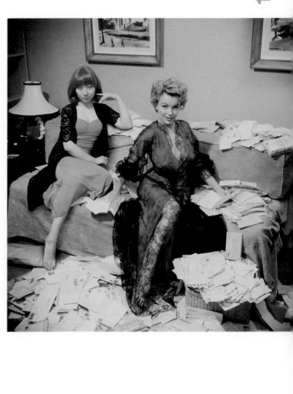

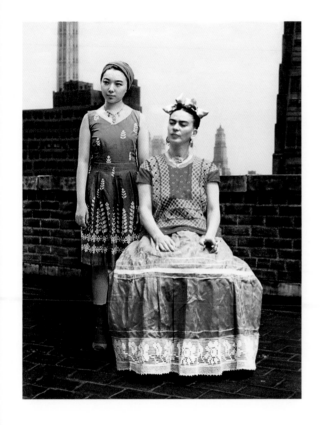

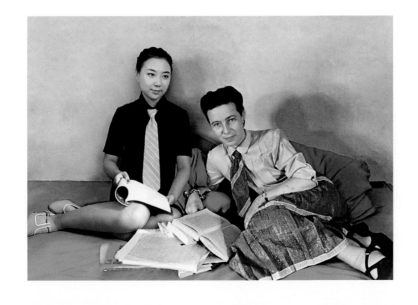

Silin Liu

A.A. (Authentic Authenticity) ⊕

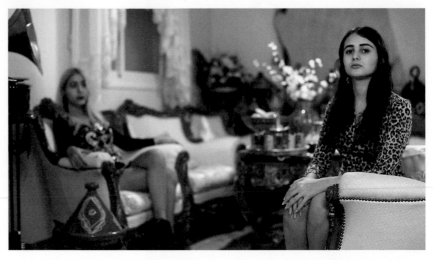

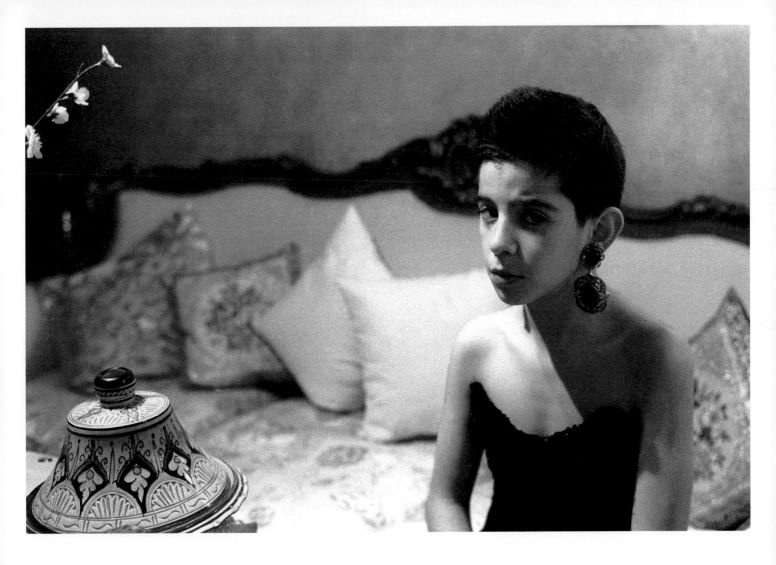

Michael Liani

Love Has to Be Reinvented ⊕

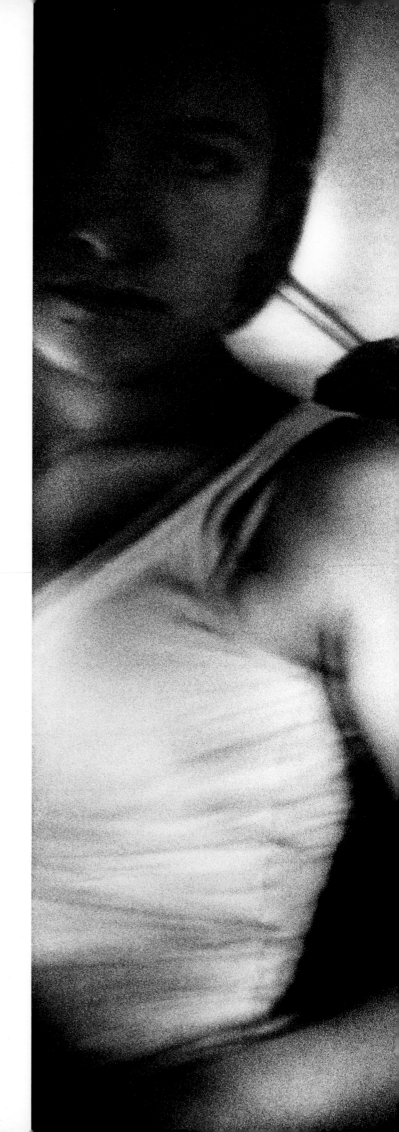

Piotr Zbierski

Love Has to Be Reinvente

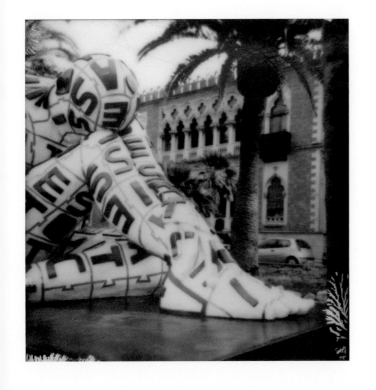

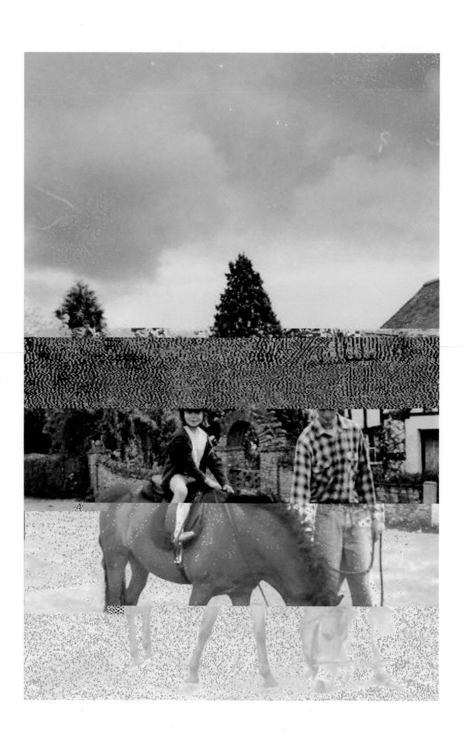

Elizabeth Hewson

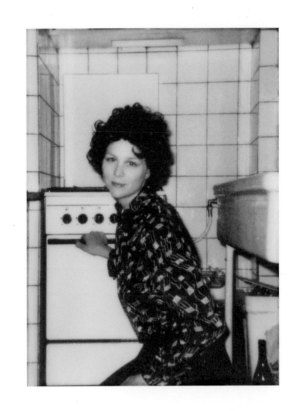

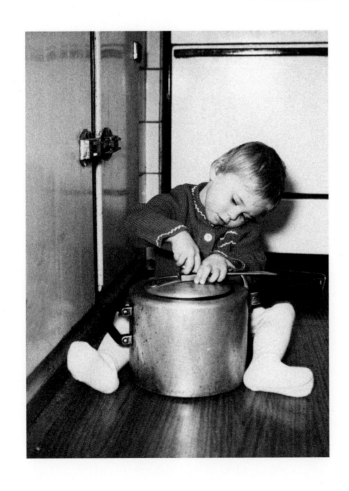

Anna Gutová & Gabriel Fragn

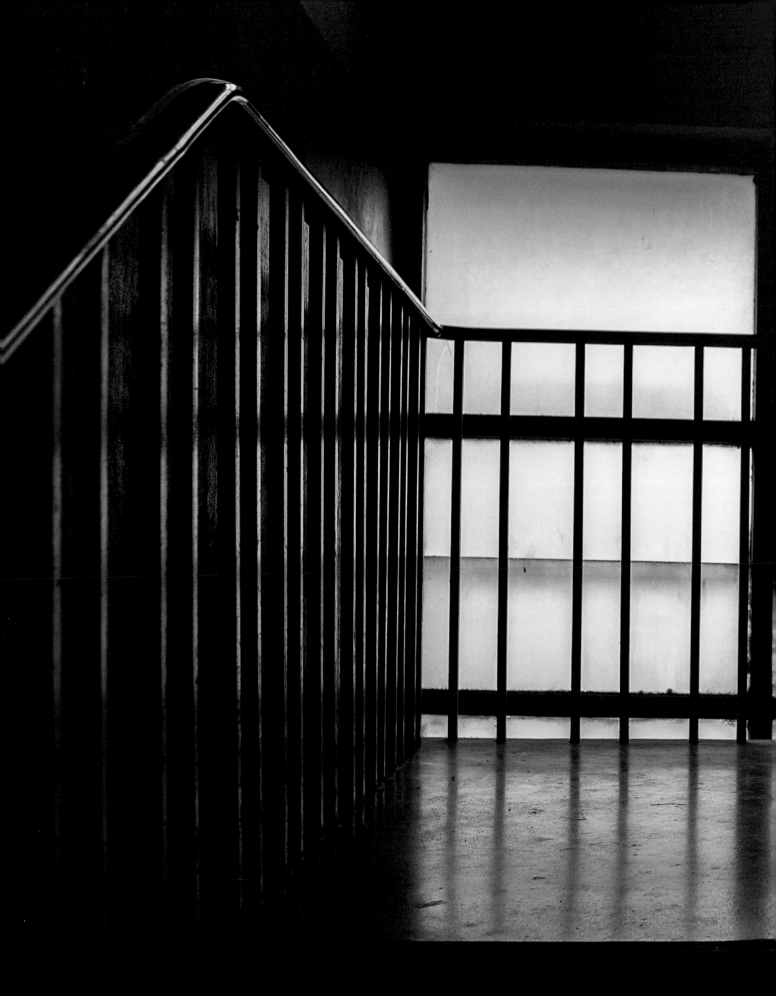

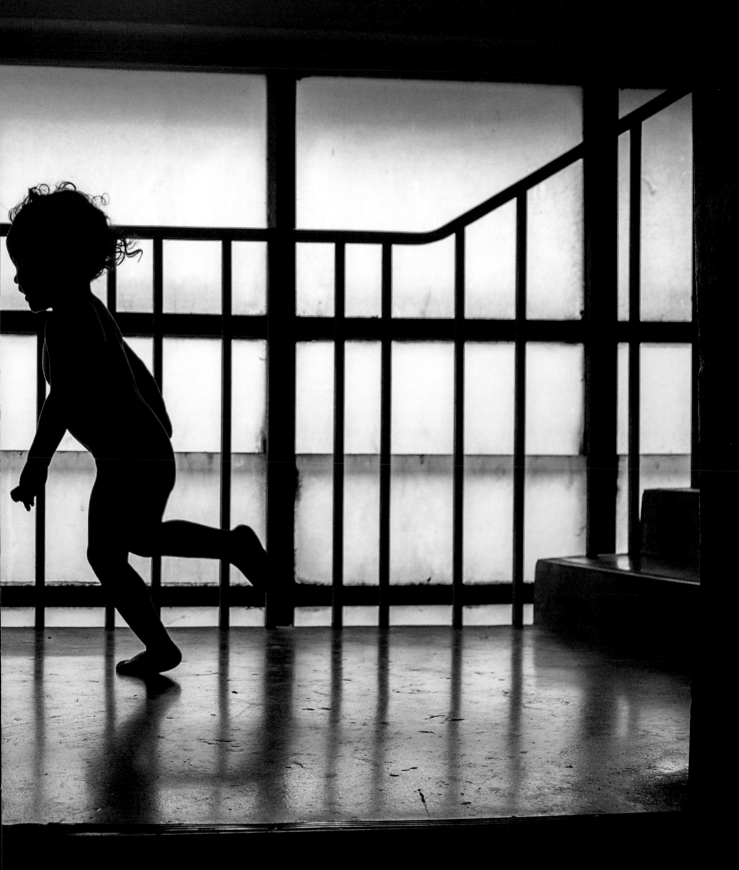

A Boy Who Was Kidnapped by Time

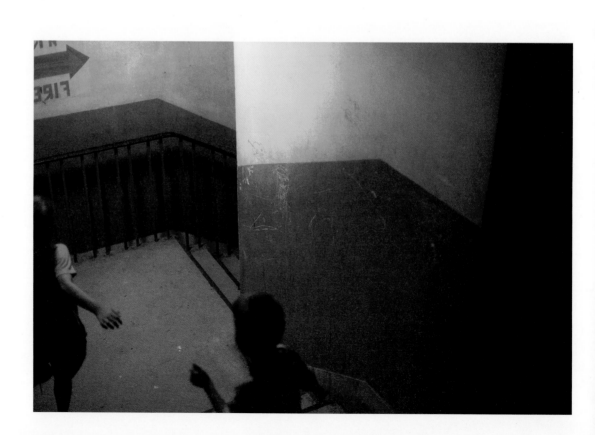

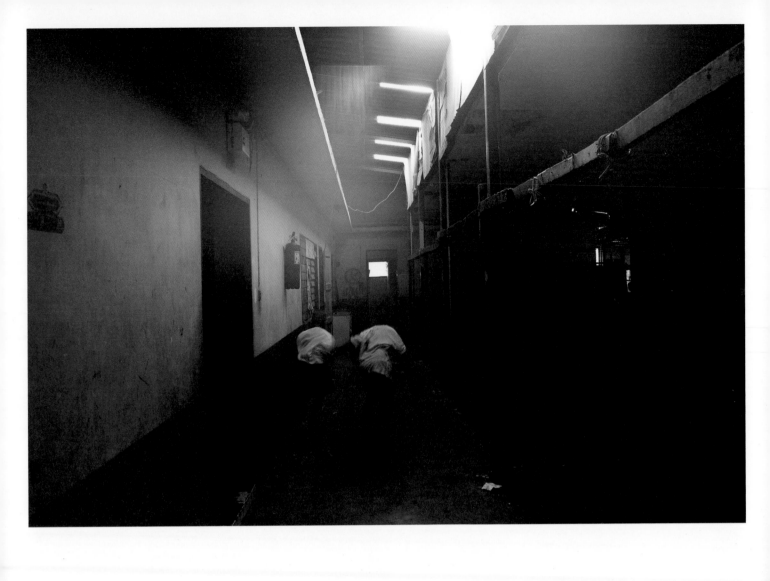

Harit Srikhao

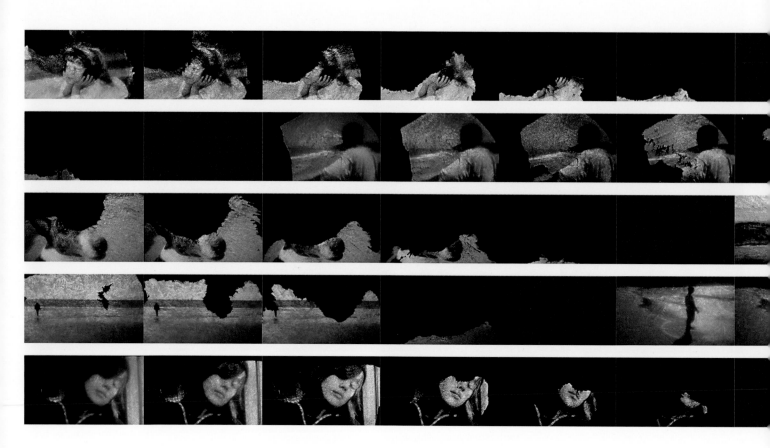

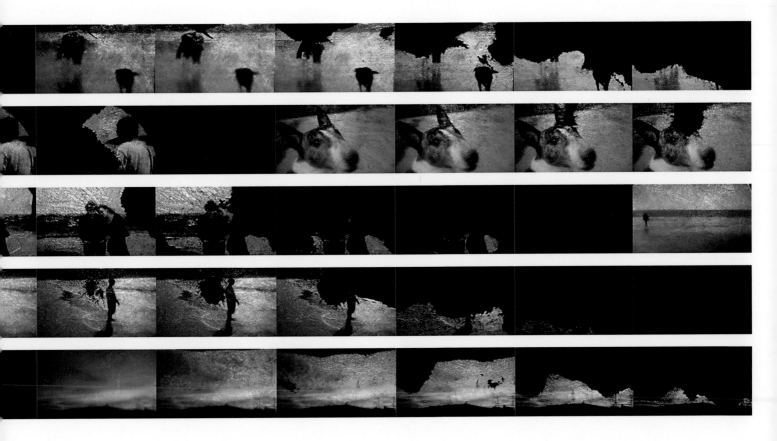

Ombre p

"Every time a new generation makes its appearance on the stage of life, the world's symphony strikes a new tempo."

Giovanni Papini

Every five years, the Musée de l'Elysée has to fine-tune its vision of what it means to be a "young photographer today," an exciting, albeit difficult task. This was already the case when William A. Ewing, Director of the Musée de l'Elysée from 1996 to 2010, launched the concept ten years ago, and it is even more so today. Over a billion images are exchanged on the social networks everyday. The multiplicity of these photographs, constantly being replaced by others, leaves a wide array of unanswered questions. How can we claim to recognise, at the global scale, the early signs of a great future photographer? Such is the daunting challenge of the reGeneration³ exhibition, insurmountable but well worth the effort.

The 2015 edition is characterised by its multidisciplinary approach: the selection of candidates was open to all types of artistic endeavours that involved photography (prints, videos, installations, multimedia projects, photography books), with 83 art schools worldwide contributing to the pre-selection process. We are therefore not speaking of a spontaneous generation but of emerging artists who have taken up the challenge, or in this case, the legacy. They are ensuring the future by combining what exists today with what will endure. Each reGeneration hopes to be a crystallisation. The young artists chosen, demiurges, are the messengers of the future. The Musée de l'Elysée therefore plays its role of relay, presenting or, more precisely, representing future generations.

A photograph does not copy reality; he/she interprets it. Moreover, the reality of images as a reflection tends to no longer exist: virtual, subliminal images saturate the brain and change the way we see things, the reality of what is seen. Photography, a global and planetary art, leads the way to a stimulating confrontation when presented in this way.

Creativity is essential to be a great artist, but so is endurance. No one can predict what the future of the unrestrained pursuit of these emerging photographers will be, and it is just as well. It is enough to love them at a given moment. "According to Socrates, love is the appetite of generation by the mediation of beauty" (Montaigne, Essays, III). I like to think that this is also true for this reGeneration³ exhibition.

The Musée de l'Elysée would like to thank all of the artists who participated in the exhibit as well as the many photographers who submitted applications. We would like to express our gratitude to the art schools that proposed the work of their most promising students and to Skira for co-editing the catalogue.

The Musée de l'Elysée would particularly like to acknowledge Parmigiani Fleurier, a tremendous support and the main partner of this ambitious exhibition that well deserves a place on the international stage.

Tatyana Franck
Director of the Musée de l'Elysée

"Earlier much futile thought had been devoted to the question of whether photography is an art. The primary question — whether the very invention of photography had not transformed the entire nature of art — was not raised."

Walter Benjamin, "The Work of Art in the Age of Mechanical Reproduction," in *Sur l'art et la photographie*, Carré, Paris, 1997 [1955]

Launched in 2005, the *re*Generation project, devoted to the emerging international photographic scene, is one of the Musée de l'Elysée's trademarks. In order to ensure the quality of the proposals submitted while bringing the project to full fruition, the Musée de l'Elysée chose to work with art schools throughout the world who were asked to submit a selection of the best work of their recent graduates for this ambitious project dedicated to the future of photography.

Whereas this initiative was considered to be innovative ten years ago, "young" photography today is the target of numerous competitions, prizes and exhibitions. With this in mind, the Musée de l'Elysée decided to present a third edition of *re*Generation within the framework of its 30th anniversary festivities. A project like this provides the opportunity to have access to a wide panorama of emerging artistic creation at a given moment and to place it within a perspective.

For this new edition, we wanted to emphasize the multifaceted nature of photography. Since its invention, the medium has been applied to a wide range of activities (scientific research, the development of documentary archives, a means of reproduction in the publishing industry, etc.) before becoming a "democratic" practice within everyone's reach. At the same time, an aesthetic history specific to the medium evolved, and visual artists began to use photography for their works by the end of the 1960s.

We therefore broadened the selection of fine art schools contacted and the call for proposals clearly specified our interest in all artistic approaches that involved photography. The result is a selection of 50 works representative of the "permeable"

nature of the medium, ranging from individual prints and photographic series, to artists' books and multimedia installations, and including videos, projections, films and performances, as well as on-site installations.

The current generation stands out by its multidisciplinary training that combines different interests and practices in several artistic domains, sometimes with studies in the humanities and social sciences. The projects submitted bear witness to their interest in a global history of photography that is not just limited to the aesthetic history of the medium and that takes into account the multiple uses of this reproduction tool. Their approaches also reveal the influence of a more recent field of research known as visual studies. These artists more often make reference to critical works on photography such as the writings of Roland Barthes, Walter Benjamin and Susan Sontag, rather than to famous photographers or aesthetic trends in the field. Their culture of the constructed image made obsolete the question of photographic truth, while their practice freely takes other forms and is regularly associated with the plastic arts.

It therefore comes down to proposing an "experience." The studio is the ideal venue for these creations and the artists also contribute to the format of the book to present their works. Published at their own expense, these books constitute an alternative form of expression to that of an exhibition. Layout of the works warrants particular attention. The association of images and the integration of other elements (texts, sounds, videos and even objects) contribute to the awareness of the complexity of the subject presented and its interpretation. The projects are generally based on individual experiences — personal or family stories, everyday events — which are indeed the most intuitive subjects for these young artists.

After a careful review of the applications received, we were able to identify three major themes that appeared to be representative of the leitmotifs of the emerging art scene: the variety of approaches for dealing with documentary subjects; the question of memory; and the wealth of aesthetic

photographic expressions inspired by the history of the medium and, more broadly, the history of art. These themes are non-exhaustive and are proposed as a sort of guideline to interpret the works selected.

The diversity of documentary forms

"To take photographs is not to take the world for an object, but to make it an object, to exhume its otherness buried beneath its alleged reality, to bring it forth as a strange attractor, and pin down that strange attraction in an image."

Jean Baudrillard, *For Illusion Isn't the Opposite of Reality*, 1998

Even if photography has always been a way to apprehend reality, contemporary documentary approaches take the most diverse forms. The massive consumption and profusion of images related to current events as well as the trivialisation of its production — to the detriment of photojournalism and photo essays — have seriously compromised the quality of visual information. This observation led to the necessity of creating new documentary forms, characterised by their proclaimed subjectivity.

The traditional documentary form, which is characterised by a certain distance from the subject and a frontal and centred framing that allows a clear and immediate reading of the subject photographed, is still widely used. Rachel Boillot's *Post Script* series is a good example, deploring the dramatic consequences of the closing of more that 3,500 post offices in rural communities in the southern United States. Paul Samuels' portraits of young men from Johannesburg's *XVI X* suburb address the question of the influence of the social environment on the definition of an individual. For his photographic series on the Boiko tribe, Jan Brykcyński merges atmospheric lighting with this same aesthetic in order to express the timeless character of this community.

The development of a specific organisation and the addition of elements from different contexts highlight the

subjectivity of photographic works. Rachel Cox chronicles the life of her grandmother after she was diagnosed with a degenerative brain disease. Her images of portraits, objects and places that her grandmother was attached to are presented like a series of photographic "clues." Ulrike Schmitz adds a narrative aspect to the sequencing of the series, *Museum of your Memory*, inspired by film stills to present her photographs. This work, like *Akkar*, the book by Philippine and Constance Proux, testifies to the current trend among artists of reappropriating archival images, particularly for investigative works.

The addition of texts also adds to the complexity of the subjects presented. For her series devoted to men who have suffered from sexual abuse, Emily Macinnes superimposes texts that document the thoughts and experiences of the victims on the portraits she has made of them. The violent contrast between the written testimony and the austerity of the images addresses the issue of masculine vulnerability. Jonna Kina has chosen the aesthetics and the form of typology for her series of objects used for the reproduction of sound effects. By "captioning" her photographs with the simulated sound, the images become mental references of a sound experience. Giacomo Bianchetti physically confronts Swiss economic powers by photographing the entrances to their corporate headquarters. By adding texts that document his experience when the photograph was taken, he raises the question of public space and the balance of power.

The large painting-like format in photography is tending to disappear, replaced by multimedia installations that stimulate all of the spectator's senses to more effectively immerse him in a given universe. Gaia Squarci's project devoted to people who have become blind bears witness to their difficulty to create a new existence: her photographs that reveal their new condition are accompanied by their transcription in braille and sound recordings. Karel Koplimets adds body bags to his photographic installation and video, *Case N° 8. You'll Always Find Me in the*

Kitchen at Parties, to address the question of homicides in Estonia.

Stagings and fictions are also explored to deal with sociocultural subjects. By choosing the traditional form of the Ottoman miniature for his photomontages of contemporary portraits, Sinan Tuncay highlights the weight of tradition in modern Turkish culture. Jennifer B. Thoreson combines staging and sculptural creations to address the themes of faith and resistance. We also find performances like Juno Calypso's video that reinterprets a TV advertising for an electronic anti-wrinkle mask sold in the 1980s in order to denounce the diktat of youth on the female condition.

The question of memory

"What the Photograph reproduces to infinity has occurred only once: the Photograph mechanically repeats what could never be repeated existentially."

Roland Barthes, *Camera Lucida: Reflections on Photography*, 1980.

This theme illustrates the importance of autobiographical works. Awareness of the loss of childhood memories inspired many projects such as the metaphoric and nostalgic images of *A Boy Who Was Kidnapped by Time* by Harit Srikhao. Emilie De Battista expresses the fleeting nature of memory with videos that record the decomposition in real time of family photographs projected on melting ice. Elizabeth Hewson creates a more oppressive atmosphere to deal with the same subject: she corrupts the digital files of her childhood images that she then translates into discordant sounds using databending.

The domain of fiction is often preferred to address the question of identity. Both the artist duo, Anna Gutová and Gabriel Fragner, and Silin Liu draw on personal or public archival documents to create fictive existences that evoke traditional family values and globalisation. For her video, *La Vague* [*The Wave*], Irene Muñoz Martin recreates the way in which her mother learned of the death of Franco and takes a look at the legacy of the dictatorship on contemporary Spanish society.

Finally, the artists explore different processes to deal with the illusory nature of attempts to record the world. Karl Isak-son took a thousand views of the same place and then presents his images at a small scale in the form of a loop-projection to emphasize the impossibility of recording everything with pho-tography. The performance of Loan Nguyen, *Le chemin de l'eau* [*The path of water*], transforms the topographic map, perceived as an exhaustive representation of a territory, into a tool of experimentation and creation. As she tells the story of a group of people who get lost in nature environment, she folds and unfolds the topographic map of the site. In *Dream Collection*, Veronika Geiger invites the spectator to apply a selection of verbs to anonymous photographs of airplanes in flight, thus evoking the subjectivity of the images and their multiple interpretations with poetry.

Diverse expressions and aesthetics of photography

"New forms in art are created by the canonization of peripheral forms."

Viktor Shklovsky in Susan Sontag, *On Photography*, 1979.

This theme is the most representative of the multifaceted nature of photography. The artists are inspired by the history of the medium and critically analyse the different uses of photogra-phy to create unique works of art. Simon Rimaz focuses on the materiality of the photographic object and presents press photographs with the original published image removed. The large-format presentation of this mutilated object addresses the question of the cropping and the notion of "spectacular" in pho-tography. Michael Etzensperger produces sequences of images that set nineteenth-century photographic reproductions of antique sculptures in motion, revealing the limits of the medium to reproduce a three-dimensional object, despite the numerous theories dedicated to this practice.

Many of the projects are devoted to the history of the scientific uses of photography and the idealised perception of the objectivity of this reproduction tool that captures reality

without any human intervention. Angélica Dass presents the limits of the identity portraits and the anthropological inventory practice by establishing a sort of typology of individual portraits to which she adds a colour from the PANTONE® line to the background, corresponding to the subject's skin tone. Marek Kucharski and Diana Lelonek tackle Darwin's theory of evolution by altering a copy of the original edition of *On the Origin of Species*. In *l'étendue de mes connaissances* [*the scope of my knowledge*], Jacinthe Robillard films and makes portraits of individuals folding an origami crane according to a pre-established model. The gestures and expressions revealed raise the question of performance and success.

Despite the fact that photographic production today is characterised by its profusion and its virtuality, some artists are drawing on the technical history of photography and adopting old processes to create unique, small-format works of a precious nature. Matt Waples has chosen the dye transfer technique for his formal abstract studies, exploring the relationship between light and photochemical reactions. Jung A Kim uses the photogram as a support for her poems.

The works here are also inspired by the fine arts, performing arts, architecture and literature. Juuke Schoorl's video, *Liquid Skin*, transforms the skin into a means of visual expression by merging radiography with choreography. Sara Skorgan Teigen draws her inspiration from the tradition of the sketchbook and the graphic arts for her meditations on organic elements in nature. The video and photographic work of Emilio Pemjean, *Palimpsest*, presents the most multidisciplinary scope, with references to the history of architecture, painting, sculpture and photography. He creates stripped-down models of the settings of masterpiece paintings that he then imbues with a skilful play of carefully gauged light.

Installations and layouts of images inspired by painting and sculpture also contribute to stimulating and even challenging our perception of the photographic image. Emile Barret's cabin and his video game immerse the spectator in a baroque

universe saturated with images made in the studio. His work combines a wide range of references and can be likened to a trompe-l'œil that addresses the question of contemporary visual culture. Along the same lines, the sculptural installation of Ola Lanko, *Romantic Act of Reason*, inspired by a tower designed by the Russian artist Tatlin in 1920, explores the boundary between reality and romanticism. Finally, in a more restrained style, Delphine Burtin recreates a personal language in the form of installations that feature everyday objects diverted from their original function.

Whereas our goal for this new edition of *re*Generation was to highlight the multidisciplinary nature of photography, the applications we received confirmed the relevance of our approach. Trained at the dawn of the digital and Internet age, this new generation of artists is less influenced by this profusion of images and the hyper-democratisation of photography that, it is true, was recently the subject of a large number of works. They instead tend to react to this sociocultural phenomenon by developing a constructed image and a critical approach influenced by the visual studies. They prefer to draw from different photographic uses, referred to as "vernacular," whose interest has considerably increased over the last ten years, and their appropriation or diversion of archival images is part of this trend. Although all of the projects do not present the same level of technical mastery — inherent to the profile of these recently graduated artists — the return to the view camera and the appropriation of former techniques — both projections and prints — bear testimony to the importance accorded to the photographic object. This new generation also takes advantage of technical innovations in order to design and put together complex installations. Photography, when taken in all its diversity, together with the plastic arts and new technologies, thus extends its boundaries to include a wide new range of explorations.

Anne Lacoste

Curator at the Musée de l'Elysée,
curator of the exhibition

Anne Lacoste

The notes presented below for each photographer were written by Lydia Dorner, Assistant curator, Emilie Delcambre and Saida Bondini, from the Department of Exhibitions. The institution that recommended the artist's work is the first one on the list of schools attended.

Ola Lanko

Ukraine, born in 1985
Gerrit Rietveld Academie, Amsterdam, The Netherlands, 2010–2012
KABK — Royal Academy of Art, The Hague, The Netherlands, 2008–2010
Taras Shevchenko National University of Kyiv, Kiev, Ukraine, 2002–2007
www.olalanko.com

→ pp. 2–3:
Ola Lanko, *Romantic Act of Reason*, 2014
Installation (inkjet prints, wallpapers and various objects)
Various dimensions
© Ola Lanko

At the heart of this plethoric installation in which photographs collide with sculptures and objects, Ola Lanko is studying the encounter between two a priori antagonistic concepts: romanticism, which relates to the imagination and to the dream, and rationality, which deals in logic and reason.

Starting with the observation that, paradoxically, humankind often strives to turn its romantic ideals into reality by mobilizing the logic and rigour of scientific knowhow and technology, the photographer seeks to question the "gray zone" that forms whenever these two disparate terms join forces.

Her reconstruction of Tatlin's Tower (1920), an archetype of this kind of thought, reminds viewers of a Constructivist monument intended as a triumphant symbol of Russian modernism, and yet which remained a drawing-board fantasy.

Lanko deepens her exploration of the phenomenon by complementing the installation with dozens of archive images — from artistic, scientific, or everyday sources — selected for their analytical content, but invariably bearers of a strong emotional charge.

Further evidence is adduced by many designs for "flying machines" — that incarnation of the inherently human desire to transcend our earthbound condition.

By exploiting concepts such as profusion and *mise en abyme*, Ola Lanko also gets to grips with the issue of the complexity and diversity of image interpretation.

An integral part of the piece, some 2,800 pages detailing the concepts, examples, and references that went into making the eponymous installation accompany the four works shown.

Robert Mainka

Poland, born in 1990
The Polish National Film, Television and Theater School in Łódź, Poland, since 2011
www.robertmainka.com

→ pp. 4–5:
Robert Mainka, *Lavish Fields*, 2014
Installation (wallpapers, objects)
Various dimensions
© Robert Mainka

A series containing more than a hundred photographs, *Lavish Fields* undertakes the metaphorical description of four elements inherent to human nature: desire, thought, feeling, and the body. In composing what is a kaleidoscopic and theatrical construction, Robert Mainka takes as his starting point his immediate environment. The themes chosen are expressed in various media: painting, sculpture, exterior and studio photography.

If each of the featured images seems to represent a particular situation and possesses a specific meaning, they remain ambivalent and mysterious; nonetheless, in spite of their disparity, they follow a coherent sequence in which circular forms counterbalance bright colours.

The title of the piece makes explicit reference to the poem *The Waste Land*, written between the wars by the American writer T. S. Eliot (1888–1965). A key monument of modern poetry, this epic of 434 lines, particularly experimental in its form, interlards symbolism with the systematic recourse to literary and cultural allusion.

Deploying fragmentation and juxtaposition, Mainka revisits the disjointed structure of Eliot's magnum opus, switching abruptly and repeatedly from one character or atmosphere to the next.

Magdalena Baranya

Switzerland, born in 1981
ZHdK — Zürcher Hochschule der Künste, Zürich, Switzerland, 2010–2015
F+F Schule für Kunst und Design Zürich, Zürich, Switzerland, 1998–2001
www.magdalena-baranya.allyou.net

→ pp. 6–9:
Magdalena Baranya, *Carpet II* (print on silk, 165 × 105 cm) [p. 7] and *Floor II* (wallpaper [detail], 110 × 270 cm) [pp. 8–9], from the series *Dust Catcher*, 2015
© Magdalena Baranya

For her series *Dust Catcher*, Magdalena Baranya sought inspiration from the knickknacks, commonly called "dust traps," which adorn the interiors of holiday homes.

After building up a kind of visual archive with photographs of the ornaments found in vacation apartments, she then disposed the objects in almost obsessively repetitive patterns, creating multi-coloured graphic compositions that take the form of carpets or wallpaper.

At first sight, the overloaded aesthetics of the furnishings designed by Baranya seems to refer back to the outmoded decor of the average short-let apartment. Yet, despite the profusion of the objects appearing within it, the weave structure allows every element featured to be clearly distinguished.

The arrangement chosen derives from the traditional quadripartite division of the Persian garden, defined according to their conception of the Garden of Eden. Through this reference to Paradise, in combination with the accumulative nature of works comprised of nondescript objects, Baranya challenges the wasteful, excessive character of present-day consumer society more broadly.

Emile Barret

France, born in 1989
ECAL — University of Art and Design, Lausanne, Switzerland, 2008–2012
Ateliers de Sèvres, Paris, France, 2007–2008
www.emilebarret.com

→ pp. 10–11:
Emile Barret, *LLIAISONS*, 2015
Installation (print on fabric, video game)
Various dimensions
© LLIAISONS, Emile Barret & Co

LLIAISONS unveils a baroque and exuberant world born from a profusion of related images that invade every component in the installation — cabin, fabric, seat, computer.

Born in London in the course of an artists' residency in which Emile Barret took part, the project is the fruit of a collaboration between several visual artists.

A visual construction saturated with references, *LLIAISONS* invites visitors, as its creator puts it, to "stroll" among an array of photographs, installations, films, performances, sounds, and sculptures created in synergy during an episode of collective creation.

The video game designed by the artist on that occasion proposes a disturbing "circuit" through the pictures, the aim being one of total sensory and perceptual destabilization. "Augmented reality," allowing digital images to be superimposed simultaneously over reality and creating an interface between the real world and virtual data, is today a rapidly evolving concept: Emile Barret's version is intensely personal and artistic.

His work thus conducts viewers through a fantastical and theatrical virtual environment that plugs in directly to the photographer's imagination.

With Philippe-Albert Lefevbre and Ana Varela, Nadine Capdevielle and Bruno Barret, Maya Rochat, Florian Luthy, Florence Jung and Nicolas Leuba, Fabrice Schneider, Romain Mader, (Music for) Eggplant, Julien Grémaud, K3.14COUZ, Paul Barret and Raphaël Faure, Ali-Eddine Abdelkhalek and Félix Salasca, Baptiste Gratzmuller, and Karolina Kula.

Matt Waples

Canada, born in 1992
Ryerson University, Toronto, Canada, since 2011
www.mattwaples.com

→ pp. 12–13:
Matt Waples, from the series *Colour Studies*, 2014
Dye transfers
8 × 6 cm
© Matt Waples

Matt Waples's concerns centre on the encounter between light and diverse photosensitive chemical compounds — the very process that spawned photography.

For his series *Colour Studies*, Waples took as his starting point the dye transfer technique: developed in the second half of the twentieth-century, this colour-printing process requires layering three dye matrices (yellow, magenta, and cyan) onto baryta- or gelatine-coated receiver sheets. A lengthy and costly process originally taken up by the advertising industry and only later adopted by artists, it results in remarkably stable colour prints of impressive texture and depth.

Waples co-opts this technique — which, since the papers employed are no longer manufactured, is today on the way out — to create pure visual abstractions.

Separating the various elements required for photographic enlargement, here the three basic colour layers no longer resolve into a single figurative whole, but instead are arranged into perfectly geometrical compositions.

By way of what is a deconstruction of photography's most purely technical — and, hence, most eminently objective — building blocks, the artist questions the photographic act itself.

Benjamin Swanson

United Kingdom, born in 1989
NTU — Nottingham Trent University, Nottingham, United Kingdom, 2011–2014
University of Leicester, Leicester, United Kingdom, 2009–2010
www.benjamin-swanson.com

→ pp. 14–17:
Benjamin Swanson, from the series *The Conquest of Materials*, 2014
Inkjet prints
38,1 × 30,48 cm [pp. 14–15 and 16] and 25,4 × 20,32 cm [p. 17]
© Benjamin Swanson

A cross between still-life photography and sculpture, *The Conquest of Materials* is conceived as a series of geometrical constructions — polystyrene spheres, copper tubes, octagons, paving-stones, etc. — realised and reworked in studio. In his workshop-cum-laboratory, Swanson exploits an image bank of abstract representations taken from mathematics and science, ridding them of their original meaning and exploring them in a purely aesthetic fashion. To this end, Swanson employs dynamic points of view and an elaborate approach to lighting that brings out the texture of each object.

The Conquest of Materials is thereby the direct descendant of early researches by the "engineer photographers" of the twentieth-century avant-garde, who directed their energies to experimental photographic practices in which the medium is treated primarily as an objective tool for optical investigation. If these practitioners took up modern scientific discoveries and technical advances for research purposes, Swanson opts to subvert them. Ensuring a crisp, precise rendering in a range of muted colours, the British artist thus transforms his images into ideal entities, in the pursuit, as it were, of a "perfect" artistic photographic practice.

Delphine Burtin

Switzerland/France, born in 1974
CEPV — Ecole de photographie de Vevey, Vevey, Switzerland, 2011–2013
www.burtin.ch/photographie

→ pp. 18–19:
Delphine Burtin, *Sans condition initiale*, 2014–2015
Installation (wallpaper and inkjet prints)
Various dimensions
© Delphine Burtin

Through the object constructions and photographs in her installation *Sans condition initiale* [*With no initial condition*], Delphine Burtin's pursues her conceptual investigations of the leitmotiv of the "visual accident." Present in all her images, she views this discordant motif as a way of attracting our visual attention and sowing doubt into our perception of reality.

In this extremely controlled series contrived in studio, the artist deepens her explorations of the limits to and the ambivalence of human understanding.

Supremely economical in terms of technique and colour, she amasses, aligns, overlaps, and arranges ordinary objects — glass, fly-swat, sphere — that she characterises as "pieces of world." From these "existing visual fragments," Burtin adumbrates an entirely reconfigured visual semiotics.

By hijacking objects from their everyday use and reassigning their significance, the arbitrary combinatory game generated by the artist results in a surprising photographic language, in which objects we thought we knew become unfamiliar and the incongruous associations they set in train undermine our conventional representations.

If Delphine Burtin's works have often been discussed in terms of still-life photography, in the present case it would be more pertinent to talk of the photography of sculpture. *Sans condition initiale* investigates the interaction between objects transformed into sculptures, sculptures that subsequently morph into photographs, and photographs that revert back to the status of sculptural objects by occupying all three dimensions of space.

Emilio Pemjean

Spain/Chile, born in 1971
EFTI — Escuela de Fotografía y Centro de Imagen, Madrid, Spain, 2010–2012
ETSAM — Escuela Técnica Superior de Arquitectura de Madrid, UPM — Polytechnic University of Madrid, since 1989
www.emiliopemjean.com

→ pp. 20–21:
Emilio Pemjean, *Palimpsest I. Alcázar de Madrid (Spain). Architect Juan Gomez de Mora, 1636. Spanish Royal Family Palace. Destroyed by a fire in Christmas Eve of 1734* [p. 20, top] and *Palimpsest II. Oude Langendijk, Delft (Netherland), about 1600. Painter's study and family residence. (Mother in law's property)* [p. 20, bottom], from the series *Palimpsest*, 2011–2013
Inkjet prints
50 × 50 cm
Emilio Pemjean, *Untitled*, from the series *Palimpsest* [p. 21], 2015
Video
4'36"
© Emilio Pemjean

Emilio Pemjean's work centres on architectural interiors illustrated in paintings by old masters, from Vermeer to Velázquez.

Simultaneously architect and photographer, Pemjean assembles reduced-scale models of famous pictorial compositions, from which he removes all objects and figures. By erasing the pictures' temporal data, as well as their original contents — though remnants remain discernible on the floor and on the walls —, Pemjean encourages viewers to concentrate on and reinterpret the empty spaces that constitute the true protagonists in his work.

This process of purification and reconstruction is also evoked by the metaphorical title of the series, *Palimpsest*, which designates an ancient manuscript from which the

original text has been erased and overwritten with a new one, leaving the obliterated script barely visible underneath.

The video accompanying the series contextualises the pictures geographically and invites the beholder to reflect, in the footsteps of the great masters of the past, on the question of light and on its role in the construction and perception of space. Thanks to this multidisciplinary approach, the *Palimpsest* project presents a novel and unusual take on works dating back many centuries.

Simon Rimaz

Switzerland, born in 1987
CEPV — Ecole de photographie de Vevey,
Vevey, Switzerland, 2008–2014
www.simonrimaz.ch

→ pp. 22–23:
Simon Rimaz, *Study N° I*, from the series
Etudes de vitesse, 2013
Inkjet print
90 × 120 cm
© Simon Rimaz — CEPV

Following on from the series, *Unusual View of Unknown Subjects*, the project *Etudes de vitesse* [*Studies of speed*] by Simon Rimaz presents remnants of pictures for the press that remained on the cutting-room floor. The artist collects from various international dailies unique and unpublished silver prints showing motor races, reprinting them on a vast format. The new image is then cropped and the area published removed — an act that thus deprives the picture of its principal subject.

Now reduced to functioning as a frame, the mutilated photographs oblige viewers to turn their attention to the setting or background. Enlarging these hollowed-out images emphasizes their materiality. The chief protagonist in Rimaz's photographs is thus the extraneous, what lies out of shot.

Through the blurred background — out of focus, since the camera is fixed on the speeding car —, the photographer offers a study of the search for movement and its visual and sensory perception that has formed an integral part of the aesthetics of modern photography since the famous picture taken by Jacques-Henri Lartigue (1894–1986) at the Grand Prix Automobile Club de France in 1912.

Tereza Zelenkova

Czech Republic, born in 1985
Photography Programme, Royal College of
Art, London, United Kingdom, 2010–2012
University of Westminster, London, United
Kingdom, 2007–2010
www.terezazelenkova.com

→ pp. 24–25:
Tereza Zelenkova, *Freud's Study*, from
the series *The Absence of Myth*, 2013
Double-page spread of the book
23,5 × 35 cm
© Tereza Zelenkova

Taking as her starting point the "critical dictionary" compiled by the French writer and philosopher Georges Bataille (1897–1962) for the Surrealist review *Documents* (1929–1931), Tereza Zelenkova realises a work in a similar vein that combines writings and conventional photo prints produced over a number of years. In his articles Bataille associated text and image in order both to provide a concrete description of the various themes and objects addressed and to differentiate his approach from that of traditional academia.

Zelenkova's project is a more personal take using a similar method. The words or terms selected are defined by a text in which factual explanation is interlarded with more private concerns and illustrated by a juxtaposition of several improbable-looking photographs, in what is a common Surrealist practice.

The influence of this art movement is also underscored by the name of the series, *The Absence of Myth*, the title chosen for the English edition of a collection of Bataille's writings on Surrealism.

Michael Etzensperger

Switzerland, born in 1982
ZHdK — Zürcher Hochschule der Künste,
Zürich, Switzerland, 2009–2012
LUCA — School of Arts, Brussels, Belgium,
2011–2012
www.michaeletzensperger.ch

→ pp. 26–29:
Michael Etzensperger, *Nike 1* [p. 26, top];
Nike 2 [p. 26, bottom]; *Nike 3* [p. 27]; *Nike 4*
[p. 28] and *Nike 5* [p. 29], from the series
*Normalstandpunkt, kein anderer als die
direkte Vorderansicht*, 2013
Inkjet prints
42 × 35 cm
© Michael Etzensperger

Michael Etzensperger's series deals with the photographic reproduction of an ancient sculpture of a Nike, a goddess in Greek mythology who personifies victory and triumph. Bringing to life the flattened, unmoving sculpture, trapped within the frame of a reproduction, the artist liberates the classical masterpiece from the constraints of photography and releases her into a three-dimensional space.

Nike thus questions the traditional role of photography in reproducing sculpture and the limits of such technology in accounting for volume.

Already practiced in the nineteenth-century, photographic reproduction has been the subject of many theories. Etzensperger's interest focuses primarily on the writings of art historian Heinrich Wölfflin (1864–1945). While acknowledging the benefits of this mode of reproduction in making unique artworks more widely known, Wölfflin mistrusted the impact of the angle chosen by the photographer on the viewer's perception of the objects represented. Wölfflin went on to define an "ideal," frontal viewpoint, which he characterised as unimpeachably objective and thus a model for any presentation of an artwork.

Michael Etzensperger's fugitive *Nike* in her turn further explores the idea of a photograph that might convey not only the aesthetic of a pre-existent work, but also its visual effect and its original proportions precisely and accurately.

Juuke Schoorl

The Netherlands, born in 1989
KABK — Royal Academy of Art, The Hague,
The Netherlands, 2010–2014
ArtEZ Institute of the Arts, Arnhem, The
Netherlands, 2007–2010
ABKM — Maastricht Academy of Fine Arts,

Maastricht, The Netherlands, 2006
www.juuke.nl

→ pp. 30–33:
Juuke Schoorl, *Liquid Skin*, 2014
Video
4'50"
© Juuke Schoorl

In collaboration with choreographers Imre and Marne van Opstal, the photographer Juuke Schoorl presents a video piece mixing dance with references to the utilisation of photography in medicine.

The artist projects images of human anatomy onto the surface of the performers' bodies: recalling the technique of X-rays, lungs, spinal columns, kidneys, and hips take shape and then vanish as the dancers breathe and move their limbs.

More than a century after the discovery of this radiation — an essential late nineteenth-century medical advance that for the first time provided access to the structure of a living body, the skeleton and the internal parts of which could be viewed on photosensitive film —, Juuke Schoorl's subversion of the basic codes of radiography resolves into a highly personal vision.

In place of the coldness and technical rigour of scientific imagery, this reinterpretation of the language of X-ray spawns a dreamlike and sensual world, where the blue-tinged skin of his dancers morphs into a theatre of visual expression.

Li Zhi

China, born in 1979
Beijing Film Academy, Beijing, China, 2010–2013
Kunming University of Science and Technology, Kunming, China, 1997–2001

→ pp. 34–35:
Li Zhi, *Jansen. Feature Type: Crater, craters, a circular depression. Named for: Zacharias Janszoon; Dutch optician (1580–1638). Location: 13.50°N 28.70°E. Size: 23.0 km / 14.3 mi* [p. 34, upper left]; *Lambert. Feature Type: Crater, craters, a circular depression. Named for: Johann Heinrich Lambert; German astronomer, mathematician, physicist (1728–1777). Location: 25.80°N 21.00°W. Size: 30.0 km / 18.6 mi* [p. 34, upper right]; *Linné. Feature Type: Crater, craters, a circular depression. Named for: Carl von Linné; Swedish botanist (1707–1778). Location: 27.70°N 11.80°E. Size: 2.0 km / 1.2 mi* [p. 34, lower left]; *Marius. Feature Type: Crater, craters, a circular depression. Named for: Simon Mayer; German astronomer (1573–1624). Location: 11.90°N 50.80°W. Size: 41.0 km / 25.5 mi* [p. 34, lower right] and *Al-Bakri. Feature Type: Crater, craters, a circular depression. Named for: Ibn Muhammad Al-Bakri; Spanish-Arab geographer (1010–1094). Location: 14.30°N 20.20°E. Size: 12.0 km / 7.5 mi* [p. 35], from the series *Lunar Crater*, 2014
Inkjet prints
32 × 32 cm [p. 34] and 100 × 100 cm [p. 35]
© Li Zhi

The photowork *Lunar Crater* presents a replica of the craters that cover the Moon's surface. In studio, the artist reconstructs its geological features out of a plaster powder refined through a sieve, using wads of cotton and a syringe filled with air. The assembled models are then photographed and digitally manipulated to recreate a background resembling the starry sky that envelops the surface of the Moon.

To underpin these topographical reconstructions with scientific validity, Li Zhi has studied technical texts on the subject and drawn up an as accurate catalogue as possible of the craters that recalls an astronomical inventory.

Each photograph is captioned in accordance with the system of official nomenclature for lunar features, the names of which commemorate scientists and astronauts of the past.

Zhi's piece plays on this naming system to address more broadly the profound human need to leave a trace of its passage on this remote and unexplored terrain.

The series *Lunar Crater* thus simultaneously references the role of photography in science and investigates the fascination human beings feel for this mysterious and eternal celestial body.

Jae Hoon Lee

South Korea, born in 1973
Elam School of Fine Arts, University of Auckland, New Zealand, 1999–2012
San Francisco Art Institute, San Francisco, CA, United States, 1996–1998
www.jaehoonlee.net

→ pp. 36–37:
Jae Hoon Lee, *Peak*, 2014
Wallpaper
100 × 224 cm
© Jae Hoon Lee

Jae Hoon Lee utilises digital photomontage to create landscapes. Presenting existing places or situations, the computer-altered images superimpose several photographs of the same site taken at different times.

Thus the artist does not envisage photography as necessarily immortalising the present moment; instead it can overlap several temporal levels. In this manner, shorn of its topographic and temporal coordinates, the scenery shown acquires universal value.

The mountain of Annapurna in Nepal, for instance, while conserving its principal distinctive features, is transformed into an illusory image that reflects rather the artist's personal experience.

Lee's choice of large formats for his installations immerses viewers in the landscapes and thus emphasizes the at once familiar and destabilizing character of the pictures.

Jacinthe Robillard

Canada, born in 1979
le Cabinet, espace de production photographique, Montreal, Canada, since 2012
Concordia University, Montreal, Canada, 2004–2012
UQÀM — Université du Québec à Montréal, Montreal, Canada, 2001–2004
www.jacintherobillard.com

→ pp. 38–39:
Jacinthe Robillard, *appointments' journal* (detail) [p. 38] and *untitled (Chris)* [p. 39], from the series *l'étendue de mes connaissances*, 2012

Installation (wallpaper, 97 × 152 cm; inkjet
print, 50 × 60 cm and video, 32'00")
© Jacinthe Robillard

Created in 2012, the series *l'étendue de mes connaissances*
[*the scope of my knowledge*] fosters an artless yet ironic
approach to the notion of the identity and individuality of
body language.

Without informing them of her intentions, the artist invites
some friends and relations to a performance. Seated at
a table facing the camera, they are then asked to make an
origami in accordance with the sequence of folds indi-
cated on a panel set up in front of them.

Robillard reconfigures the record of the experiment into
a behavioural study, which describes the reactions of
subjects faced with an unusual task that pushes them to
the edge of their "comfort zone."

The series, comprised of portraits of their facial expres-
sions, gestures, and attitudes, is accompanied by a video.

As summarized in *appointments' journal*, Robillard's
project culminates in the presentation against a neutral
backdrop of the characteristic markers of an individual's
gestures and tics as manifested in situations of isolation
and concentration.

Marek Kucharski & Diana Lelonek

Poland, born in 1982 and in 1988

Marek Kucharski:
University of Arts in Poznań, Poland, since
2010
The Polish National Film, Television and
Theater School in Łódź, Poland, 2006–2009
University of Warsaw, Warsaw, Poland,
2001–2006
www.kucharskimarek.com

Diana Lelonek:
University of Arts in Poznań, Poland,
2008–2014
NTU — Nottingham Trent University,
Nottingham, United Kingdom, 2012
Shanghai Normal University, Shanghai, China,
2011
www.dianalelonek.tumblr.com

→ pp.40–43:
Marek Kucharski & Diana Lelonek, *There's
nothing there, anyway*, 2014
Installation view [pp.40–41]
Double-page spread from the book with
original photographs [pp.42–43]
20 × 26 cm
© Marek Kucharski & Diana Lelonek

The artists Kucharski and Lelonek propose here a modern
adaptation of the influential theory of the evolution of spe-
cies proposed by naturalist Charles Darwin (1809–1882)
by making physical modifications to his groundbreaking
publication, *On the Origin of Species*, which appeared in
1859.

Working in tandem, they take a 1909 edition of the
book and transform its subject matter: erasing sections
of the text, they convert it into a narrative by inserting
photographs of a personal character taken during a trip
to Australia — a continent they here consider as the
cradle of terrestrial life. The pictures are combined with
unattributed photos and reproductions showing living
organisms taken from scientific documents.

In *There's nothing there, anyway*, the theory of evolution
is thus rewritten in the light both of historical events, with
particular reference to colonialism, and with the pho-
tographers' personal experiences in the field.

In the case of the installation created for this publication,
the two photographers can be imagined as an Adam
and Eve for the modern age, as harbingers of a "revised
version" of the history of humanity.

Angélica Dass

Brazil/Spain, born in 1979
EFTI — Escuela de Fotografía y Centro
de Imagen, Madrid, Spain, 2011–2012
URFJ — Federal University of Rio de Janeiro,
Brazil, 2003–2006
SENAI-CETIQT — Technology Center
of Chemical and Textile Industry, Rio de
Janeiro, Brazil, 2000–2002
www.angelicadass.com
www.humanae.tumblr.com

→ pp.44–47:
Angélica Dass, *Humanae*, since 2012
Wallpapers
25 × 25 cm each
© Angélica Dass

Begun in 2012, the series *Humanae* by Angélica Dass con-
sists in portraits presented without distinction of age, reli-
gion, nationality, gender, or social class of the hundreds
of people who took part in her vast project. The artist's
portraits take their cue from the conventional standards
of anthropological or official photography (frontally posed
and lit head and shoulders shots).

Behind the photographs, Dass adds a monochrome back-
drop in a shade selected from the PANTONE® range so
as to match the participant's skin colour. By way of such
systematic classification, the *Humanae* series questions
the concept of difference and race, without asserting a
definitive point of view.

Although the background tone chosen brings out the
sitter's ethnic identity, the manner in which the prints
are arranged is based on no hierarchical or chromatic
categories. Thus, if the alphanumeric codes of the indus-
trial colour system allow each sitter to be identified and
distinguished precisely, together the figures form part of a
collective composition arrived at through the juxtaposition
of individual types.

Dass's simple yet powerful project lays the foundations for
a discussion of ethnic equality that leaves interpretation
up to the viewer.

Mohit Bhatia

India, born in 1983
NID — National Institute of Design,
Gandhinagar, India, since 2012

→ pp.48–49:
Mohit Bhatia, *Hare Krsna Hare Rama*,
from the series *Medium IS CON*, 2014
Inkjet print
75 × 50 cm
© Mohit Bhatia

Mohit Bhatia's photo series questions the reading
offered by the ISKCON (International Society for Krishna

Consciousness) movement of the *Bhagavad Gita*, a Sanskrit poem whose title means literally "Song of the Blessed One" that constitutes one of the main textual sources of Hindu wisdom.

Bhatia photographs present tableaux inspired by Plato's allegory of the cave. Her protagonists appear as incarcerated and as isolated as the prisoners in the philosopher's allegory which demonstrates how the human condition prevents man from attaining intelligible knowledge.

The metaphor is developed visually in contrasting chiaroscuro images that recall the darkness and the shadows on the wall in Plato's cave.

The texts accompanying the images juxtapose original extracts from the sacred scriptures with their interpretation by A. C. Bhaktivedanta Swami Prabhupada, the founder of ISKON, that reveal his erroneous readings of Hindu teaching. In combination, the textual studies and metaphorical images coolly expose the prelate's manipulations and denounce the state of ignorance in which the sect lives.

Jung A Kim

South Korea, born in 1978
BTK — University of Art & Design, Berlin, Germany, 2013
CAU — Chung-Ang University, Seoul, South Korea, 2012–2014
www.jungakim.com

→ pp. 50–51:
Jung A Kim, *Cover* [p. 50]; *Unfold* [p. 51, top] and *Double spread* [p. 51, bottom], from the series *Pond of Silence*, *photogram diary books*, 2013–2015
Photograms
7,25 × 10,5 cm [p. 50]; 29 × 21 cm [p. 51, top] and 14,5 × 10,5 cm [p. 51, bottom]
© Jung A Kim

Pond of Silence reflects on the relationship between nature and humankind, presented as a series of about a hundred photoworks exploring the technique of the photogram.

This historic process, developed and popularized in the first half of the nineteenth-century by William Henry Fox Talbot, consists in printing directly onto paper sensitized with silver salts the outlines of plants or other objects; the image is obtained by simple exposure to light, without the intervention of a camera.

Purely experimental from the outset, in art history the practice is associated with the avant-garde, with Dada and the Bauhaus, for example. Jung A Kim reinterprets the technique in a contemporary manner, presenting a fragmentary piece featuring a multitude of such photograms, which, linked by written texts, are arranged into an artist's book.

The texts superimposed over the formal poetry conjured up by the light effects in the photographic pictures are melancholy in character, fragments of the artist's personal memories and thoughts concerning the shifting nature of the human soul.

Sara Skorgan Teigen

Norway, born in 1984
ICP — International Center of Photography, New York, NY, United States, 2011–2012
Fatamorgana — The Danish School of Art Photography, Copenhagen, Denmark, 2008–2009
www.saraskorganteigen.com

→ pp. 52–53:
Sara Skorgan Teigen, *Fractal State of Being*, 2012
Double-page spread from the book
29,5 × 41,5 cm
© Sara Skorgan Teigen

The artist's book entitled *Fractal State of Being* is constructed as a poem that explores the inner stirrings of the human soul.

Combining photographs, notes, and drawings, Sara Skorgan Teigen revisits the tradition of the sketchbook: ancillary works often relegated by art historians to the status of mere documents, these sorts of materials, in addition containing an artist's sketches and preparatory drawings, amount to a more or less partial anthology of her annotations and sources of inspiration.

Teigen then illustrates her own personal feelings — extremely abstract and fleeting, for most part — in the form of hybrid documents comprised primarily of photographs of stony and watery landscapes in which she "lays herself bare" in series of tableaux. Over these images she draws skeins of words, plant forms, and locks of hair, in both pencil and ink.

Leitmotivs that recur on each double page, these organic-looking drawings also seem to resonate with the title of the project. From the Latin *fractus*, meaning "broken," the term "fractal" designates an extremely indented geometrical object, in which a basic structure repeats itself endlessly at every scale. This reference to mathematics reinforces the fragmentary nature of Sara Skorgan Teigen's work, already manifest in the choice of the sketchbook structure.

Jan Brykczyński

Poland, born in 1979
Institute of Creative Photography, Silesian
University in Opava, Czech Republic, since
2013
The Polish National Film, Television and
Theater School in Łódź, Poland, 2002–2005
www.janbrykczynski.com

→ pp. 54–57:
Jan Brykczyński, from the series *Boiko*,
2009–2011
Inkjet prints
36 × 45 cm
© Jan Brykczyński

Jan Brykczyński's series of photographs entitled *Boiko* introduces us to the everyday life of an almost legendary ethnic group that have settled on the borders of the Ukraine in the Carpathian mountain range. Since no one member wields total control over the frontiers of his land, it seems as if this group has evolved in a territory with uncertain limits, chronologically as well as geographically.

In pictures that are highly individual in terms both of atmosphere and colour, Brykczyński seeks to return us to the past, to a world where time seems suspended and people are preoccupied with ancestral acts and objects that have long vanished from elsewhere.

As Polish photographer freely confesses, his intention in visiting the Boikos was to experience for himself the ideal of rural life in a primordial, perfect form.

The photographic series testifies to an experience during which Brykczyński immersed himself in a universe where, it is said, events can be caused by sorcery, where white magic rubs shoulders with black, and where good is never very far from evil. A paradoxical world, which Jan Brykczyński used to know only from folktales told him when he was a child, and which, in order to create this series, he spent almost three years tracking down among the Boikos.

Rachel Boillot

United States, born in 1987
Master of Fine Arts in Experimental and
Documentary Arts at Duke University,
Durham, NC, United States, 2012–2014
Tuffs University, Medford, MA, United States,
2005–2010
SMFA Boston — School of the Museum
of Fine Arts, Boston, MA, United States,
2005–2010
www.rachelboillot.com

→ pp. 58–61:
Rachel Boillot, *28531 The Postmistress's
Daughter, Harker's Island, NC* [p. 58, top];
27208 Bennett, NC [p. 58, bottom]; *31649
Jack, Postmaster and Sheriff, Stockton, GA*
[p. 59, top]; *71316 David at the Old Post Office,
Acme, LA* [p. 59, bottom]; *38630 Farrell, MS*
[p. 60, top]; *29923 Gifford, SC* [p. 60, bottom];
38839 John, Derma, MS [p. 61, top] and *28464
Marty's Place, Teachey, NC* [p. 61, bottom],
from the series *Post Script*, 2013
Inkjet prints
50 × 63 cm
© Rachel Boillot

In 2011, 3,653 post offices were shut down in the US, mainly in the Southern states, and, since then, the rate of closures has steadily accelerated. In an increasingly digitized landscape, the fate of the postal service earlier generations grew up with looks doubtful and it is surely condemned in the long term to a slow but inexorable demise.

Like an archaeologist faced with the impending loss of a jewel of cultural heritage, Rachel Boillot has travelled to several of the localities affected to record them before they disappear completely.

Once on location, she found much more than mere post offices: she discovered places where people chat and interact; living, breathing places at which entire rural communities are used to meeting up.

Moreover, the young American artist quickly realized the links between this side-effect of modern social development and her own chosen medium. As the world switches to digital, what can the future hold for analogue photography?

What role is left for film, for the negative, for the tangible medium? Like letters, film photography seems imperilled. And Rachel Boillot pursues the analogy further, reflecting on how, when an envelope is sealed — or a film exposed —, their fate becomes independent of their creator. Once a letter reaches its recipient, the sender can never take back what she has written; in this she is just like the photographer, who has to learn how to relinquish control over events that occur after the shutter has clicked.

Corinne Silva

United Kingdom, born in 1976
London College of Communication, UAL —
University of the Arts London, London, United
Kingdom, 2009–2013
University of Brighton, Brighton, United
Kingdom, 2007–2009
NTU — Nottingham Trent University,
Nottingham, United Kingdom, 1999–2002
www.corinnesilva.com

→ pp. 62–63:
Corinne Silva, *New suburb of Tangier placed
in former mining region La Unión, Murcia*,
from the series *Imported Landscapes*, 2010
Inkjet print
80 × 100 cm
© Corinne Silva

Rather than as a purely documentary record, the three parts that make up *Imported Landscapes* — the result of Corinne Silva's discovery of the geomorphic similarities between the landscape of the south of Spain and that of Morocco — need to be approached as in situ installations.

While crossing from the Moroccan coast near Tangier to the Algerian border, the British artist was forcibly struck by how closely the scenery resembled what she was familiar with in southern Spain. If factual analogies — of climate, flora, fauna, etc. — abound, the resemblance also stems from shared traditional trading practices, as well as from invasions and waves of migration.

Silva then reinterprets these similarities by importing the Moroccan landscape over to the other side of the Straits of Gibraltar. Once back from her travels, she places giant posters of the photographs she took in Morocco on hoardings erected in the region of Murcia.

These new, imaginary landscapes invite viewers to reconsider the relationship between North and South and the porosity of borders, simultaneously adding a new chapter to the venerable history of landscape photography.

Giacomo Bianchetti

Switzerland, born in 1982
CEPV — Ecole de photographie de Vevey,
Vevey, Switzerland, 2010–2013
www.giacomobianchetti.ch

→ pp. 64–65:
Giacomo Bianchetti, *ZFS*, from the series
Can I?, 2012
Inkjet print
50 × 40 cm
© Giacomo Bianchetti — CEPV

Subtitled "an experimental device to test the limits of power," the series *Can I?* by the Swiss Giacomo Bianchetti investigates the relationship between the twenty companies quoted on the SMI (Swiss Market Index) and the concept of public space. Bianchetti employs his chosen medium to personally confront these corporations, whose ultimate purpose is to generate profit, even if this sometimes means employing ethically dubious means.

His action consists in placing himself on the public highway, just in front of the entrance to the headquarters of each firm, on the very edge of their private property. Armed with a large-format camera — selected as much for its visibility as for aesthetic reasons — Bianchetti's act is one any citizen might make and comparable to a perfectly normal request for information, if more noticeable and more deliberate.

This direct, physical face-off with power aroused reactions of astonishment, outrage even. The texts accompanying these architectural views recall the subsequent interactions (or the lack thereof), in what amounts to a critique of Switzerland's legendary laconism and its preoccupation with discretion and anonymity.

Karel Koplimets

Estonia, born in 1986
Estonian Academy of Arts, Tallinn, Estonia,
2005–2013
FAMU — Film and TV School of Academy
of Performing Arts in Prague, Prague, Czech
Republic, 2007–2008
www.karelkoplimets.com

→ pp. 66–67:
Karel Koplimets, *Case N° 8. You'll Always Find
Me in the Kitchen at Parties*, 2014
Installation (gelatin silver prints,
28,5 × 38,5 cm; video, 15'13" and body bags)
Various dimensions
© Karel Koplimets

Statistics inform us that the majority of homicides in Estonia are committed on private property and, for the most part, the perpetrator is well known to their victim. Those responsible are frequently under the influence of alcohol and act without premeditation, grabbing the first weapon that comes to hand.

Following on from a previous piece, *Suburbs of Fear* (2012), which already dealt with insecurity in the outskirts of several Estonian cities, Karel Koplimets continues his investigation of the mechanics of fear, a social phenomenon he evokes in diverse media.

Here the artist conducts viewers through an installation featuring video, a sequence of silver prints, and body bags so they can experience for themselves the menace of crime and brutally confronting them with its disastrous consequences.

Yet a threshold has clearly been crossed: if *Suburbs of Fear* was set in dark alleyways at night, this new work leaves the city streets to enter the home, thus suggesting that the threat lurks everywhere and that it is perhaps nearer than one thinks.

Ulrike Schmitz

Germany, born in 1975
Ostkreuzschule für Fotografie, Berlin,
Germany, 2008–2012
Rheinische Friedrich-Wilhelms-Universität,
Bonn, Germany, 1997–2001
Universität Hamburg, Hamburg, Germany,
1994–1996
www.ulrike-schmitz.com

→ pp. 68–69:
Ulrike Schmitz, *Museum of your Memory*,
2012
Inkjet prints
40 × 40 cm each
© Ulrike Schmitz

Following the radical change of direction that led Ulrike Schmitz from the study of law to that of photography, the *Museum of your Memory* deals with a subject bound up as much with German history as with her own life.

Within the context of German reparations after the Second World War, in 1946 several thousand German scientists working in aviation were forcibly removed, together with their families, to Stalin's USSR to add their efforts to the development of the nation's aircraft industry. Uprooted from Germany and prevented for several years from going home, the scientists saw themselves obliged to begin a new life in the outskirts of Moscow. If some never made it back, Ulrike Schmitz's own family returned to Germany after eight long years languishing in the village of Podbrezje.

In an explicit act of remembrance, the Berlin artist has tracked down traces of her grandparents deported to the Soviet Union some sixty years ago. In what is a very intimate installation, she juxtaposes photographs of present-day Podbrezje taken on her travels with doctored stills from Russian propaganda films of the Stalinist era.

As she freely confesses, Schmitz thus discovered her "own reality — independent of the past and distorted by media, but, maybe, possessing its own truth."

Constance
& Philippine Proux

France, born in 1991 and in 1986

Constance Proux:
ESA LE 75 Ecole Supérieure des Arts,
Brussels, Belgium, 2012–2014
ERG — Ecole de recherche graphique,
Brussels, Belgium, 2011–2012
Université de Paris-Sorbonne, Paris, France,
2008–2011

Philippine Proux:
Ecole Normale Supérieure de Cachan, France,
since 2013
Ecole Normale Supérieure de Lyon, France,
2007–2013

→ pp. 70–71:
Constance & Philippine Proux, *Akkar*, 2014
Double-page spread from the book
23,5 × 30,5 cm
© Constance & Philippine Proux

Translation from the book (p. 71):

Hussam, a charismatic 30-year-old, is a well-known local figure. Together with his wife, he runs the store that supplies the camp and oversees a worksite to build a dozen small mud houses at the edge of the camp. Very popular, Hussam always has people around him, but he prefers to speak to us alone because what he has to say is difficult.

We take a walk so that we can talk. The sun is setting on the wheat fields. In front of this spectacle, Hussam says that he is a man of the countryside and that people who live in the countryside naturally have a beautiful soul. In his region, the countryside surrounding al-Qusayr, nature is beautiful and generous and people live in harmony. Ismaelites, Sunnis, Alawites — regardless of their religion.

The jacket that Hussam is wearing today is an important memory. Even beautiful, he says.

The winters are harsh where he lives. At the beginning of the revolution, all of the men in Hussam's village got together and made a group order for the same jacket — easier and less expensive — to keep themselves warm during peaceful demonstrations. They organized their trips together and all went to demonstrate in al-Qusayr.

The *Akkar* project is the product of the collaboration between two sisters, Constance and Philippine, both motivated by the desire to address an issue at once topical and dramatic: that of refugees fleeing to escape conflict and desperate to improve their lives.

Rejecting sweeping statements and facile platitudes, in constructing their polymorphic view of the problem the sisters appropriate the classic codes of documentary.

The project initially saw the light of day as a book. By the time they had collected testimonies from many Syrian and Lebanese refugees and recorded their extraordinary personal accounts and life stories, the Proux sisters had amassed a substantial corpus they were determined to transmit in their turn.

Condensing countless hours of conversation into a brief text recounting the subject's journey and exile, the written material is underpinned visually by photographs: portraits, objects, and landscapes. In the end, it seems not to matter whether the words are a commentary on the images or vice versa.

Once in the exhibition space, the project morphs into a fully fledged installation. Leaving the printed page, the images line the walls, while the texts become scattered words, thereby complementing the photographs and rekindling the debate around the complex text/image relationship.

Artur Gutowski

Poland, born in 1990
The Polish National Film, Television and Theater School in Łódź, Poland, since 2010
Universitas Kristen Petra in Surabaya, Indonesia, 2013–2014
www.arturgutowski.com

→ pp. 72–73:
Artur Gutowski, from the series *Topeng Monyet*, 2014
Inkjet prints
50 × 33 cm
© Artur Gutowski

Topeng Moyet (literally "masked monkey") is a project centred on the "monkey shows" of Indonesia, which consist in exhibiting various primates trained to perform acrobatic numbers, such as driving a motorbike, using a mobile telephone, or saluting like a soldier. Following pressure from animal rights organizations, this street art is in the process of being banned throughout Southeast Asia.

Wearing masks made from doll's heads, the monkeys are retired after just five years; injured and traumatized, those that did not die on tour end their days tied to a tree in their owner's garden.

Shot in Surabaya when the practice was not yet forbidden, Gutowski's photographs revisit the codes of the traditional portrait, thus further enhancing the anthropomorphic character of these strange performances. The Polish photographer poses the monkeys in full costume, tightly framed against a black background, so they resemble figures in an open-air theatre waiting for the curtain to rise.

The critical distance apparent in this gallery of portraits with respect to the coercive nature of an entertainment intended oddly enough primarily for children is denoted by the invariable presence of chains behind each masked figure.

Gaia Squarci

Italy, born in 1988
ICP — International Center of Photography, New York, NY, United States, 2011–2012
University of Bologna, Bologna, Italy, 2007–2010
www.gaiasquarci.com

→ pp. 74–77:
Gaia Squarci, *Alexandra Hobbes, blind since the age of four because of domestic violence, listens to the television in the apartment where she lives with her husband Elijah Hobbes, albino and visually impaired. The blind listen to television and hope for a device that more fully describes scenes so they can enjoy the programs on the same level as the hearing impaired. New York, NY. April 16, 2012* [pp. 74–75], *Installation view* [p. 76] and *Collin Watt, visually impaired, climbs a rope in his backyard. He is a karate teacher for the visually impaired and works out daily. Queens, New York. July 10, 2012* [p. 77], from the series *Broken Screen*, since 2012
Installation (inkjet prints, 40 × 60 cm; bas-relief prints, 20 × 30 cm and audio tracks)
© Gaia Squarci
p. 76: © Laurence Cornet for the design
p. 77: © Fray DeVore for the drawings

Starting with the fact that the blind have to live in a sighted world and are subjected to its rules and *modus operandi*, Gaia Squarci's interest focuses on people who lost their sight at one point during their lifetime, and thus who have had to reconstruct their identity and their relationship to the world. The Italian artist thereby deploys

the concept of blindness as a metaphor for a reality she invites viewers to experience in *Broken Screen*.

Each section of her installation comprises a black-and-white photograph that evokes this new existence, a bas-relief image, and samples of sounds. Whereas the photograph hanging on the wall is hidden behind a piece of cloth, visitors wearing headsets can listen to a description of it recorded in a loop by people of all ages and cultures — a decision designed to ensure diversity and to underscore the subjectivity of our perceptions.

As they listen, visitors can familiarise themselves with the scene in the image by feeling a bas-relief of it placed just beneath the photograph. Produced from a digitized image in which the dark areas are printed out in relief, this Braille reproduction functions as a tactile pendant to the photograph taken by the artist. Both the audio and the bass-relief join to form a mental image in the mind of the beholder. Only then does he or she lift the cloth to unveil the original photograph.

The goal of the piece is to call in question the predominance of the visual in our perception of reality. In *Broken Screen*, Squarci appeals to visitors to ponder our reactions when exposed to diverse stimuli and thus reminds us that photography presents just one view of reality, and never reality itself.

Emily Macinnes

United Kingdom, born in 1989
NTU — Nottingham Trent University, Nottingham, United Kingdom, 2009–2012
www.emilymacinnes.com

→ pp.78–81:
Emily Macinnes, *Anthony (44)* [pp.78–79]; *Patrick (53)* [p.80] and *Mark (64)* [p.81], from the series *Paradise Lost: Testimonies of Abuse*, 2013
Inkjet prints
30 × 30 cm
© Emily Macinnes

Begun in 2012, Emily Macinnes's project deals with the rarely broached issue of sexual abuse committed on men. Travelling through the United Kingdom and meeting male victims, the young Scottish photographer and journalist collects statements and confessions that had sometimes remained unsaid until her intervention. With a consummate command of the art of portraiture in both image and word, the profound sense of dignity with which Macinnes endows this singularly powerful series is most impressive. If her work casts light on the sheer amount of sexual abuse carried out on males, beneath the surface it is the shame and secrecy surrounding this scourge that transpires most forcefully.

Paradise Lost: Testimonies of Abuse also confronts a prevalent discrepancy in attitude with respect to men, often perceived uniquely as perpetrators of abuse and seldom as victims. In tackling head-on such a traumatic theme in a candid yet sensitive manner, Macinnes lifts the veil on a widespread social phenomenon. Her choice of a title derived from John Milton's epic, which endeavours to "justify the ways of God to men," only stresses more acutely the unjustifiable nature of such acts that coincide, surely, with the loss of the paradise of childhood.

Martyna Pawlak

France/Poland, born in 1988
Ecole nationale supérieure Louis-Lumière, Noisy-le-Grand, France, 2009–2012
www.martynapawlak.fr
www.followingme.fr

→ pp.82–85:
Martyna Pawlak, *Nadine* [pp.82–83] and *Jessica Daubertes et Monsieur Monsieur* [pp.84–85], from the series *Following*, 2012
Video
3'56"
© Martyna Pawlak

A multimedia series on digital identity, *Following* presents a gallery of portraits created from Twitter accounts.

In order to question our daily digital experience, Martyna Pawlak turns the spotlight on the American social network, whose popularity has grown in leaps and bounds since its creation in 2006 and which today reaches into millions of homes.

By visiting each of them personally, the Franco-Polish artist's portraits show the participants in the project in their everyday setting. On an Internet platform she has created herself — www.followingme.fr — she then confronts Twitter users with their avatar, thus teasing out the coincidences and discrepancies between an individual's true identity and that of their digital double.

Each photograph in the installation is accompanied by a synthetic voice that reads out tweets posted on the update thread of each avatar. At once weird and funny, some of the, often pointless, comments in the resulting sequence are extremely sarcastic.

The series thus reveals the overlap between what is private (a home setting shown in photographic portraits) and the kind of digital anonymity behind which it is always possible to hide. Dubbed an "artistic-digital initiative" by one of the protagonists, this burningly topical project speaks volumes as to our multivalent interactions and identities in what is an ultra-connected society.

Paul Samuels

South Africa, born in 1989
The Wits School of Arts, University of the Witwatersrand, Johannesburg, South Africa, 2008–2012
www.paulsamuels.co.za

→ pp.86–89:
Paul Samuels, *Darren* [p.86, top]; *Lorcan* [p.86, bottom]; *Warren and Russel* [p.87, top]; *Sean* [p.87, bottom] and *Ethan* [pp.88–89], from the series *XVI X*, 2012–2014
Inkjet prints
55 × 75 cm
© Paul Samuels

Named after the postcode for the unassuming Johannesburg suburb of Edenval, Paul Samuels' series *XVI X* had its origin in an offer from the owner of a tattoo parlour with the district's insignia on his ankle to do something similar for the young South African artist as a twenty-first birthday present. Naturally, Samuels jumped at the chance to be emblazoned with a motif he had long admired on the biceps of other guys in the neighbourhood. Only later did he start to question their sense of identity and to investigate the real reasons behind it.

Though Samuels is not fond of the term "fraternity," this is what it is: a feeling of belonging to the same group, geographically circumscribed and defined by shared sociocultural values.

These white, middle-class South African children are certainly assailed by questions of identity — an understandable phenomenon in a nation still scarred by the Apartheid years.

The pastimes, such as heavy metal and skateboarding, that bind them together seem to conceal a certain angst. "Young and angry," Samuels describes them. Without always knowing why, nor about what. Perhaps it's the feeling of injustice when they compare their lot to that of the spoiled brats in the nearby suburb of Bedfordview, all smart houses, designer clothes, and fast cars.

XVI X is though less an objective portrait of disaffected youth and more a dive into the photographer's own everyday existence: the models are all childhood friends, neighbours, or family members. The participative aspect of the project is key. The poses are chosen by the sitters themselves, eager to massage the image they project. Collaborators on the artwork rather than subjects in a documentary, they soon betray the sense of fragility that lurks beneath the strutting and posturing. A trace, in all probability, of the close relationship between them and their compassionate observer.

Laurence Rasti

Switzerland, born in 1990
ECAL — University of Art and Design, Lausanne, Switzerland, 2011–2014
CFPAA — Professional Training Center in Applied Arts, Geneva, Switzerland, 2005–2009
www.laurencerasti.ch

→ pp.90–93:
Laurence Rasti, from the series *Il n'y a pas d'homosexuels en Iran*, 2014
Inkjet prints
55 × 44 cm
© Laurence Rasti / ECAL

Iranian by both her parents, Laurence Rasti grew up in Switzerland, resulting in a cultural hybridization that very early on spurred her to explore the often paradoxical concepts of identity embedded in the two cultures in an effort to confront questions of power and sex and the border between masculine and feminine.

Whereas more and more Western countries authorise marriage between people of the same sex, in Iran homosexuality is still punishable by death. Since it is considered pathological, transsexuality remains the only practice tolerated by law, and as such it has become the sole option for citizens who choose to stay. The majority of such young people, however, opt to leave their homeland and flee to countries where they can live their sexuality free of oppression.

Profoundly immersive, Rasti's work led her to Denizli, a small town in Turkey through which transit hundreds of Iranian homosexual refugees waiting for a permit to travel to a land of refuge where they will be able to regain their lost freedom.

In a context in which anonymity remains the safest option, the series of photographs *Il n'y a pas d'homosexuels en Iran* [*There are no homosexuals in Iran*] questions fragile concepts such as identity and gender, and endeavours to

bestow a face on young people temporarily robbed of their own.

Nobukho Nqaba

South Africa, born in 1992
Michaelis School of Fine Art, University of Cape Town, Cape Town, South Africa, 2009–2013

→ pp.94–95:
Nobukho Nqaba, from the series *Umaskhenkethe likhaya lam*, 2012
Inkjet prints
30 × 20 cm
© Nobukho Nqaba

"Umaskhenkethe" is one of many terms in the Xhosa language spoken in Southern Africa to designate those Chinese-made plastic bags ubiquitous nowadays in low-income families. Meaning literally "traveller," it has become a global symbol for migration, voluntary or involuntary, long-distance or local.

For Nobukho Nqaba, born and bred during Apartheid, these bags remind her more especially of her mother, a key figure in her life and the mainstay of the family, who, whenever she visited relations on farms in Cape Province, would bring back bags just like these bulging with homemade sweets. For Nqaba, this mundane article offers a constant reminder of the past and of a childhood spent on the road locked in the daily struggle for a better future.

Since on the road she has often had to pack away all she owns in such a bag, she has grown to see it as a kind of home. It is then only natural that Nqaba's work involves the reconstruction, in studio, of an interior lined entirely with these "China bags," among which she acts out her life in a new abode emblazoned with their instantly recognisable crisscross pattern.

Jennifer B. Thoreson

United States, born in 1979
UNM — University of New Mexico, Albuquerque, NM, United States, 2011–2014
University of Texas at Arlington, Arlington, TX, United States, 1998–2001
www.jenniferthoresonfineart.com

→ pp.96–99:
Jennifer B. Thoreson, *Cancer* [pp.96–97]; *Hair Cloak* [p.98, top]; *Soulmates* [p.98, bottom]; *Little Baby* [p.99, top]; *Inseparable* [p.99, bottom], from the series *Testament*, 2014
Inkjet prints
40 × 50 cm
© Jennifer B. Thoreson

Jennifer B. Thoreson's art revisits themes associated with human fragility, pain, vulnerability, and disease — and, finally, with the resilience that suffering can bring to the fore.

Focusing on the complexity of relationships — ties of blood, as well as love and friendship —, the American photographer's interest focuses on that particular moment when catastrophe lurks just around the corner, when relationships are pushed to breaking point by the vagaries of existence, when the burden seems so heavy that it threatens to drag you down.

To create her series *Testament*, Thoreson rented an empty house, spending almost a year converting it into a makeshift sanctuary that serves as a backdrop to her painstakingly devised scenes. The objects appearing in the image are manufactured out of wool, clay, beeswax, or even human hair — a choice of materials that alludes to the symbolic language of the Bible.

While the sculptures reference the artist's childhood, the house too resembles a home in rural Texas — a place of strict religion and discipline in which Thoreson spent her early years.

Sinan Tuncay

Turkey, born in 1986
SVA — School of Visual Arts, New York, NY, United States, 2011–2013
SU — Sabanci University, Istanbul, Turkey, 2005–2010
www.sinantuncay.com

→ pp. 100–101:
Sinan Tuncay, *Bridal Bath* [p. 100]; *Illegitimate* [p. 101, upper left]; *Prayer* [p. 101, upper right]; *Votive* [p. 101, lower left] and *Wedding Night* [p. 101, lower right], from the series *Public Intimacy*, 2015
Inkjet prints
80 × 56 cm
© Sinan Tuncay

Public Intimacy is a series of five photographic tableaux directly inspired by the pictorial style of the miniatures illustrating the great manuscripts of the Ottoman Empire from the fifteenth-century. Aping key components in their composition, the Turkish artist here replaces meticulous painting with photography, addressing this time-honoured illustrative tradition from a contemporary angle.

The pictures are built up from a collage of a hundred or so images, some taken by the artist, some from extraneous sources.

All the characters consist in minor variations on two figures; a man and a woman, whose faces, photographed separately, are joined to several bodies in different postures, each ostensibly embodying an "Oriental" stereotype.

Setting aside the essential theme of the original miniatures — ceremonial life under the sultans —, Tuncay reconfigures their pictorial codes to depict the ordinary but symbolic phases of Turkish life, such as marriage.

The series opens with the bride being bathed, a tradition that demands the future wife be washed in the presence of her in-laws. Concluding with the wedding night, culturally the bath functions as a celebration of the loss of virginity.

By juxtaposing private and public life, this project thus aims to explore the paradoxical codes that underlie social self-presentation in modern Turkey, a country that remains patriarchal and fixated by fantasies of female virginity and the heteronormative male image.

Rachel Cox

United States, born in 1984
UNM — University of New Mexico, Albuquerque, NM, United States, 2010–2013
University of North Texas, Denton, TX, United States, 2003–2006
www.rachelcoxphotography.com

→ pp. 102–105:
Rachel Cox, *Mind Meld* [p. 102]; *Bequeath This, Glass I* [p. 103]; *Wiglet 11* [p. 104, upper left]; *Wiglet 12* [p. 104, upper right]; *Don't Smile, Smile* [p. 104, bottom]; *Casket* [p. 105, top] and *Two-turtles* [p. 105, bottom], from the series *Shiny Ghost*, 2012
Inkjet prints
75 × 75 cm [p. 103 and p. 105, bottom]; 60 × 50 cm [p. 102] and 45 × 45 cm [p. 104 and 105, top]
© Rachel Cox

In *Shiny Ghost*, Rachel Cox investigates her growing relationship with her dying grandmother as she gradually lost her battle against a degenerative brain disease. Instead of focusing on the illness itself, the photographs highlight the interactions between the two women and the vanity the granddaughter sometimes attributed to the old lady. Confronting the imminent loss of a family member, the artist re-examines the photographs she took, building them into a narrative that forms a record of their daily meetings and conversations.

Lavishing especial care on the composition and ordering of these photographs of places, of her grandmother and of her belongings, Cox testifies to the final moments of a life slowly flickering out.

The camera thus becomes a prosthesis that conveys an intimacy the protagonists never really shared before — as if, as the end neared, the potential for a kind of mutual absolution was realised at last.

Juno Calypso

United Kingdom, born in 1989
London College of Communication, UAL — University of the Arts London, United Kingdom, 2010–2012
Chelsea School of Art, UAL — University of the Arts, London, United Kingdom, 2007–2008
www.junocalypso.com

→ pp. 106–107:
Juno Calypso, *12 Reasons You're Tired All The Time*, 2013
C-Type print
153 × 102 cm
© Juno Calypso

Juno Calypso deals with self-portraiture, advancing a critical stance on modern rites of seduction and beauty by deploying the character of Joyce, a fictional double.

Setting up her avatar in various imaginary interiors, in which the least detail is carefully contrived — a powder-pink bedroom; a secretary's office invaded by 1980s computer equipment; a reception desk in a beauty parlour, etc. — the London artist uses Joyce both to call into question femininity as a construct and to denounce the planned obsolescence of hi-tech devices.

The multidisciplinary artist's video entitled *The Linda Evans Rejuvenique Facial Toning System* (2012), selected to appear in the exhibition *re*Generation³, operates as a spoof on an old advertisement praising the merits of an electronic anti-wrinkle mask. Typical of the artist's weirdly kitsch world, not even its countless layers of nail varnish and foundation quite manage to drown out the undercurrent of feminist critique.

Jonna Kina

Finland, born in 1984
University of the Arts Helsinki, Academy of
Fine Arts, Helsinki, Finland, 2006–2013
Aalto University School of Arts, Design and
Architecture, Helsinki, Finland, since 2010
SVA — School of Visual Arts, New York, NY,
United States, 2013
Bezalel Academy of Art and Design,
Jerusalem, Israel, 2008–2009
www.jonnakina.com

→ pp. 108–111:
Jonna Kina, *Empty space; Dinosaur skin;
Shotgun; Chair; Champagne; Wind* [p. 108];
Waves; Bed; Church bell; Snow; Pigeons; Fire
[p. 109] and *Leaves of grass* [p. 111], from the
series *Foley Objects*, 2013
Inkjet prints
38 × 38 cm
© Jonna Kina

In 1956 René Magritte declared: "A thing which is present
can be invisible, hidden by what it shows." It is an apho-
rism that perfectly sums up the work of Jonna Kina.

The series *Foley Objects* presents about thirty objects —
everyday things for the most part — in an equal number
of photos, each accompanied by a short caption. At first
blush, the latter seems to bear no relation to the image
associated with it, conjuring up an atmosphere of surreal-
ist weirdness.

Then, little by little, it dawns on the viewer that the phrase
relates to the sound made by the object depicted. Once
this principle is grasped, perusing this gallery of images
becomes not only disconcerting but fun too. And it is not
long before one catches oneself hearing the photos.

In audiovisual parlance, the term "Foley" designates sound
effects added to a movie at postproduction. The noise of
footsteps, of a door slamming, of a piece of paper being
screwed up — the types of sound not easily recorded
during the shoot. The Finnish artist organises photographs
of the objects used by technicians to reproduce these
sounds into a typology. Yet this arrangement quickly
appears as more than a mere nomenclature, since, above
and beyond its purely documentary approach, the series
offers a veritable experience of synaesthesia that requires
us to reflect on our perceptions and on the limits of the
text/image relationship.

Veronika Geiger

Denmark, born in 1987
The Glasgow School of Art, Glasgow, United Kingdom, 2009–2012
Iceland Academy of the Arts, Reykjavik, Iceland, since 2014
UNM — University of New Mexico, Albuquerque, NM, United States, 2010

→ pp. 112–113:
Veronika Geiger, *Dream Collection*, 2014
Installation (gelatin silver prints, printed captions and archival gloves)
50 × 40 × 6 cm
© Veronika Geiger

Works by multidisciplinary artist Veronika Geiger — photographs, video, and sculpture installations — investigate the concepts of gravity and time, with a predilection for themes such as the sky and the action of flying.

Dream Collection presents a box containing a selection of anonymous found photographs of aeroplanes in flight. To this the artist appends a selection of verbs that these images evoke — "fold, prepare, look, recall, lift, launch, leap, go, propel, soar, hover, fly" —, presented here in the same container, together with the photos. Underlining the artist's physical intervention and the contemplative character of her approach to the images, the careful ordering of the texts contrasts with the less regular arrangement of the photos.

The inclusion of a pair of white gloves in the installation incites visitors to associate the verbs with the photographs: thus, *Dream Collection*, with poetry and subtlety, addresses the question of the interpretation of the image.

Loan Nguyen

Switzerland/France, born in 1977
HEAD Genève — Haute école d'art et de design de Genève, Switzerland, since 2012
CEPV — Ecole de photographie de Vevey, Vevey, Switzerland, 1997–2000
www.loan-nguyen.net

→ pp. 114–117:
Loan Nguyen, *Le chemin de l'eau*, 2014
Filmed performance
10'
© Loan Nguyen — HEAD

First and foremost, *Le chemin de l'eau* [*The path of water*] is a record of a story about a group of hikers on an ill-fated excursion through the Vaud Alps: trapped on a steep path from which there is no way down, they eventually had to be rescued by the emergency services.

Loan Nguyen's interest centres on the act of performance: in the presence of the gallery-goers, the artist recites testimony from one of the missing women that tells of her misfortune and that of her companions on the excursion, all the while folding and unfolding a large, physical map in time with the story and with the mounting tension between the imprudent ramblers.

If video thus becomes a tool for documenting the performance, the map, complete with the bumps and creases left by the new folds, affords its tangible trace.

The piece is supplemented by material gathered from a visit Loan Nguyen made to the scene of the hike: photographing various objects she found there, which, as she sees it, constitute evidence for the narrative (bits of wood, puddles, pebbles), she has gradually assembled a purely imaginary inventory of memories.

Irene Muñoz Martin

Spain, born in 1991
HEAD Genève — Haute école d'art et de design de Genève, Switzerland, since 2012
UCM — Universidad Complutense, Madrid, Spain, 2009–2013

→ pp. 118–119:
Irene Muñoz Martin, *La Vague*, 2014
Video
13'08"
© Irene Muñoz Martin — HEAD

→ p. 119:
Photographs by Marino Borga from *La Vague*
© Marino Borga

Madrid, November 20, 1975. For the very first time, Spain plays host to the 7th World Eurhythmics Championships. On the same day, comes news of the death of the dictator, Franco.

In her video work, Irene Muñoz Martin confronts these two concomitant events, using a fictional account of her mother's presence in the crowd at the competition to set up a dialogue between them. Representing an entire generation that grew up under Franco, the then young woman becomes a function of the debate that sprung up during the four-day event that witnessed the turning of an important page in the nation's history.

The video's hypnotic voiceover intones observations on a society whose national identity was shaken to its foundations by Franco's death, echoing in the process the Hispanic artist's concerns some forty years later as to how collective memories are constructed.

So as to address the issues that interest her, Muñoz Martin's artistic practice (video, photography) often couples art and autobiography and her pieces chiefly originate from personal experience — her own or that of others. Assembled from archive film and more recent, personal photographs, *La Vague* [*The Wave*] seeks to understand how we retroactively apprehend history in accordance with what has been handed down to us, as well as with our own memories and life experiences. "Showing us through metaphor," the artist concludes, "how recollecting and reactivating our memory amounts, in fact, to a kind of mental gymnastics."

Silin Liu

China, born in 1990
Tsinghua University, Beijing, China, since 2013
LAFA — Lu Xun Academy of Fine Arts, Shenyang, China, 2008–2012

→ pp. 120–123:
Silin Liu, *Andy Warhol and Me*, 2014 [p. 120, top]; *Soong May-ling and Me*, 2012 [p. 120, bottom]; *Marilyn Monroe and Me*, 2014 [p. 121, top]; *Frida Kahlo and Me*, 2014 [p. 121, middle] and *Simone de Beauvoir and Me*, 2013 [p. 121, bottom], from the series *Céline Liu*, 2012–2014
Inkjet prints
8,3 × 8,3 cm [p. 120 and p. 121, top]; 10 × 7 cm [p. 121, middle] and 7 × 10 cm [p. 121, bottom]
© Silin Liu

Céline Liu — the Westernised form of the artist's name — is a series that began in 2012, when the Chinese photographer became interested in those charismatic figures of femininity who are now, in her eyes, universally recognized icons.

Collecting photos of her subjects from the Internet, Silin Liu, a dab hand at digital photo retouching and manipulation, appropriates them by adding a picture of herself.

The photographs she doctors are very diverse in origin: commemorative or documentary, commercial or artistic, they all possess a unique context and backstory.

Her intention, as well as to rub shoulders with timeless celebrities, is to constitute a new context for the images, breathing new life into them and simultaneously addressing the issue of cultural globalisation. In order to reinforce still further the already ambiguous nature of these composite images, the artist here plays fast and loose with their private, intimate character.

By choosing a small format, Liu embraces the aesthetics of the family scrapbook, though the photos are framed in large mounts that accentuate their precious, almost votive quality.

Michael Liani

Israel, born in 1987
Minshar School of Art, Tel Aviv, Israel,
2010 – 2014
Bezalel Academy of Art and Design,
Jerusalem, Israel, since 2014
The Open University, 2011 – 2015

→ pp. 122 – 123:
Michael Liani, *A.A. (Authentic Authenticity)*,
from the series *Migdal HaEmek*, 2014
Video
5'19"
© Michael Liani

The tautological character of the title of this film is deceptive: the thinking behind it is far less straightforward than it might lead one to believe. Tackling the question of sexual identity as it is perceived in Eastern and Western cultures, this black-and-white piece offers a glimpse of the tension between these two very different worlds.

Of Moroccan origin, Michael Liani was born and grew up in Migdal HaEmek, a small satellite town in northern Israel. As a teenager, he struck out for the "big city," as much in a search for himself as in a bid for independence. Once in Tel Aviv, known as the "white city" owing to its sleepless nights, Liani soon found himself living in a bubble in which religions, cultures, and sexualities mix and mingle. Drawing on these experiences, he has since endeavoured through video and photography to give account of the "hybridization" he discovered in the capital.

To the accompaniment of a pounding soundtrack interrupted by abrupt silences, viewers are invited to enter a cosy living-room in which every stereotype is rehearsed. Conjuring up distant memories of his family life, the short video shows three adolescents — two girls and a young boy — observing their movements as they perform an enraptured Oriental dance routine.

Conforming to the female/male dichotomy thus established, the whole piece is framed around duality: between East and West, motion picture and still, music and silence… A world of division in which one still has to find a place and forge one's authenticity.

Piotr Zbierski

Poland, born in 1987
The Polish National Film, Television and
Theater School in Łódź, Poland, since 2006
www.piotrzbierski.wordpress.com

→ pp. 124 – 127:
Piotr Zbierski, from the series *Love Has to Be Reinvented*, 2012 – 2015
Installation (inkjet prints, 60 × 60 cm;
Polaroids, 10,8 × 8,8 cm and video, 38'52")
© Piotr Zbierski

Love has to be Reinvented is a multimedia installation that explores the domain of the intimate in a combination of photography, video, and audio. The predominance of close-up corresponds to Zbierski's stated ambition "to get closer to life and to people, to be able to look them straight in the eye."

To this end, the artist, often with a touch of wistfulness or fantasy, treats his photographic practice as a means of materializing human feelings.

By opting for photographic techniques and media from the past — gelatine silver film, Polaroid for its colour, archive pictures for the video — Zbierski accentuates a dreamlike atmosphere in which lack of focus seems motivated by the desire to capture the "image behind the image," to seize those instants when the unconscious fleetingly re-emerges and floats back to the surface.

It is then no surprise to hear the artist confessing to being deeply moved by a fragment from Jean Cocteau's diaries in which the poet compares the "world of his dreams" to a second life, possessed of its own storehouse of memories.

As for knowing which has priority, looking or remembering, waking or sleeping, the photographer does not say.

Karl Isakson

Sweden, born in 1983
The Royal Danish Academy of Fine Arts,
School of Visual Arts, Copenhagen, Denmark,
since 2009
www.karlisakson.com

→ pp. 128 – 129:
Karl Isakson, *Home, 1000 Photographs*, 2011
16 mm film loop
© Karl Isakson

In *Home, 1000 Photographs*, Karl Isakson's interest is directed to the question of recording the real and to the documentary function of photography. The subject is his own house; the exercise — an exhaustive representation of this familiar environment.

Over a three-month period, Isakson took a thousand photographs of every last detail of his home. He then edited the series as 16-mm film footage and projected at 24 frames a second.

The choice of video for the images evokes the process that created the series, as well as its almost obsessive character, while opting for a mode of projection dating from the 1970s adds a certain materiality to the experiment.

Moreover, showing a thousand images condensed into a mere three-minute video loop, in such a compact format, ensures the spatial and temporal continuity of the series.

Through such operations, the work is less something the beholder deciphers than something that imposes a visual experience upon him, thereby exposing the fraught,

perhaps illusory nature of attempting to reproduce an object completely using photography, no matter the number of pictures taken.

Elizabeth Hewson

United Kingdom, born in 1991
University of South Wales, Newport, United Kingdom, 2011–2014
University of Gloucestershire, Gloucestershire, United Kingdom, 2010–2011
www.elizabethhewson.co.uk

→ pp. 130–131:
Elizabeth Hewson, *Lacuna*, 2014
Multimedia installation (slide show with sounds)
Various dimensions
© Elizabeth Hewson

Photographs crystallize moments from our past; they leave a physical trace that recalls feelings and memories relating to a single instant frozen in the memory. But what is their significance when they record a moment long-forgotten? Hewson's project explores the relationship between the photographic medium and this twilight zone of human memory.

The artist starts from her own personal experience, digging out old family photos that show events from her childhood she no longer recollects. The images of these lapses of memory are then converted into digital files and modified by inserting in their constituent binary code data relating to the subjects of the photographs: place names, people, dates, events.

Once pixelated, the codes present a distorted version of reality that creates the sense of unease we feel when faced with the erasure of part of our life. This discomfort is exacerbated by the distorted sounds accompanying the transparencies that are obtained by converting the original negatives into audio.

Hewson's installation thereby confronts viewers simultaneously with a projection of a disfigured image and with the initial photograph, but in sound form. The choice of media thus plays a crucial role in the artist's project. The slide show, a common event in the social calendar with family or friends from the 1960s on, in combination with the "synchrocorder" that synchronises sound and picture, offers a powerful contrast to the digital, dematerialized form of the photograph.

Above and beyond any autobiographical narrative, Hewson's piece thus contributes to the more general discussion about the everyday use of photography.

Anna Gutová & Gabriel Fragner

Czech Republic, born in 1977 and in 1973

Anna Gutová:
Institute of Creative Photography, Silesian University in Opava, Czech Republic, 2004–2013
www.annagutova.com

Gabriel Fragner:
Institute of Creative Photography, Silesian University in Opava, Czech Republic, since 2004
www.gabrielfragner.com

→ pp. 132–135:
Anna Gutová & Gabriel Fragner, *I Love My Family*, 2011–2012
Installation
Various dimensions
© Anna Gutová & Gabriel Fragner

The installation *I Love My Family* is a machine that lets us go back in time. Everything it contains — from the outmoded clothes, via the poses and hairstyles of the protagonists, to the detailing of the decor —, everything reminds us of a bygone and yet oddly familiar era. The wallpaper pattern, the way the furniture is arranged, the miscellaneous photo frames... Nothing, however small, is left to chance.

This, then, is the universe recreated by the artist tandem of Anna Gutová and Gabriel Fragner: viewers are invited to make their way into a "front room" where they experience for themselves a day in the life of a typical family in former totalitarian Czechoslovakia.

Derived from their own childhood memories, Gutová and Fragner play at mummy and daddy in a series of photographs one would be proud to have unearthed in one's own attic.

Yet, these outdated interiors also serve to show how nothing ever really changes. The stereotypes, whatever they may be, live on. Because, as Gutová and Fragner themselves conclude: "Life's moments are always the same; they only happen in different times."

Harit Srikhao

Thailand, born in 1995
Photo Phnom Penh, Phnom Penh, Cambodia, 2015
KMITL — King Mongkut's Institute of Technology Ladkrabang, Bangkok, Thailand, since 2013

→ pp. 136–139:
Harit Srikhao, *A Soul at the Stair* [pp. 136–137]; *Slices* [p. 138, top]; *Slow Ballad of the Universe* [p. 138, middle]; *Kids on the Fire Exit* [p. 138, bottom]; *Kids in a Spaceship* [p. 139, top] and *Kiss of the Dead Twin* [p. 139, bottom], from the series *A Boy Who Was Kidnapped by Time*, 2014
Installation (inkjet prints, 67 × 100 cm [pp. 136–137]; 1,2 × 1,1 cm [p. 138, top]; 20 × 30 cm [p. 138, middle]; 40 × 60 cm [p. 138, bottom and p. 139, bottom] and 73 × 110 cm [p. 139, top] and viewmaster)
© Harit Srikhao

"As I walked down the stairs and looked for my way out, I saw a group of kids playing in a corner of the lobby. It was amazingly strange to see them running and playing in a place like this. I just stood there watching them for a long time. I thought back to when I was a kid and used to play with friends in the same type of place. We never felt tired or bored of our adventures in the massive, endless universe."

This is how Harit Srikhao describes a photo piece imbued at once in immense nostalgia and a bewitching, dreamlike atmosphere.

A Boy Who Was Kidnapped by Time seems to lack all anchor in reality, neither in time nor space.

Each one of the Thai photographer's images evokes some fleeting memory of childhood, a telltale trace that emerges briefly from the past only to recede once again.

Yet, as the artist says, he has practically no true recollection of this past; as if this long-lost time had in fact never truly existed. Or rather, as if, resurfacing so frequently, it has finally merged with the present to form a disconcerting continuity.

Hung to take advantage of the images' diverse formats, the series conjures up memories that are constantly being reconstructed and whose trajectory is anything save linear. As for the child's vision, that can be re-experienced through the little viewer with which the installation concludes.

Emilie De Battista

Switzerland, born in 1988
ECAV — Ecole cantonale d'art du Valais,
Sierre, Switzerland, 2010 – 2013
HEAD Genève — Haute école d'art et de
design de Genève, Switzerland, since 2013
www.emiliedebattista.com

→ pp. 140 – 143:
Emilie De Battista, *Ombre portée*, 2013
Videos
Various lengths
© Emilie De Battista

Deploying an extremely poetic, almost melancholic idiom, the Swiss artist Emilie De Battista explores the intrinsic relationship of the concept of memory to photography. Projecting images taken from her personal archives onto thin layers of ice, she records the slow disintegration of the "screen" as it warms up and gradually melts.

Ombre portée [*Cast Shadow*] probes the relationship between the viewer and her memory, as, over time, the latter becomes more imprecise and partial. In addition, the small size of the digital tablets on which the nine videos are shown recalls the domestic format of souvenir photographs of the kind put on mantelpieces or stuck in family albums. Photography is no longer impression, trace, or fragment. And yet, all the while remaining a vector of memory, as the video loops ceaselessly back and forth, it forever replays its own disappearance and resurgence.

Nadège Abadie FR

Shah Numair Ahmed Abbasi PK

Dinesh Abiram IN

Emily Moya Addis UK

Nadav Ariel IL

Magdalena Baranya CH

Emile Barret FR

Elina Belou FR

Melissa Bennett ZA

Anaëlle Berroche FR

Maxime Bersweiler FR

Ofer Bessudo IL

Mohit Bhatia IN

Giacomo Bianchetti CH

Rachel Boillot US

Emily Bonnet CH

Samuel Bouaroua FR

Anaïs Boudot FR

Lisa Boyd UK

Katie Bret-Day UK

Travis Brown US

Stephanie Brunia US

Jan Brykczyński PL

Sophia Burke CA

Delphine Burtin CH/FR

Robin Butter NL

Anne-Lou Buzot FR

Juno Calypso UK

Catherine Cameron NO

Nacho Caravia ES

Lourdes Carcedo ES

Alejandra Carles-Tolra ES

Stephan Carnel MU

Amit Chahalia IN

Romain Champalaune FR

Clara Chichin FR

Oreo, Jung Min Cho NL

Mark Chung NZ

Diego Collado PE

Becky Comber CA

Constantinos S. Constantinou CY

Rachel Cox US

Maud Craigie UK

Angélica Dass BR/ES

Emilie De Battista CH

Richard Dell'aiera FR

Kristy Depper CA

Yuxiang Dong CN

Sami El Kasm FR/SY

Charlotte El Moussaed FR

James Dixon UK

Michael Etzensperger CH

Dor Even-Chen IL

Chantale Fahmi LB

Viola Fátyol HU

Catarina Ferrão Ribeiro Da Silva PT

Filipa Maria Ferreira Saraiva Vicente PT

Va-Bene Elikem Fiatsi crazinisT artisT GH

Russ Flatt NZ

Joachim Fleinert DK

Konstantinos Foukis GR

Philippe Fragnière CH

Nicole Clare Fraser ZA

Andréanne Gagnon CA

Veronika Geiger DK

Timothy George UK

Irina Ghenu RO

Morgane Gille FR

Sara Glahn DK

Maryse Goudreau CA

Roei Greenberg IL

Emma Grosbois FR

Emily Grunfeld US

Anna Grzelewska PL

Anna Gutová & Gabriel Fragner CZ

Artur Gutowski PL

Afif Dimitri Haddad LB

Andrew Hammerand US

Felicity Hammond UK

Kristiina Hansen EE

Dominic Hawgood UK

Zhang Hengtai CN

Elizabeth Hewson UK

Karl Hoedl AT

Thomas Hofer AT

David Hornillos ES

Karl Isakson SE

Natali Issahary IL

Dominika Jackuliaková SK

Shaheen Jaffrani PK

Jakub Jančo SK

Tamara Janes CH

Marc André Jésus CA

He Jinsong CN

Janie Julien-Fort CA

Tugba Karatop TR

Shaina Kasanoff US

Mark Kasumovic CA

Aujgobee Kavishan MU

Zohar Kawaharada IL

Selina Kearney IE

Andrew Kennedy NZ

Lebohang Kganye ZA

Hertta Kiiski FI

Hannah Killoh UK

Jung A Kim KR

Jinyoung Kim CA

Jonna Kina FI

Lisa King ZA

Defne Kırmızı TR

Cassandra Klos US

Shunsuke Konno JP

Karel Koplimets EE

Babis Kougemitros GR

Charlotte Krieger CH

Anni Kruus FI

Marek Kucharski & Diana Lelonek PL

Paul Kuimet EE

Antonia Kuo US

Jesus Labandeira Gómez ES

Esteban Lahoz Montolar ES

Ola Lanko UA

Arnold Lebovics FR

Jae Hoon Lee KR

Aislinn Leggett CA

Joëlle Lehmann CH

Antonis Lekkos GR

Sukefan Li CN

Michael Liani IL

Claire Liengme CH

Silin Liu CN

Jérémy Lopez FR

Jack Luke UK

Emily Macinnes UK

Sahar Mactabi IR

Liam Magee UK

Robert Mainka PL

Tiu Makkonen FI

David Manley AU

Georgia Maragkopoulou GR

Stefano Marchionini IT

Vittorio Marrucci IT

Lucy Marthaler CH

Balázs Máté HU

Ryan Mathieson CA

Adrienna Matzeg CA

Alexander McOuat CA

Abel Minnée NL

Hadar Mitz IL

George Morris UK

Mafalda Mata Pereira Domingos PT

Irene Muñoz Martin ES

Miriam Naeh IL

Shogan Naidoo ZA

Vinicius Nakashima BR

Dylan Nelson US

Anna Marie Němcová CZ

Loan Nguyen CH/FR

Justin Nolan US

Nobukho Nqaba ZA

Julianna Nyíri HU

Olya Oleinic MD

Hanna Sophie Orlowski DE

Linda Pagani US

Yehezkel Panet IL

Katie Pankowski UK

Marcela Paniak PL

Miren Pastor ES

Martyna Pawlak FR/PL

Ruth Peche ES

Emilio Pemjean ES/CL

Louis Perreault CA

Dylan Perrenoud CH

Mickele Petruccelli Pucarelli BR

Cosimo Piccardi IT

Joanna Piotrowska UK

Daniel Polacek CZ

Constance & Philippine Proux FR

Maksymilian Radawski PL

Nazanin Rahimi IR

Laurence Rasti CH

Evan Rensch CA

Eduardo Restrepo Castaño CO

Chloe Riddell NZ

Simon Rimaz CH

Jacinthe Robillard CA

Sara Romani IT

Juliette Russbach CH

Roxy Russell CH/UK

Sanni Saarinen FI

Charles Sainty US

Paul Samuels ZA

Rhombie Sandoval US

Naima Miriam Savioli IT

Ramona Schacht DE

Josh Schaedel US

Ulrike Schmitz DE

Juuke Schoorl NL

Karine Shabtai IL

Gauri Shetye IN

Corinne Silva UK

Marcello Simeone IT

Jean-Vincent Simonet FR

Ruta Skemaite LT

Sara Skorgan Teigen NO

Federico Sposato IT

Gaia Squarci IT

Harit Srikhao TH

Juraj Starovecký SK

Locrin Stewart CA

Benjamin Swanson UK

Éva Szombat HU

Lara Tabet LB

Kristi Terakita CA

Adira Thekkuveettil IN

Jennifer B. Thoreson US

Michal Tobiass IL

Sinan Tuncay TR

Hagai Ulrich IL

Navah Uzan IL

Maria Vazquez FR

Nuno Venâncio PT

Mai Vie De Monat DK

Kendra Wallace CA

Ashley Walters ZA

Beibei Wang CN

Matt Waples CA

Qu Weiyuan CN

Asia Weksler IL

Katelyn White US

Jagoda Wisniewska PL

Jessica Wolfelsperger CH

Sam Wood UK

Siwen Yan CN

Dan Yuan CN

Francesca Zagni IT

Mario Zamora ES

Piotr Zbierski PL

Tereza Zelenkova CZ

Li Zhi CN

Magdalena Żołędź PL

Non exhaustive list subject to the applicants' discretion

List of the contributing institutions

Academy of Fine Arts and Design SK

Akademia Fotografii PL

ALBA — Lebanese Academy of Fine Arts LB

Ar.Co — Centro de arte & comunicação visual PT

Art Center College of Design US

Beijing Film Academy CN

Blank Paper Escuela de Fotografía ES

BTK — University of Art & Design DE

Camberwell College of Art, University of the Arts London UK

Centro Universitário Belas Artes de São Paulo BR

CEPV — Ecole de photographie de Vevey CH

COFA — University of New South Wales AU

Concordia University CA

ECAL — University of Art and Design CH

ECAV — Ecole cantonale d'art du Valais CH

Ecole nationale supérieure des Beaux-Arts FR

Ecole nationale supérieure Louis-Lumière FR

Edinburgh College of Art UK

Edinburgh Napier University UK

EFTI — Escuela de Fotografía y Centro de Imagen ES

Elam School of Fine Arts NZ

ENSAPC — Ecole Nationale Supérieure d'Arts de Paris Cergy FR

ESA LE 75 Ecole Supérieure des Arts BE

Esban — Ecole supérieure des Beaux-Arts de Nîmes FR

Estonian Academy of Arts EE

ETIC — Escola de Tecnologias Inovação e Criação PT

F+F Schule für Kunst und Design Zürich CH

Fachhochschule Dortmund DE

Fondazione Studio Marangoni IT

Gerrit Rietveld Academie NL

Ha'midrasha Faculty Of Arts, Beit-Berl College IL

HEAD Genève — Haute école d'art et de design de Genève CH

Hong Kong Baptist University, Academy of Visual Arts CN

ICP — International Center of Photography US

Institute of Creative Photography, Silesian University in Opava CZ

IVS — Indus Valley School for Art & Architecture PK

Jhurry R — JR School MU

KABK — Royal Academy of Art NL

Kwame Nkrumah University of Science and Technology GH

La Cambre — Ecole nationale supérieure des arts visuels BE

LAFA — Lu Xun Academy of Fine Arts CN

le Cabinet, espace de production photographique CA

Le Fresnoy — Studio national des arts contemporains FR

London College of Communication, UAL — University of the Arts London UK

Market Photo Workshop ZA

MassArt — Massachusetts College of Art and Design US

Master of Fine Arts in Experimental and Documentary Arts at Duke University US

MCAD — Minneapolis College of Art and Design US

Michaelis School of Fine Art, University of Cape Town ZA

Minshar School of Art IL

MOME — Moholy-Nagy University of Art and Design Budapest HU

Musrara — The Naggar School of Photography IL

NID — National Institute of Design, Gandhinagar IN

NSCAD University — Nova Scotia College of Art & Design CA

NTU — Nottingham Trent University UK

Ostkreuzschule für Fotografie DE

PHotoEspaña International Centre Alcobendas PIC.A ES

Photography Programme, Royal College of Art UK

Photo Phnom Penh KH

Ryerson University CA

School Friedl Kubelka for Artistic Photography, Vienna AT

School of art design, Beijing Institute of Graphic Communication, University of China CN

SMFA Boston — School of the Museum of Fine Arts US

Sophia Shree B.K. Somani Polytechnic IN

SVA — School of Visual Arts US

Technological Educational Institute of Athens GR

Tehran Arts University IR

The Banff Centre CA

The Glasgow School of Art UK

The Polish National Film, Television and Theater School in Łódź PL

The Royal Danish Academy of Fine Arts, Schools of Visual Arts DK

The Wits School of Arts, University of the Witwatersrand, Johannesburg ZA

Tokyo Polytechnic University JP

Tsinghua University CN

Universitatea de Arta si Design Cluj-Napoca RO

University of Arts in Poznań PL

University of South Wales UK

University of the Arts Helsinki, Academy of Fine Arts FI

UNM — University of New Mexico US

UQÀM — Université du Québec à Montréal CA

URFJ — Rio de Janeiro State University BR

Vu, centre de diffusion et de production de la photographie CA

ZHdK — Zürcher Hochschule der Künste CH

We would like to express our heartfelt gratitude to the 53 artists chosen for this third edition of the *re*Generation project, for their invaluable collaboration and their enthusiasm throughout the creative process these last months: Magdalena Baranya, Emile Barret, Mohit Bhatia, Giacomo Bianchetti, Rachel Boillot, Jan Brykczyński, Delphine Burtin, Juno Calypso, Rachel Cox, Angélica Dass, Emilie De Battista, Michael Etzensperger, Veronika Geiger, Anna Gutová & Gabriel Fragner, Artur Gutowski, Elizabeth Hewson, Karl Isakson, Jung A Kim, Jonna Kina, Karel Koplimets, Marek Kucharski & Diana Lelonek, Ola Lanko, Jae Hoon Lee, Michael Liani, Silin Liu, Emily Macinnes, Robert Mainka, Irene Muñoz Martin, Loan Nguyen, Nobukho Nqaba, Martyna Pawlak, Emilio Pemjean, Constance & Philippine Proux, Laurence Rasti, Simon Rimaz, Jacinthe Robillard, Paul Samuels, Ulrike Schmitz, Juuke Schoorl, Corinne Silva, Sara Skorgan Teigen, Gaia Squarci, Harit Srikhao, Benjamin Swanson, Jennifer B. Thoreson, Sinan Tuncay, Matt Waples, Piotr Zbierski, Tereza Zelenkova and Li Zhi.

This project would not have been possible without the participation of the institutions contacted that shared the work of their best students with the Musée de l'Elysée. We take this opportunity to thank all of the photography professionals who contributed to this endeavour.

We would also like to extend our thanks to William A. Ewing, Director of the Musée de l'Elysée from 1996 to 2010, and to Nathalie Herschdorfer, former Curator at the Musée de l'Elysée, who designed and initiated the *re*Generation project and who were responsible for the first two editions (2005 and 2010), as well as to Jean-Christophe Blaser and Radu Stern, respectively co-curator and consultant of the first edition.

We are grateful to the Canton of Vaud and, in particular, to Anne-Catherine Lyon, State Councilor, and Brigitte Waridel, Head of the Department of Cultural Affairs. Likewise, we would like to thank the Musée de l'Elysée Foundation and its president, Jean-Claude Falciola, and the Cercle of the Musée de l'Elysée and its president, Camilla Rochat.

We would like to express our gratitude to Parmigiani Fleurier for their invaluable support that allowed us to produce this exhibition and to integrate the application of augmented reality into this book.

Many thanks to the team of the Musée de l'Elysée without whom a project of this magnitude would not have been possible: Loïc Ahlgren, Ludivine Alberganti, Maria Amendola, Mélanie Bétrisey, Saida Bondini, Arthur Brügger, Ghislain Butscher, Roxana Casareski, Justine Chapalay, Stéphane Chapuis, Laetitia Chazottes, Nathalie Choquard, Jean-Jean Clivaz, Corinne Coendoz-Fazan, Emilie Delcambre, Jessica Di Ciocco, Lydia Dorner, Tatyana Franck, Pierre Furrer, Cloé Giotto, Daniel Girardin, Christine Giraud, Michèle Guibert, Laurence Hanna-Daher, Afshan Heuer, Pascal Hufschmid, Juliette Hug, Sinje Kappes, Anne Lacoste, Yannick Luthy, Jessica Maillard, Julie Maillard, Pauline Martin, Giuliana Merlo, Christelle Michel, Nicole Murmann, Pascale Pahud, Raquel Pérez Baena, Hervé Pfister, Frédéric Porret, Simira Räbsamen, Caroline Recher, Sarah Rérat, Carolina Romero, Holly Roussell Perret-Gentil, Natacha Salzmann, Carole Sandrin, Manuel Sigrist, Cecilia Suarez, Maelle Tappy, Maude Tissot, Cécile Ulrich, Mathias Velati and Anastasia Zakharova.

The authors are particularly grateful to Laurent Cochet who was responsible for all of the prints for the exhibition. His collaboration with the artists and our entire team was vital to the preparation of the exhibition in the best possible conditions. We are also grateful to Laurence Martin and Bruno Le Namouric for their expertise and participation in the layout and framing of the prints. Thanks also to Claude Roubaty and Antoine Meier of the Antidote Studio who were responsible for the exhibition's graphic design, as well as to the Lausanne GuestHouse & Backpacker for providing accommodations for the artists.

We would like to thank the team of translators who prepared the English version of this catalogue: Gail Wagman, Stéphanie Klebetsanis and David Radzinowicz. Thanks as well to Susan Pickford, translator, for her enthusiastic support and direction under extremely tight deadlines.

We are particularly grateful to Jennifer Sunier and to Samuel Perroud of SUPERO (www.supero.ch) for the extraordinary care given to the design of the book, as well as to Giuseppina Leone, Emma Cavazzini, Anna Albano and Marcello Francone of Skira editore, and Frédéric Jordi of the printing compagny Courvoisier who accompanied us during all of the phases of its production, printing and distribution. Finally, we would like to extend our special thanks to Arthur Brügger, coordinator of the Musée de l'Elysée Publications, for his remarkable work and dedication throughout the entire preparation of this book.

Acknowledgements

Design
SUPERO, www.supero.ch

Copy editor
Anna Albano

This publication was produced on the occasion of the exhibition, *re*Generation³: Which approaches for photography?

Musée de l'Elysée, from 29 May to 23 August, 2015

The exhibition was produced by the Musée de l'Elysée, Lausanne ww.elysee.ch

Book edited by Anne Lacoste and Lydia Dorner

Curator
Anne Lacoste, assisted by Lydia Dorner, Emilie Delcambre and Saida Bondini

For the Musée de l'Elysée

Director
Tatyana Franck

Registrar
Corinne Coendoz-Fazan

Technic
Simira Räbsamen, assisted by Yannick Luthy, Jean-Jean Clivaz, Michèle Guibert and Ghislain Butscher

Prints
Laurent Cochet

International tour
Pascal Hufschmid, assisted by Holly Roussell Perret-Gentil

Translations
Gail Wagman, Stéphanie Klebetsanis and David Radzinowicz

Communication and press
Julie Maillard, assisted by Maria Amendola

Augmented reality
Manuel Sigrist, assisted by Ludivine Alberganti

Bookstore and publishing
Arthur Brügger and Nathalie Choquard

In 2015, the Musée de l'Elysée turns 30.

PARMIGIANI
FLEURIER

First published in Italy in 2015 by
Skira editore S.p.A.
Palazzo Casati Stampa
via Torino 61
20123 Milano
Italy
www.skira.net

Printed and bound in Italy and Switzerland. First edition

ISBN: 978-88-572-2824-2
(for Skira editore)

ISBN: 978-2-88350-108-9
(for the Musée de l'Elysée)
Depot legal: mai 2015

Distributed in USA, Canada, Central & South America by Rizzoli International Publications, Inc., 300 Park Avenue South, New York, NY 10010, USA.

Distributed elsewhere in the world by Thames and Hudson Ltd., 181A High Holborn, London WC1V 7QX, United Kingdom.

Paper
Xper premium white 140 g/m²
Pop'Set cloud 90 g/m²

Cover
Papyrus Gmund Action, one side with iridescent effect, fine grain 310 g/m²